AMERICAN ART
SINCE 1945

Dore Ashton

AMERICAN ART
SINCE 1945

NEW YORK
OXFORD UNIVERSITY PRESS
1982

First published in Great Britain 1982
by Thames and Hudson Ltd

First published in the United States of America 1982
by Oxford University Press, Inc.

Copyright © 1982 Thames and Hudson Ltd, London

ISBN 0–19–520359–3
Library of Congress Catalog Card Number: 81–83435

DL.: TO–1188–81
Printed and bound in Spain

Contents

Introduction

The events that comprise a history of modern art are not easily assimilated to an epithet. Because they are dependent on the existence of works of art, they do not always fall into place no matter how much the chronicler strains to wedge them into a compact period. An enduring work of art eludes final definition and can never be confined in a single segment of history. This paradoxical situation leads the historian of culture into many conundrums. He is usually constrained to define ambient events, life histories and other facts of time and place, while gingerly backing off from the work of art. Even so, a hard light focused on the esthetic assumptions underlying the entire enterprise of modern art does cast reflection on the individual work of art. Once that light is played on the tumultuous history of "isms" in the modern era, certain truths emerge, among them the truth that no history of modern art should be strictly confined within a given period–least of all the decade–and that underlying convictions and assumptions are often carried for generations.

Still, it cannot be denied that the favored method of phrasing history in the modern period is to divide it into decades. Most interpreters are well aware that the decade tic is really too much of a convenience. Yet they are forced to take into account genuine patterns of events and psychological needs. Occasionally, as in cycles of war, prosperity, and war, the decade does mysteriously function as a natural marker. In the arts, the insistent reference to decades is not entirely groundless insofar as the established movements, particularly in early 20th-century history, tended to spend themselves within the decade. For all that, assumptions based on still earlier modern epochs, such as in the 19th century, often survive for many decades–sometimes even for a century or more.

For instance, during the 19th century, many artists viewed with alarm what they called the "industrialization" of the arts. Well-known

writers complained that the swift expansion of the newspaper industry encouraged a debased and vulgar literature. Painters feared that the machine lithograph reproduction would cheapen their work and lead to false notions about the value of art. Their anxiety accumulated into a vague attitude of defiance sometimes called art for art's sake, or romanticism. In response, there were other attitudes that were diametrically opposed. Certain artists welcomed the mass media as instigators of democracy, initiators of a new popular esthetic, distillers of Utopian visions. Both sides of these arguments had been inspired by the rapid development of modern technology; both represented legitimate fears, and both arguments have lingered into our own century. Some artists still argue today for the autonomy of their art and others argue for an art that relates to the larger community and reflects social commitment. The questions raised in the 19th century on these two broad issues have been reiterated by each generation in the 20th century. Despite the vast diffusion of words and images in our century, and the increasingly efficient means of purveying them, the anxiety and disaffection of artists have not been dispelled, nor has the nature of their questions been substantially altered.

1

The artists who began to seem important in American culture after 1945 – and who were soon to be vital to Europe and Japan as well – were not, properly speaking, a generation. They were born mostly between 1880 and 1922, from widely differing backgrounds. A few had long been known as professional artists. Arshile Gorky, for example, had been in a group show at the Museum of Modern Art in 1930 and had his first one-man exhibition as early as 1934. His friend, Willem de Kooning, on the other hand, was known to fellow artists for years before he had his first one-man show in 1948. The oldest artist to gain prominence after 1945, Hans Hofmann, had come from Europe with a reputation primarily as a teacher and had his first one-man show in 1944 when he was sixty-four years old; while the youngest, Theodoros Stamos, was only twenty-one when he had his in 1943. Aside from this wide disparity in ages, there was also a tremendous range in temperament and formation. There were those who developed a passionate allegiance to the modern tradition as represented by the great Europeans Picasso, Matisse, Mondrian and Miró. Some, such as Gorky, de Kooning, Pollock and David Smith, kept in close touch with the Russian painter John Graham, who arrived in New York in the '20s with an intimate knowledge of the lives and development of the European major artists. Others, such as William Baziotes, Adolph Gottlieb, Mark Rothko, David Hare and Robert Motherwell, were stirred by the echoes of Surrealism and watched closely as the movement dilated in Europe and eventually reached America. Still others, among them Bradley Walker Tomlin, Jack Tworkov and Lee Krasner, were faithful to the tradition running from Cézanne to Cubism. Then there were a few artists associated with the Abstract Expressionists who were determinedly provincial and, like Clyfford Still, vociferously denied all traditions and affected ignorance of the modern past.

Aside from the broad cultural differences among those who made up the configuration of Abstract Expressionists, or New York School artists, there were numerous alliances and friendships that brought unlikely companions together. Philip Guston and Jackson Pollock—the one an immigrant child of Russian Jewish background and the other the son of Western farmers—attended the same Los Angeles high school. They and others from equally diverse backgrounds made acquaintance with still others from the heart of America, or transplanted from Europe and Asia, as they lined up together during the Depression to collect their paychecks from the government's arts projects. With such a broadly diverse background, the artists who were acknowledged after the War as belonging to a "movement" created many, and often insoluble, problems for those who wished to prove their cohesiveness as a movement. Most of the artists were already in their mid-thirties to mid-forties, and had experienced the rapid transformation of American society during their lifetimes with varying degrees of hardship and alienation. Their common ground was in having known all too well the cultural crises that assailed America after World War I. As many cultural histories recount, the unsettling years after the War were filled with a national anxiety to find and define an American culture. In the quest, Americans who were visual artists were to be claimed last. Unlike their European counterparts, the Americans had no standard route toward the title of artists. Nothing could be taken for granted in the U.S., where the intellectual was generally an expendable ornament to the real business at hand, which was business. What it meant to be an artist became a serious question in America, far more serious than in Europe where, no matter how grudgingly, an artist was an acknowledged member of the social entity.

In the U.S., artists were confronted with questions of conscience at every turn. They grew accustomed to grappling with contradictions. If they were young in the '20s, they were hearing the uncertain voices of disaffected intellectuals denouncing America's absorption in mindless technological expansion. Suddenly they looked around, these worried writers and artists, and saw chains of supermarkets springing up overnight. They saw the tireless construction of skyscrapers and the chaos of expanding urban sprawl. They bought radios, like everyone else, and heard the blatant lies of the suddenly flourishing advertising business. In the vulgarization of newspapers, which also came in chains, and the mass inculcation of consumerism through radio, many

intellectuals saw disaster. The cultural values to which they aspired seemed irrelevant and all but unattainable. Increasingly, the columns of the weekly journals and little magazines carried worried critiques of American life, and even indictments of the very foundation of its culture. Attentive artists noticed new interpretations of tradition, sometimes very bitter. They heard denunciations of the previously lauded pioneer spirit—interpretations that damned the pioneers for their excessive individualism. "Over and over again," writes Richard Pells, "writers reproached the pioneer for destroying the wilderness but substituting nothing in its place, exalting the principles of individualism and competition while ignoring the benefits of cooperation and community, and sacrificing art to the hard demands of daily survival."[1] On the other hand, artists and writers sensed the disillusion and pessimism behind the façade of Jazz-Age exhilaration. They understood that many among the older generation, who had once cherished liberal principles of political engagement, were now to relinquish their dreams of social change. To many writers the ideological ambitions that had flared up after the stimulus of the Russian Revolution began to seem fruitless. They discerned deleterious effects when ideology lodged in the arts, and they began to move toward the old position of art for art's sake that had itself been a product of similar situations during the 19th century. When R. P. Blackmur and Lincoln Kirstein founded the literary review *Hound and Horn* in 1927, they worked on the assumption that "a sound philosophy will not produce a great work of art and a great work of art is no guarantee that the ideas of the artist are sound."[2]

Their position was ruefully revised when the effects of the Great Depression began to seem nearly fatal to the country around 1932. Then, most intellectuals had to reflect that the extreme social and economic disorder was somehow related to the values of the preceding decade. The necessity for a revision of values was so basic that many artists performed a *volte face*. It occurred to them that not even art could survive the cataclysm. Something, perhaps even some ideology, had to be adopted if only for survival's sake. The growing necessity for collective action—whether in terms of workers' rebellions or artists' organizations—brought about a painful confrontation with the immediate past. For artists who, during the '20s, had declared themselves in the great modern tradition, the purity and remoteness of modern art no longer seemed bearable in the face of cultural collapse. The artist's proud isolation no longer seemed conducive to vigorous per-

formance. Individualism, so forcefully argued and debated in the '20s, now seemed of dubious value. Even the most reverent of the modernists such as Gorky began to cast about for a means of integration within American society as a whole, and for a stance that incorporated attitudes only recently regarded as inappropriate to the development of high art. The notions of community and collectivism that had once seemed inimical to artistic life began to trouble many artists. Troubling issues became more acute when the government organized the vast network of assistance programs that coalesced into the WPA arts projects. Artists faithful to the ideals of the modern French tradition found themselves moving closer to those who, like the Marxists, advocated commitment within the artistic process itself. Some, such as Jackson Pollock, were momentarily detained by the dream of expressing the American experience in explicit terms. Others accepted the messianic pronouncements hailing from Mexico that easel painting was a bourgeois leftover and that public art such as the Mexicans' murals was the only legitimate art form. The pressure somehow to relate to the vast suffering of Depression America was so intense during the early '30s that most practising artists succumbed to some degree. Even those who determinedly sustained the modern vision in their work moved in their civic life to an almost contrary position, advocating social action and mass reform – sometimes even revolution.

As the '30s advanced in chaotic upheavals, the Marxist ideal gained ground, plunging many painters and sculptors into terrible conflicts that would be resolved only when the political life of the intelligentsia was seriously undermined, first by the Moscow trials and then by the Hitler–Stalin pact. A small relief from the dilemma of public versus private art and committed art versus art for art's sake appeared in the form of an article in the *Partisan Review* signed by Diego Rivera and André Breton, in which the right of an artist to be free from ideological demands was forcefully asserted. (In reality this manifesto had been drawn up by Leon Trotsky and Breton but was signed by Rivera for reasons of political expediency.) The Mexican who had been much admired by the artists of the New York School, along with Siqueiros and Orozco, seemed to be saying that you could be a revolutionary artist and still be a modernist – a message that was balm to the sorely tried souls of the more ambitious artists caught in the crossfire of rhetoric that had so disrupted their development. Reading *Partisan Review*, as many artists did in those dark days before the U.S. closed down its social experiment to prepare for war, those who had more or

less arrived at the same position could feel vindicated. If even Rivera, a real fighter in the front lines of revolutionary artistic life, could make such a declaration, certainly they who had tried so hard to accommodate the vast accident of history called the Depression also had the right to shift position. In addition, Breton, who would soon arrive as a refugee in New York, had for years been a familiar name to many New York artists who had kept track of French Surrealism and who, after Julien Levy opened his influential gallery in 1931, frequented Surrealist exhibitions and read any relevant literature they could find.

The resolution of the dilemma concerning social and political commitment did not, however, resolve the fundamental problem of the American artist. That problem, filtered through the upheavals of the '20s and '30s, remained a problem of identity. Artists felt more alienated than ever and esthetically less certain. Adolph Gottlieb, recalling those years, said that by the age of 18 he had clearly understood "that the artist in our society cannot make a living from art; must live in the midst of a hostile environment; cannot communicate through his art with more than a few people; and, if his work is significant, cannot achieve recognition until the end of his life if he is lucky and more likely posthumously."[3] Although Gottlieb pointed out that around 1940 he no longer felt his situation was hopeless, he nevertheless took it for granted that he faced a hostile environment. Among themselves, the artists who began to feel more confident around 1940 were not consistently so. The word "bankrupt" haunts their statements and occurred in many discussions from the mid-'30s on. But the conflicts that had accompanied the '30s with such violence subsided into a deep need for catharsis that, by the early '40s, was to find expression in a reckless embarkation into the unknown that came to be called Abstract Expressionism.

Whatever else can be said about the Abstract Expressionists, it is undeniable that they were veterans in the practise of doubt. Out of the serious dilemmas of the '30s grew skeptical attitudes that could only be altered by the sweeping sense of a *tabula rasa* that overtook them in the '40s. Through having wrestled with serious and important questions all through their youth, these artists earned the right to what T. S. Eliot called "the awful daring of a moment's surrender." Later, Harold Rosenberg would give the most accurate description of their state of mind when he wrote the famous paragraph:

At a certain moment the canvas began to appear to one American painter after another as an arena in which to act—rather than as a

13

space in which to reproduce, re-design, analyze or "express" an object, actual or imagined. What was to go on the canvas was not a picture but an event.[4]

There were no "typical" artists in the movement, but Arshile Gorky, with his extravagant esthetic gestures, does reflect the formation of other kindred spirits in his generation. During the '20s he had first-hand experience with the bohemian revolt against bourgeois values, having installed himself in the heart of Greenwich Village upon his arrival from Europe. His respect for the advanced culture represented by French painting and poetry was unbounded. He appropriated the European traditions and set himself to school first with Cézanne whom he studied closely, later with Picasso, and finally with Miró. There were others who shared his enthusiasm for those modern masters, but none went quite so far as Gorky, who was the butt of many studio jokes for his unswerving apprenticeship. When he brought his works to Julien Levy, he was told they were too Picassoid, and responded with dignity: "For a long while I was *with* Cézanne, and now I am *with* Picasso." According to another anecdote, a fellow artist twitted Gorky for having worked so long to perfect the Picasso sharp edge only to be confronted in the late '30s with works in which Picasso had blurred and dripped the edges. "If Picasso drips, I drip," Gorky declared. His fealty to Paris did not, however, exclude close associations with American painters. His friendship with Stuart Davis reflected the shared assumptions of many early abstract painters that the appropriate language for a modern painter derived from Cubism. Even during the '30s, when he was a committed campaigner on the Left and a leader of the Artists' Union, Davis maintained his firm modernist convictions. Writing for the Whitney Museum's exhibition of 1935, "Abstract Painting in America," he stressed certain principles germane to the American painters. "Art is not and never was a mirror reflection of nature . . . Art is an understanding and interpretation of nature in various media. Since we forego all efforts to reflect optical illusions and concentrate on the reality of our canvas, we will not study the material reality of our medium, paint on canvas or whatever it may be." Davis acknowledged that many American artists were not scientifically dedicated to such strictures, but "even in those cases where the artistic approach has been almost entirely emotional, the concept of the autonomous existence of the canvas as a reality which is parallel to nature has been recognized."

14

Gorky's patient studies of the modern idiom, augmented with studies of masters of the past such as Vermeer, Paolo Uccello and Ingres, flowed into his activities during the Depression, even into his murals for public places such as those done for the WPA at Newark Airport. Despite his aloofness from the political groups common during the period, Gorky had been touched by the search for community and the common belief that art should not be severed from society. His chief model in this case was Léger, whose social commitment seemed endemic in his art and who yet was faithful to principles derived from Cubism. In carefully planning the murals, Gorky struggled to find accommodation with the current demand for social significance. He never compromised with the provincial notions of American-type art but he did wistfully strive to reach a broader segment of the society, as one of his statements at the time suggests:

Of course the outward aspect of my murals seemingly does not relate to the average man's experience. But this is an illusion! . . . Certainly we all dream and in this common denominator of everyone's experience I have been able to find a language for all to understand.[5]

No doubt Gorky did hope to find a language for all to understand. For a time he was enthusiastically convinced that Surrealism, with its emphasis on dreams and its old battlecry from Lautréamont, "Poetry is made by all, not one," could provide the means. His interest in Surrealist thought, stirred in the early '30s, was heightened when he met and befriended the newly arrived Matta Echuarren, who had been associated with the Surrealist group in Paris. Matta, who had written in 1938 about his theory of "psychological morphology," was soon joined by the leader of the Surrealists, André Breton. (Breton was known to many of the Abstract Expressionists, some of whom, resenting his European manner and cultish deportment, dubbed him "Mr. God.") Impressed with Gorky's work of the early '40s, Breton wrote a sensitive essay for his first exhibition at the Julien Levy Gallery which not only captured the character of Gorky's work, but also heralded the postwar climate of esthetic revolt in 1945. He called Gorky an "eye-spring" and, in diction inspired by Gorky's late paintings delicately scored with linear rhythms, wrote that the eye

was made to cast a lineament, a conducting wire between the most heterogeneous things. Such a wire, of maximum ductility, should allow us to understand in a minimum of time the relationships which

connect, without possible discharge of continuity, innumerable physical and mental structures.

Taking up the theme of the 19th-century Utopian, Charles Fourier, Breton maintained that the key to a philosophic universe in which art takes a natural place was the concept of analogy. He said that Gorky had expressed the essence of nature in hybrid form, fusing the flux of memory and contemplation of natural spectacle in images that could not be simply still lifes or landscapes or easily identifiable configurations:

Here for the first time nature is treated as a cryptogram. The artist has a code by reason of his own sensitive anterior impressions, and can decode nature to reveal the very rhythm of life.

Breton's allusion to the artist as a decipherer of nature's cryptogram, and as a conducting wire of "the very rhythm of life," could well have referred to many of the other painters who at about the same time launched into the realm of psychology and sought to express deep intuitions of life. As Breton's text shows, he himself was sustaining the tradition of the Romantics of the 19th century who referred, as did Baudelaire, to nature as a cipher and an alphabet. Breton's contribution in the 20th century was to add *human* nature to the sum of coded cues, and Gorky and most of the other Abstract Expressionists were installing themselves in the great Romantic tradition with this added dimension. Certainly the paintings that Gorky showed in 1945 were the culmination of many experiences, both his "sensitive anterior impressions" and his practical exploration of various painterly idioms. They were an exquisite resolution into analogy. He had not forgotten his models, as could be seen in the 1944 "The Liver is the Cock's Comb," in which both Kandinsky's and Miró's visions are fused in a unique blend of color that serves to determine various spatial stages, and of line that carries the hybrid connotations that stimulated Breton.

For the final three tragic years of his life, Gorky reached into the rich memories of his childhood in Turkish Armenia, and into his poetic treasury to create a system of analogies that freed him from both representational literalism and abstract automatism. He had been chided by Clement Greenberg after his first show for doing "biomorphic" Surrealist painting that "emphasizes the dependent nature of his inspiration," but in fact, the works of his last years carried his unmistakable mark and have since been acknowledged as singular expressions of a master painter. He had, like several others among the

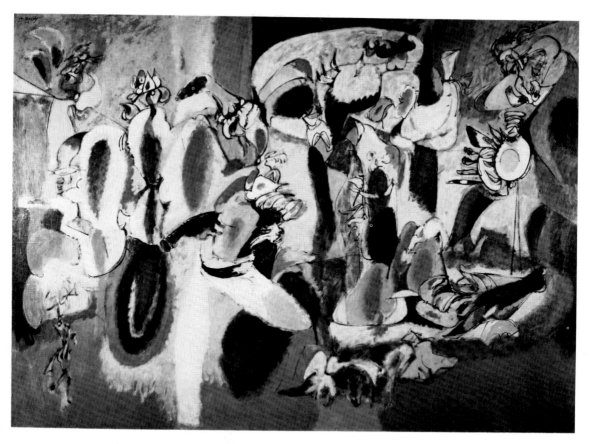

I ARSHILE GORKY *The Liver is the Cock's Comb* 1944

Abstract Expressionists, succeeded in making "a new beginning," an ideal that was repeatedly put forward during the '40s.

The new beginning–which meant freedom from the demands of the '30s as well as from those of modernism itself–was as keenly pursued by Gorky's friend, Willem de Kooning. During the early war years he began to clarify his vision of analogy, freely adapting biomorphic forms as defined by both Picasso and the Surrealist successors, to a vision of spatial ambiguity resting on a Cubist base. De Kooning, with his strong background in academic painting acquired as a youth in Amsterdam, and his visible pleasure in heterodoxy, was a unique figure among artists. He was well known during the '30s and generally considered an artist's artist until his belated one-man show in 1948. His quick eye, like Gorky's, scanned the entire history of art for inspiration, and his hand never hesitated to move in disparate directions. His exemplary freedom inspired other artists. Even his hesitant work of

the '30s had an air of adventurousness that foretold his later audacities. He understood more than most of his colleagues how free a painter must be to emerge unscathed from shifting circumstance.

De Kooning told his biographer Thomas B. Hess that there were three toads in the bottom of his garden: color, line and form. Sometimes he preferred the word "shape." These three elements are in the bottom of every painter's garden, but for de Kooning, they stood out in relief, and had to be dealt with one by one until a total integration occurred somewhere en route in a painting. In the mid-'40s he worked assiduously with the three elements, taking great care to make them ambiguous enough to suggest a host of organic metaphors. A characteristic work of *c.* 1945 is "Pink Angels," in which a host of highly suggestive shapes, pink and fleshy, straddle the foreplane. Their contours are given in long, sinuous strokes of the liner brush—that sign-painter's boon that he once introduced to Gorky—and a scaffolding of rectilinear forms provides stability. These flying shapes, so elastic and ebullient, were never to be abandoned. Even an abstract form, de Kooning said, has to have a likeness, and he worked for years to find the exact abstract forms that could be at once suggestive, even specific, and ambiguous in relation to the total composition.

A couple of years later de Kooning was at work on the series of enamel-and-oil paintings in black and white that so startled his viewers in his first show. These were fraught with visual ambiguities. Black shapes slid into white in elisions that were completely unconventional. At times the white line whipped through the entire composition like a comet, giving no rest. Plane overlapped plane, but also there were interruptions that departed from a coherent Cubist articulation of the surface. These interruptions were becoming essential to de Kooning, and when he went back to color, as he did in "Ashville" of 1949, he brought with him the lessons of the black and white paintings. In it everything is orchestrated in several keys. There are the necessary stabilizers in a series of shelf-like horizontals, and in the rhythmic color accents. There are shapes that curve and hint at human members, buttocks and breasts, eyes and mouths. There are interstices through which clear spaces are briefly perceived, and there are lines lightly brushed over, linking one kind of experience with another in juxtapositions that fully justified the epithet "Abstract Expressionist." But the total measure of de Kooning's Expressionism was yet to come in the series of studies of women that began around 1950 and is still in progress. His swerving from apparent abstraction

18

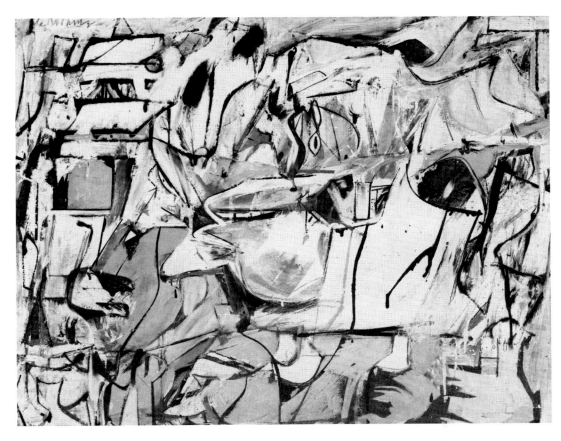

2 WILLEM DE KOONING *Ashville*
1949

3 WILLEM DE KOONING *Woman, I*
1950–52

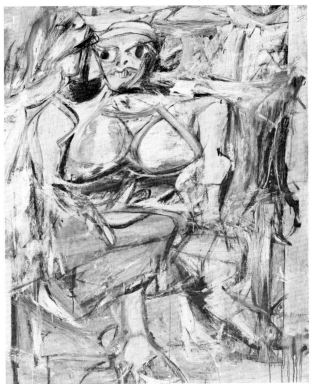

to what appeared to be a figurative art indicates the character of the decade of the '50s with its experimental, unmoored character. Although critics were adequately shocked by the eruptive paint quality, the savage and often funny satire in the new de Kooning women, they might have seen that it was a theme he had long explored, and that, in the women, he brought his full powers to bear. All his toads were out croaking. Indignation on the part of orthodox abstract defenders did not faze de Kooning. He told David Sylvester,

It's really absurd to make an image, like a human image, with paint, today, when you think about it . . . But then all of a sudden, it was even more absurd not to do it. . . . It did one thing for me: it eliminated composition, arrangement, relationships, light—all this silly talk about line, color and form—because that was the thing I wanted to get hold of . . .[6]

The shocks de Kooning administered were matched only by the initial shock Jackson Pollock produced when he first showed his poured paintings. He had begun as a rebel (he and Philip Guston had been thrown out of high school for having inspired a revolt) and had known the passions of the '30s—particularly on the political Left—first-hand, having come to New York in 1930. His studies with Thomas Hart Benton fortified his resolve to find an appropriate expression of his American experience and his early works reflect Benton's interest in regional rural life. Like other intellectuals of the period, Benton looked to the agrarian South and Midwest as a model of community and values not corrupted by rampant capitalism and technological inhumanity. He may have seen the misery and injustices attendant on the system, but basically Benton dreamed back to a time of rural simplicity in his paintings. Other artists of the Left, fully aware from their own experience of the mortifying effects of urban unemployment, made pilgrimages to Mexico to study peasant life and its reflection in the great new murals by Rivera, Siqueiros and Orozco, and when those artists appeared in the United States, watched them respectfully and yearningly. Pollock admired them greatly and was to work later on with Siqueiros in his experimental workshop on 14th Street. He looked back to the same Renaissance sources that the Mexicans had drawn upon in their mural movement, but he also meditated on his lonely Expressionist forebear, Albert Pinkham Ryder, while still a student. Gradually Pollock turned his attention to modern painters, especially Picasso, and a little later the Surrealists such as Max Ernst and André

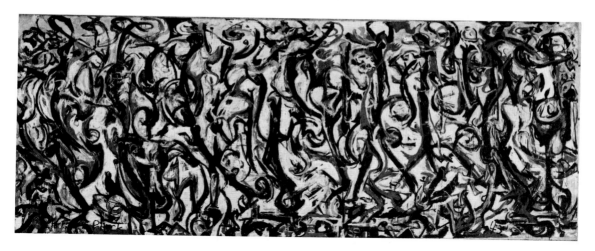

4 JACKSON POLLOCK *Mural* 1943

Masson. Like practically every one of the Abstract Expressionists, he had seen reproductions of Picasso's drawings based on the Spanish Civil War, and had looked at "Guernica" fervently when it was shown in New York in 1939. By the time Peggy Guggenheim encountered Pollock in 1943, he was thoroughly versed in the modern masters and had assimilated them in his work.

Guggenheim recognized Pollock's intensely original approach to the problems all American painters faced in the early '40s and lost no time in putting him on contract to her "Art of This Century" gallery and commissioning him to do a mural for her New York apartment. Pollock's hope, as he said at the time, was to find a means of making something between an easel painting and a wall painting, and he produced just that: a syncopated composition filled with curvilinear suggestions of figures that moved across the canvas surface as would an ancient frieze. Within a very short period Pollock had found a means of expression personal enough to attract the critic James Johnson Sweeney, who said in the foreword to Pollock's first one-man show in 1944 that his work was volcanic, unpredictable, lavish, undisciplined, explosive and untidy. These were not negative epithets, given the temper of the time: on the contrary. Sweeney extolled Pollock's freedom from others' opinions and his stylistic independence. "What we need is more young men who paint from inner impulsion," Sweeney wrote. He was soon to get them. The young

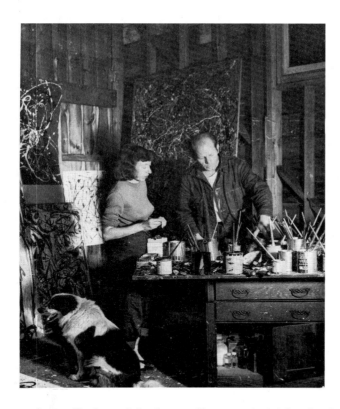

5 JACKSON POLLOCK
and LEE KRASNER
*c.*1950

6 JACKSON POLLOCK
Composition 1950

painter Robert Motherwell seconded him in *Partisan Review*, writing
in the 1944 Winter issue that Pollock

represents one of the younger generation's chances. . . . In his exhibit,
Pollock reveals extraordinary gifts: his color sense is remarkably fine,
never exploited beyond its proper role; and his sense of surface is
equally good. His principal problem is to discover what his true sub-
ject is. And since painting is his thought's medium, the resolution
must grow out of the process of his painting itself.

The reference in Sweeney's foreword to inner impulsion—another
version of Kandinsky's inner necessity which in turn derived from
German Romantic sources in the 19th century—caught the spirit of
the moment in which one artist after another had tried to formulate
the landscape of his inner world with the kind of responsible freedom
advocated by the Existentialists. By the time Pollock exhibited his
poured paintings in 1948, startling not only the public but many
artists as well, the rhetoric of the studios had swelled with the romantic
notions of freedom, innerness, risk, and spirituality. Pollock's gesture—
to paint on the floor with any tools he found appropriate, and to
establish baroque rhythms that denied the immediate modern past—
was seen as exemplary by the artists who would eventually be called

"action painters." He had, as de Kooning said, broken the ice. The need to get as close to the wellsprings of emotion as possible, to connect with the rhythms of the universe in a Nietzschean access of inner effusion, spurred Pollock to work with unstretched canvas on the floor, moving around it like a ritual dancer. The great skeins of color, woven in transparent plane over plane, did suggest a fresh way of representing pictorial space and was to inspire other artists to dispense with recent conventions.

On the West Coast, Clyfford Still was storming the citadels of convention at the newly reorganized California School of Fine Arts in San Francisco from 1945 to 1950, thundering against all convention, above all pictorial conventions, and situating his young acolytes in an imaginary world peopled with menacing traps set by the art world.

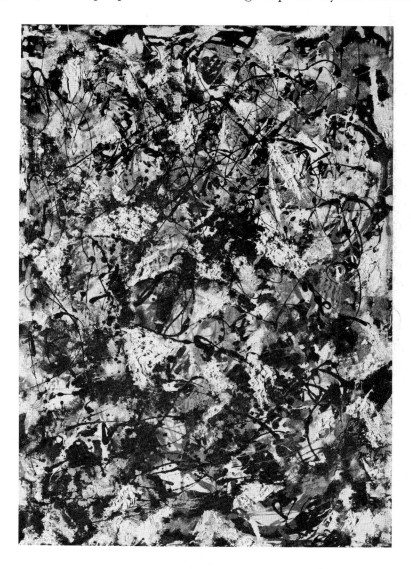

Still soon joined Pollock at the Art of This Century Gallery where he had his first one-man show in 1946 presented by Mark Rothko, who wrote that Still belonged to "the small band of Myth Makers who emerged here during the war." Rothko saw in the jagged, fetish-like shapes of the dark paintings ancestral phantasms common to his own work and Pollock's. Shortly after, Still awed his audiences by eliminating the monkey-wrench forms, phallic shafts and nimbused figures that had made his work seem symbolic, in favor of immense opaque surfaces with lightning-bolt rents. In the heavily trowelled new works, Still sometimes laid on enormous areas of a single omnivorous color broken only by a few erupting lines suggesting great primordial spasms. Like Pollock before him, Still startled his viewers with his bold disavowal of the inherited forms of abstraction. He influenced many younger artists on the West Coast through offering them, as critic Kenneth B. Sawyer said, the only viable alternative to Cubism.

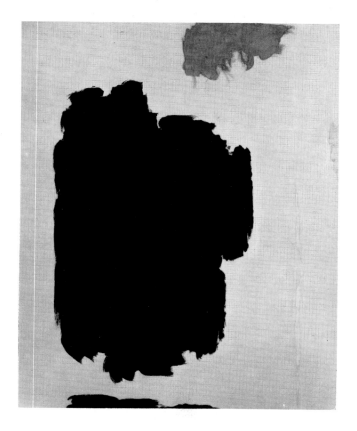

7 CLYFFORD STILL
Untitled No. 1 1951

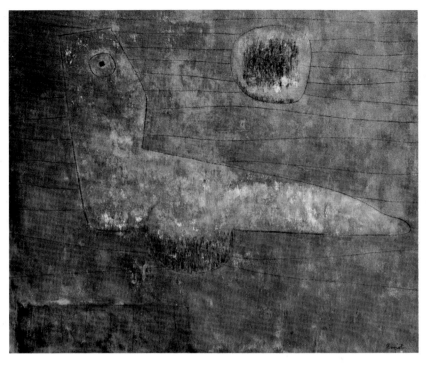

8 WILLIAM BAZIOTES *The Mummy* 1950

Increasingly in the late '40s the notion of "inner impulsion" guided the hands of painters. Some had already struck the opening blows during the war years at Peggy Guggenheim's gallery. Emboldened by the European presence (dozens of eminent artists arrived in New York as émigrés), younger Americans became increasingly assertive. Their exposure to Guggenheim's husband, Max Ernst, and his acquaintances Mondrian, Léger, Masson, Duchamp, Tanguy and others who frequented the gallery, heightened their excitement and pushed them into ever more extravagant adventures. Even so meditative a temperament as William Baziotes's found expression in terms of the new emphasis on the inner wilderness to be explored. In 1944, the year of his first one-man show at Guggenheim's gallery, Baziotes explained that subject-matter in his painting was often revealed only as he worked, and three years later reiterated this, saying that "What happens on the canvas is unpredictable and surprising to me." His description of the working process as being so dependent on intuitive

25

insights en route conforms to the general Abstract Expressionist attitude toward the canvas. Baziotes called his canvases his "mirrors" and added, significantly, "They tell me what I am like at the moment."[7] The issue of self-discovery through the rituals of painting was to become salient in the entire rhetoric of the New York School painters.

The lure of the inner world had long worked upon Mark Rothko and Adolph Gottlieb, who had both turned in the late '30s from moody figurative Expressionism to symbolism drawn from archaic sources. Together with their friend Barnett Newman, who was at that time a kind of Socratic gadfly in artistic circles, they had contested the prevailing currents during the Depression. Like their European mentors, particularly the Surrealists, they had begun to scour distant horizons, looking to ancient societies, and Indian art and cave paintings, as well as Greek poetry and myths of all nations. They were quite clear in their minds that the historicism of the technological era was deleterious to the soul of art. Their brooding natures craved a symbolism that defied both the formal traditions of modern art and the figurative traditions that had so weakened the art in America of the '30s. They wrote in 1943, in one of the early "documents" of the era, that they demanded an art that adventures into an unknown world which can be explored by those willing to take risks. They declared:

It is a widely accepted notion among painters that it does not matter what one paints as long as it is well painted. This is the essence of academicism. There is no such thing as good painting about nothing. We assert that the subject is crucial and only that subject matter is valid which is tragic and timeless. That is why we profess spiritual kinship with primitives and archaic art.[8]

Although Rothko was soon to eliminate overt mythical references, and Gottlieb to simplify his grids with more abstract forms, the basic concern with spiritual values remained. In their demands they reflected the strong feelings of so many artists of their generation that modern art somehow had to be infused with values more universal and deeper than had previously been evident.

The most consistent proponent of this view was Mark Tobey, who had worked out a system that he called his "white writing," in which he could transcend both the formal characteristics of modern art and its hermetic character. He drew upon complex sources in Eastern philosophy as well as orthodox Cubism in his prolonged series of experiments that culminated in the abstractions of the early '40s

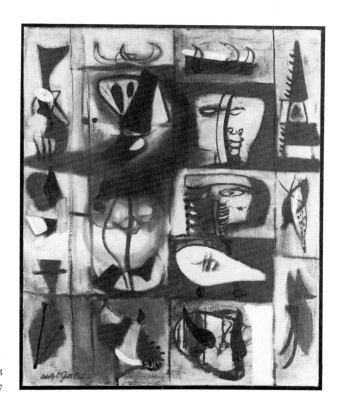

9 ADOLPH GOTTLIEB
Symbols 1947

exhibited at the Marian Willard Gallery in 1944. His deep religious
sentiments found expression in the paintings in which he wished to
"write" the light—the unifying light which he found in his meta-
physical meditations and which could express the universal values he
deemed so important. Tobey came forward with a pictorial style that
had no precedent; the cosmological spaces he dreamed found expres-
sion in closely interwoven, meandering calligraphy, transparent plane
upon plane. It was a style that struck his viewers with its suggestions of
infinity.

On a practical level, the move from inherited conventions was
assisted by Hans Hofmann in his role as teacher, lecturer and grand
old man of the art world. His influence was felt in many ways. He was
a carrier of the major modern tendencies from Europe—the coloristic
expression of Matisse and the compositional theory of Cubism, as well
as the iconoclastic attitudes of the German Expressionists. All these
tendencies were implicit in the quick moves that occurred in so many
artistic lives during the Second World War. As the '40s evolved, an

27

10 HANS HOFMANN
Immolation 1946

authentic sense of crisis overtook many artists—crisis in the original sense of the word, a "crossing." The conflicting impulses of the early '40s began to find expression in attitudes that closely resembled the dicta of the popular Existentialist philosophers. By 1948, for instance, Sartre had been extensively translated into English. Artists could read his theory in *Partisan Review* or in his book *Existentialism and Humanism* which appeared in English in 1948. Sartre spoke again and again of the necessity for each man to bring his point of view of existence out of his individual self, and at the same time, for each to acknowledge that he is always in a situation, always *vis-à-vis* the other.

Man is, indeed, a project which possesses a subjective life, instead of being a kind of moss, or a fungus or a cauliflower. . . . Subjectivism means on the one hand, the freedom of the individual subject, and on the other, that man cannot pass beyond human subjectivity. . . . What

28

we mean to say is that man is not other than a series of undertakings, that he is the sum, the organization, the set of relations that constitute these undertakings.[9]

Concomitant with these views was the notion of risk that underlay Existentialist philosophy and that began to appear frequently in artists' discussions. It became imperative for many painters and sculptors to cast out their past in search for new values. In some cases, it was a precipitate act. Bradley Walker Tomlin, for instance, whose gracefully romantic paintings in an adjusted Cubist vocabulary had won the respect of his fellow painters, suddenly began to work out a

I I BRADLEY WALKER TOMLIN *Number 20* 1949

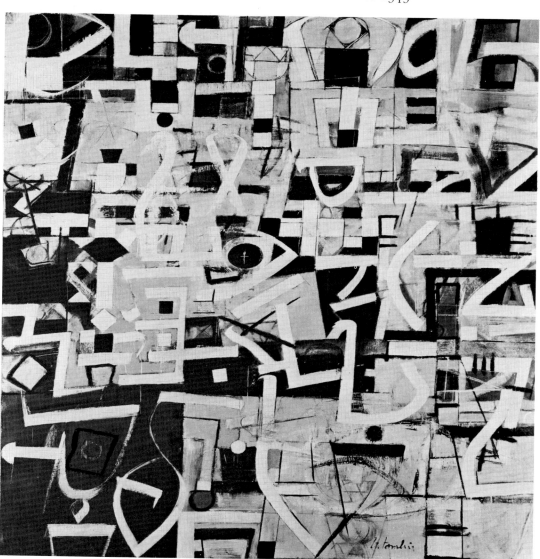

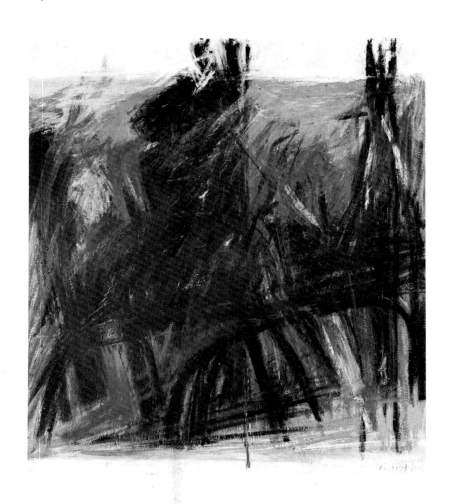

vocabulary of brushed signs that moved in stately rhythms over his entire canvas. He began to work large, and to score his surfaces with audacious marks that overrode the trellis-like grid and read like some vivacious foreign script. Jack Tworkov, also a lyrical Cubist in his work of the early '40s, released his brush in a crescendo of stroked forms toward the end of the decade. Later, these feathered shapes were lightly aligned on a barely visible grid. In these paintings, Tworkov addressed himself to mythic motifs that slid behind the ambiguous screen of painted marks. Philip Guston, who had lingered in a soft representational mode well into the '40s, suddenly felt stifled and, after months of struggle, emerged with the darkly abstract augurs of his later Abstract Expressionist works. Franz Kline, who had returned from London in 1939 to a bohemian existence as a painter of socially inspired themes, began, toward 1947, to make the cryptic ink sketches that, by the time of his first one-man show in 1950, had become the striking large black-and-white abstractions for which he was to be celebrated.

The impulse to radical change that swept through the community of artists after 1945 was keenly felt by sculptors as well. David Smith, who had studied painting, and had traveled widely in the '30s, shared with such friends as Stuart Davis and Willem de Kooning a deep reverence for the modern European masters. He had experimented early with their idioms, and in the '40s had accepted the Surrealist principles as well. Always singularly free of esthetic prejudice, Smith did not hesitate to work at times in a figurative or semi-abstract idiom and to move easily within the Constructivist tradition. He was an avid reader of *Cahiers d'Art* in the '30s where he saw reproduced not only Picasso's most recent paintings and sculptures, but also the works of the Spanish sculptors Gonzalez and Gargallo. It was his recognition of Gonzalez, and Gonzalez' role in Picasso's sculptural development, that enabled Smith to undertake his lifelong adventure as a sculptor in welded metal. By the late '40s, Smith was working in a radically reduced vocabulary of forged and welded signs that paralleled the gestures of the Abstract Expressionist painters.

12 JACK TWORKOV *Blue Cradle* 1956

13 FRANZ KLINE *Painting No. 11* 1951

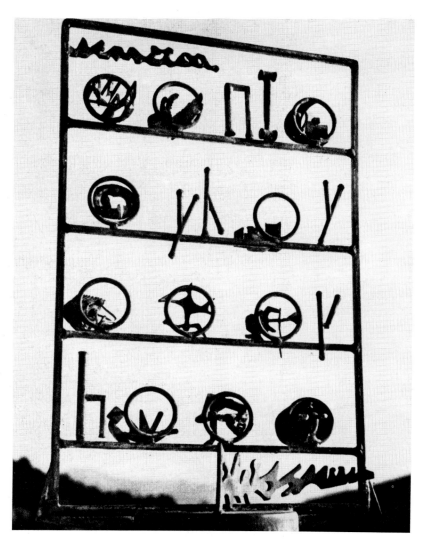

14 DAVID SMITH *The Letter* 1950

David Hare, who had been firmly ensconced in the Surrealist milieu during the war years, emerged in the late '40s with a group of sculptures that indicated his kinship with Giacometti, but also, in their eclectic freedom, showed how much the American mood had freed his hand. This could be said of Seymour Lipton, Ibram Lassaw, Jose de Rivera and Herbert Ferber, all of whom adopted toward the late '40s greatly modified approaches comparable to the new freedoms seized by the painters. Even veterans such as Alexander Calder and Isamu

Noguchi seemed to take new liberties in the postwar climate of adventure. The premises of sculpture were to be greatly enlarged as a result of the imperatives to change experienced in America after the war.

While so many artists were striking out into new territory, the activities in the supporting structure of museums, galleries and arts organizations were greatly accelerating. Americans were determined to establish a cultural visage in the world. Already in 1948 Pollock had been exhibited in the Venice Biennale—an essential factor in the proliferation of art activities during the first decade after the war. In 1950

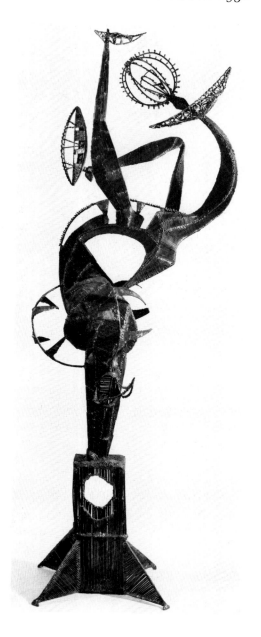

15 DAVID HARE *Juggler* 1950–51

he appeared again at the Biennale, this time with de Kooning. Even U.S. government organs were aware of the rising credit of American experimental art. In 1947 the State Department purchased 79 oil paintings and 38 watercolors to circulate abroad in an exhibition called "Advancing American Art," to which traditionalists objected so passionately that the exhibition was withdrawn and shamelessly sold off by the War Assets Administration. This was only the first of many disastrous events in the relationship between government and contemporary art. Opposition mounted during the next few years. Demagogues could all too easily associate artists of advanced tendencies with Communism—that dreaded word during the early frosts of the Cold War. Although such attacks as Representative George Anthony Dondero's sustained campaign against "Communist art" strengthened the resolve of most artists to be free of strictures, it was a serious enough threat to warrant statements of defense. One of the most unusual byproducts of reactionary heckling was a statement issued by three institutions—the Museum of Modern Art in New York, The Institute of Contemporary Art in Boston, and the Whitney Museum—in March, 1950. This elicited a guarded editorial in the *New York Times* of March 28 that aptly reflects the climate:

The stand which opposes a narrowly chauvinistic approach to art and one which rejects the notion that all esthetic innovations are somehow politically subversive and "un-American" is particularly welcome in the face of recent confused and often reckless attacks.

Such attacks were not unexpected by America's advanced artists. They only confirmed their long-standing sense of being forced into an adversary stance in relation to an increasingly prosperous but largely uncultured American society. The artists felt some urgency to create an "American" art that could be distinctive within the modern tradition. They also felt a need to lend moral authority to the profession of the arts. Philistine attacks quickened their resolve to sort out issues of social commitment, esthetic independence, art and its relations with society as a whole, and art as a transcendent force. They were prepared to assume new responsibilities, as when in 1948 William Baziotes, David Hare, Robert Motherwell, Barnett Newman, Mark Rothko and Clyfford Still decided to start a new art school significantly titled "Subjects of the Artist." Advertised as "a spontaneous investigation into the subjects of the modern artist—what his subjects are, how they are arrived at, methods of inspiration and transformation, moral atti-

34

tudes, possibilities for further explorations, what is being done now and what might be done, and so on," the school lasted only a short time. Out of its initial organization, however, sprang the sessions at Studio 35 that were to provide one of the prime art documents of the postwar period. Long sections of this three-day discussion among a number of the most serious artists in New York were published the following year in *Modern Artists in America*, edited by Robert Motherwell, Ad Reinhardt and Bernard Karpel, and published by George Wittenborn and Heinz Schultz, a team of courageous booksellers who had already embarked on an ambitious program of publishing writings of modern artists in their Documents of Modern Art series.

Such documentation served to define, or at least set apart, what came to be known as the New York School, or Abstract Expressionism. Before the mid-'40s there had been scant attention given to these artists, and few outlets for commentary. Clement Greenberg was among the first critics to write about Pollock, Gorky and some of the others in the early '40s, but he was joined by few of his colleagues until several years later. The popular press turned an avid eye on the most sensational developments, such as Pollock's so-called "drip" paintings, but for the most part responded rarely. In the late '40s more serious writing began to appear by such critics as Harold Rosenberg, Thomas B. Hess and Robert Goldwater (who had taken over editorship of *The Magazine of Art* in 1948). They were spurred on by the artists, who, in their need to define themselves and what their groupings meant, were eager to collaborate with sympathetic writers. The artists themselves generated considerable interest by asserting themselves publicly from time to time. In 1950, for instance, a group of eighteen painters, supplemented by friends among sculptors, protested that the Metropolitan Museum, in announcing a huge exhibition of American painting, had chosen for the jury artists and curators hostile to advanced art. They declared in an open letter that they would not submit. Their gesture was well noted by the daily press and seemed of sufficient importance for *Life* magazine to assign a photographer to make a group portrait of "The Irascible Eighteen," as they had been called by the *New York Herald-Tribune*. This photograph and other documents accumulating around the more important exhibitions at the turn of the decade provide a meager image of the movement, leaving out the life that swirled around the artists and the many assertions by the artists themselves that they did not constitute a movement.

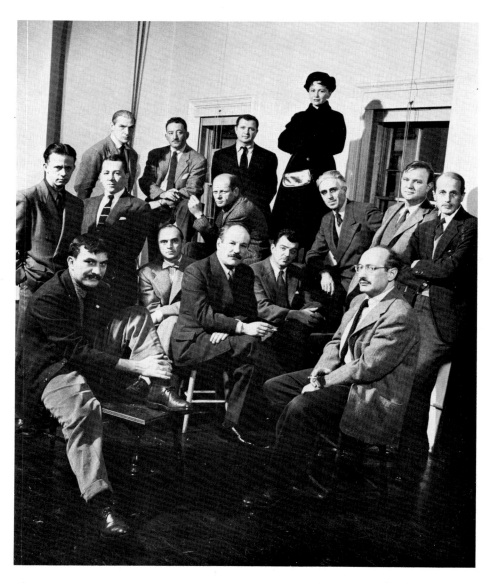

16 THE IRASCIBLES 1951: Top (l–r) De Kooning, Gottlieb, Reinhardt and Sterne, Middle (l–r) Pousette-Dart, Baziotes, Pollock, Still, Motherwell and Tomlin; Bottom (l–r) Stamos, Jimmy Ernst, Newman, Brooks and Rothko

Although critical response had warmed considerably by 1950, there were, even within the ranks of the friendly commentators, frequent demurrers. When de Kooning exhibited a large group of the Women paintings for the first time in 1953 the champions of Abstract Expressionism responded with pain, regarding his renewed interest in the

36

human figure as retrogression. Similarly there were cautious appraisals of Pollock's exhibition during the same year in which appeared a few of the late black-and-white paintings that showed Pollock fearlessly retrieving human heads and limbs and combining them with abstract figuration. Those guardians of the abstract tradition who saw in the new Pollock and de Kooning paintings a retreat from the great issues, and who rued the new "back to the figure" enthusiasm that appeared to return with a vengeance, did not fully comprehend the nature of the issues to which Pollock, de Kooning and a dozen others had addressed themselves. They had been true to their premises. Their freedom, dearly purchased over so many years, was to be extended to any subject or mode they chose to explore. They, and their closest associates, had never meant to create a style but only to express freely their sense of life and their metaphysics. They could find themselves in such texts as Karl Jaspers' statement that

The urge of man's metaphysical thinking is toward art. His mind opens up to that primary state when art was meant in earnest and was not mere decoration, play, sensuousness, but cipher-reading. Through all the formal analyses of its works, through all the telling of its world in the history of the mind, through the biography of its creators, he seeks contact with that something which perhaps he himself is not but which as Existence questioned, saw and shaped in the depth of Being that which he, too, is seeking.

As a point of view, rather than as a school, the Abstract Expressionists found definition in the questions they posed unceasingly. The general characteristics of their views were succinctly rendered by William Seitz in an unpublished doctoral thesis in which he said that the Abstract Expressionists

value the organism over the static whole, becoming over being, expression over perfection, vitality over finish, fluctuation over repose, feeling over formulation, the unknown over the known, the veiled over the clear, the individual over society and the "inner" over the outer.

These characteristics became more pronounced during the first few years of the '50s when many painters could have said, as did Hedda Sterne at the Studio 35 sessions, "I am not here to define anything; but to give life to what I have the urge to give life to . . ." Many of the artists associated with the New York School made their strongest impact only after 1950 when the movement gathered new momentum

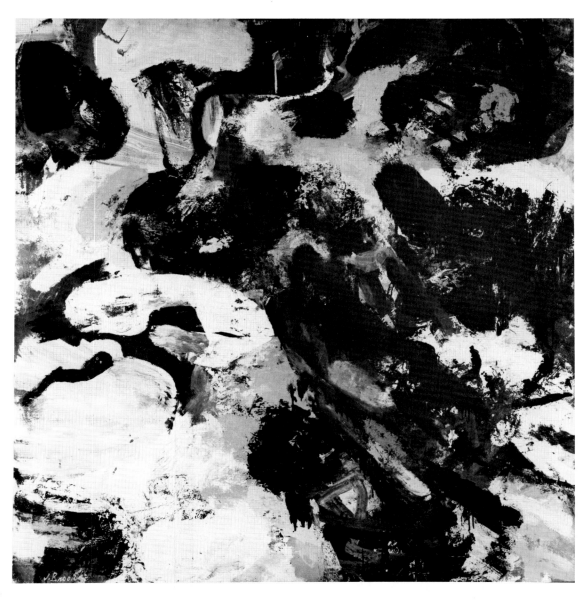

17 JAMES BROOKS *Boon* 1957

through broadening exhibition possibilities. James Brooks, for in-
stance, had his first one-man exhibition at the Peridot Gallery in 1950
and thereafter showed regularly the paintings which he said were
"done with as much spontaneity and as little memory as possible."
His paintings, kept in fluid, often transparent tones of great beauty,

38

were marked by their undulant rhythms that, while wholly free of specific reference, seemed to conjure up landscape analogies. The same was true of Adja Yunkers who, toward the mid-'50s, began a remarkable series of large pastels in which he used his sticks as brushes, laying on great sweeping forms that heaved and pitched with an elemental excitement. These artists and others made it clear that an

18 ADJA YUNKERS *Tarrassa XIII* 1958

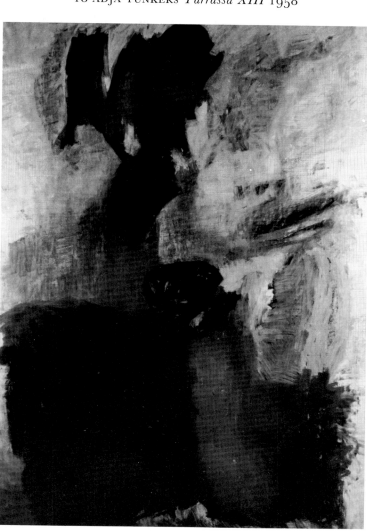

expressionist abstract sensibility had coalesced, if not into a movement, at least into a prevailing tone. This hegemony of values was acknowledged by the Museum of Modern Art when it circulated a large exhibition titled "The New American Painting" throughout Europe in the late '50s. The ample European response indicated how much ground the American artists had gained, and how "new" these artists seemed to other eyes. Europeans spoke again and again, as did Will Grohmann, the distinguished German critic and Klee biographer, of the vast dimensions of the canvases, the daring of their authors. "Americans," he wrote, "are world travelers and conquerors" and "stand beyond heritage and psychology, nearly beyond good and evil."[10] A young British author and painter, Andrew Forge, marvelled at the American painters' sense of freedom and years later recalled the enormous impact the traveling show had made on him:

When I first saw canvases by Pollock, Still, Kline, de Kooning, Rothko, it seemed to me that painting had made a totally new definition of freedom. The structures I was looking at owed nothing, or so it seemed, to the closed, self-contained, self-consistent notions of composition and pictorial syntax that my experience up to then had taught me to regard as mandatory. These canvases, apparently improvisations on a heroic scale, seemed both more rooted as object in the material facts of paint and canvas than anything I had seen before—and at the same time to be paradoxically more inward . . . Inwardness in the New Yorkers had something headlong about it. . . .[11]

Such responses gave a reality to the intimations of an authentic new movement in painting that had moved into the postwar period.

19 ARSHILE GORKY *The Betrothal II* 1947 (pp. 15, 16)

20 CLYFFORD STILL Untitled 1953 (p. 24)

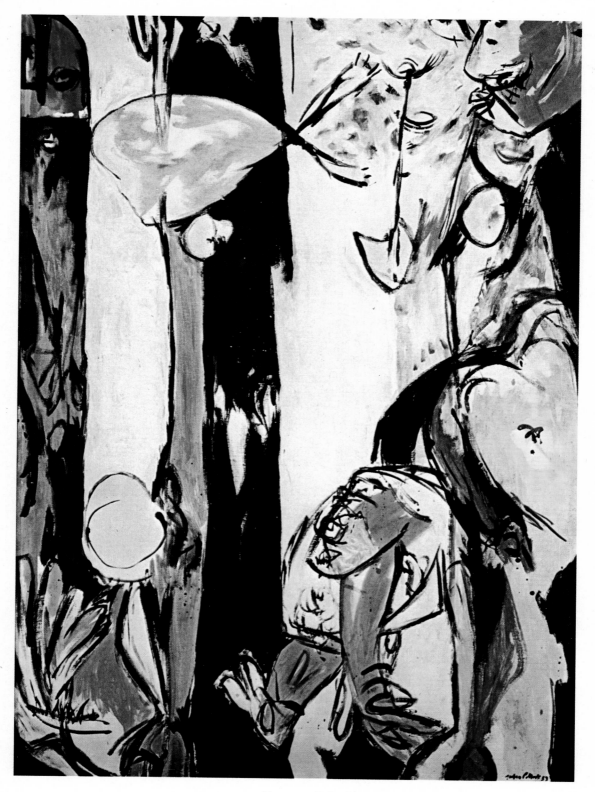

21 JACKSON POLLOCK *Easter and the Totem* 1953 (p. 37)

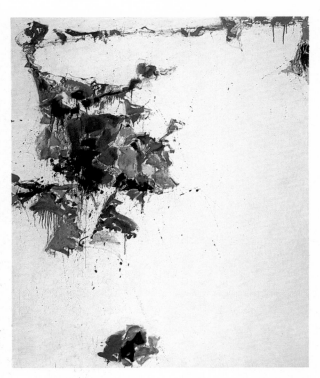

22 MARK TOBEY *New York* 1944 (p. 26)

23 SAM FRANCIS *The Whiteness of the Whale* 1957 (p. 52)

24 MORRIS LOUIS *Gamma Iota* 1960 (p. 51)

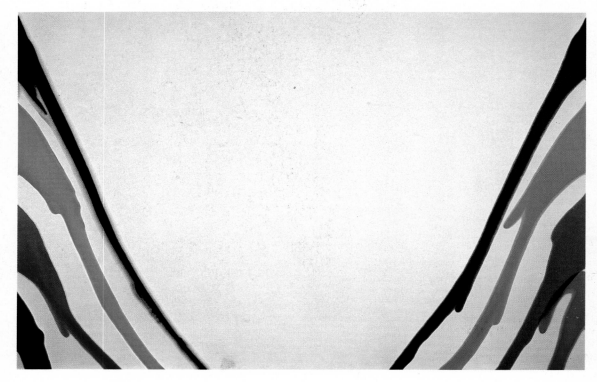

2

During the immediate postwar years everything seemed to magnify itself. The satisfactions of prosperity reached deep into the culture, softening rebellious spirits (and in some cases mollifying them into extinction) and making way for the full exploitation of the arts. Traditionally the arts were associated with leisure, and leisure with wealth, and wealth with patronage, and patronage with institutions. Now there was money and time, and even space in the popular press, for the news emanating from the suddenly enlarged art world. Still, for the generation that had broken the ground, the dream of living as artists and earning a living doing so remained largely unfulfilled. Most of them had to manage with part-time jobs even as they were being lauded in the art press and becoming celebrities in their neighborhoods. An additional psychological factor was the unspoken rule in the community of artists against giving way to success and forfeiting the role of outsider in a society of which no one approved. In what I. F. Stone called "the haunted fifties," there were plenty of sinister reminders of the old disaffecting vices of America, including the political witch hunts and a disastrous war in Korea. No artist who had lived through the upheavals of the '30s and the Second World War could be comfortable in the haunted '50s with their ugly underside of McCarthyism and cold-war sloganeering. Even the prosperity seemed suspect. The decade following the war had seen an avalanche of material goods:

In 1957, the government could issue figures establishing that, despite the slowly continuing inflation, most Americans were enjoying more real income than ever before . . . In 1954 the New York Stock Exchange had ordered a public opinion poll which found that only 23% of the population knew what stock was and only 10% were even considering putting a penny into the market. Now, one in nine adults owned stock—in some cities, Berkeley, Hartford, Pasadena, St. Petersburg

and Wilmington, for example—one in every five people, babies included, were receiving dividends.[12]

The secondary effects of such prosperity enhanced the art community in many ways. The energy that was generated in the familiar artists' haunts—the Cedar Bar and The Club—radiated far, bringing a stream of visitors to witness the legendary high life of the New York artists, ranging from ambitious new collectors from all over America to Michel Seuphor, a respected French writer who made the voyage from Paris specifically to prepare a special issue of *Art d'Aujourd'hui* on American art. He favored many of the New York School painters and, finding it hard to surrender French hegemony, ended by saluting Paris and New York, "the two capitals of the Western world." For the French, that was a mighty concession. Another notable visitor from France was Jean Dubuffet, the ironic and irascible painter who had had a *succès d'estime* in Paris after the war not unlike Pollock's in New York. Dubuffet spent several months in New York in 1951, meeting kindred spirits, broadcasting his theory of primitive art, and producing a series of "Bowery Bums" that no doubt affected certain younger artists embarking on what Dubuffet had called, in a famous Chicago lecture, "Anticultural Positions." Still another French artist, Georges Mathieu, eventually appeared in New York after having begun a campaign in France to recognize affinities with American brethren as early as 1947. Mathieu, whose interest was in "lyrical non-figurative painting," admired Gorky, de Kooning, Pollock, Tobey and Rothko especially. He had a penchant for grand occasions and had gained notoriety with his performance of painting, in which he danced his way across the canvas whipping on his paint in calligraphic flourishes. He was also a prodigious writer and editor, working for Air France's deluxe magazine, in which he devoted considerable space to the important artistic events in New York.

The broad interaction on an international scale affected the diction of local commentators. For instance, the large paintings of Franz Kline, with their vertiginously plunging black shapes reminiscent of ideograms, began to be talked about in terms of Zen. While Kline and others disclaimed the connection, the mention of Zen did indicate the renewed interest in Eastern art and philosophy among those who saw themselves in the avant garde. Michel Tapié, a critic and dealer whose term for lyrical expressionism in France was "L'Art autre," moved back and forth between New York and Paris, and managed to

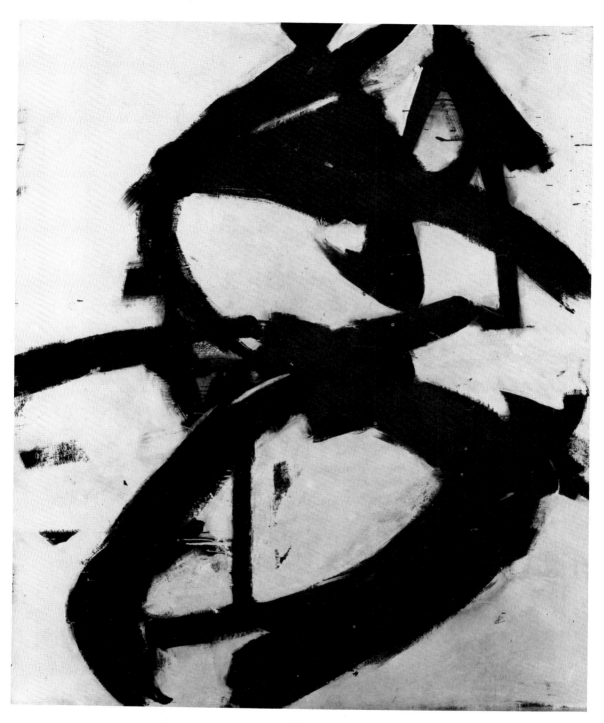

25 FRANZ KLINE *Figure 8* 1952

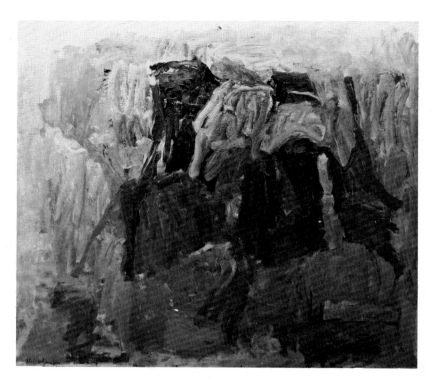

26 PHILIP GUSTON *The Return* 1956–58

enlarge the terminology on both sides of the Atlantic. Not only was
the vocabulary of vanguard criticism affected during this period, but
there was also an efflorescence of new "isms" based on the shifting
scene. After the Museum of Modern Art made its spectacular acquisi-
tion of Monet's "Waterlilies" in 1955, there was an attempt to desig-
nate a new tendency called "Abstract Impressionism." Unfortu-
nately, much of the criticism dallying with this idea centered on the
new work of Philip Guston who, toward the mid-'50s, heightened his
color slightly and organized his floating shapes in what struck certain
viewers as a kind of Impressionism. In fact Guston related more closely
to the European informalists who emphasized the movement of color-
shapes rather than linear forms. The terms of reference in Guston's
work had shifted rapidly, having moved within a matter of months
from allusions to Mondrian's plus-and-minus paintings to Monet. In
the de Kooning commentary, the term "gestural painting" became
common in the mid-'50s, beginning the long effort that is still going on
to divide off the Abstract Expressionists into subordinate categories.
Rothko was also assessed in new terms as his works grew simpler, and
the notion of a quasi-mystical icon painter gained ground.

The increasing elaboration of category and terminology was probably occasioned by the swift progress of the art community itself. It was no longer a smallish congress of loft-rats, all of whom knew each other. As the decade turned, another generation, or at least another group of ambitious artists, began to emerge. They had been drawn to New York as the new center of world-wide art either as students or as young professionals eager to become part of the newly constituted "community" of advanced artists. Among them were many epigones, particularly of de Kooning; they came to be called "The Tenth Street School" after the street in which de Kooning had had a studio in the early '50s, and in which a number of co-operative galleries had sprung up. There were also many newcomers who, having studied at Hans Hofmann's school or with various older artists, extended the Abstract Expressionist attitude of individual freedom and developed authentic personal idioms. Most of them had been born in the early-to-late '20s and had already benefited from the first generation's struggle for identity. In their case, there had been a recognized path for a young artist to take. He usually went to college (unlike his elders), where he studied art. Then he headed for the big city where he tried to assimilate artistic culture through rubbing shoulders with the elder notables either in the Cedar Bar or at the Club, or at Hofmann's school. From there to the co-operative galleries, and finally, to an uptown gallery, since the extended community of Abstract Expressionists—the so-called second generation—had the advantage of greatly enlarged exhibition facilities and an attentive art press. There were now galleries such as the Tibor de Nagy, where Frankenthaler, Rivers and Hartigan among others had their first shows, that were exclusively dedicated to the new talent of the younger generation; and others such as the Kootz, Martha Jackson and Stable Galleries that opened their doors to a wide variety of younger artists along with the older generation. These galleries attracted new collectors—middle-class, college-educated professionals for the most part, eager to join in the groundswell of the "new American art."

The strong impact particularly of de Kooning and Pollock brought attention mostly to those they had influenced. Not all of them were necessarily young. There was Morris Louis, born in 1912, whose evolution is related to that of Helen Frankenthaler, born in 1928. Louis belonged by birth to the first generation, while Frankenthaler was trained within the climate of experiment already well established. But both evolved within a visual culture that derived initially from a

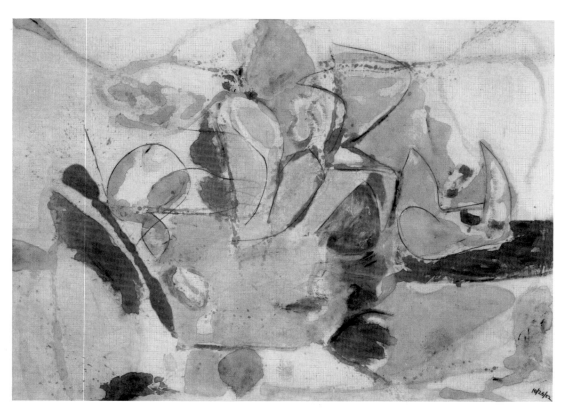

27 HELEN FRANKENTHALER *Mountains and Sea* 1952

close study of Cubism later enriched by the works of Miró, Gorky and, finally, Pollock. The chain of circumstance linking Louis and Frankenthaler began when Frankenthaler visited Pollock's studio in 1951 and saw him standing over an unstretched canvas on the floor, performing controlled improvisations that were later called "poured" or "dripped" paintings. Both Pollock's manner of working (from above looking down) and his unorthodox use of material (oil paint thinned to pouring consistency) excited her. She began experiments with thin washes on unprimed canvas and in 1952 painted the airy abstraction, "Mountains and Sea," that was for her a crucial work. Louis, who had followed Pollock's work from his distant vantage point in Baltimore, soon visited New York where he saw new Pollocks and Frankenthaler's stained abstractions. By 1953 he had dispensed with primed canvas and was moving toward a personal idiom, laying out canvas on the floor and pouring lyrical effusions. Thin washes were floated boldly on loose canvas which he pulled, tilted, folded and rolled until the hues penetrated the canvas. He had acquired from Pollock, Still

28 MORRIS LOUIS *Vav* 1960

and Rothko a taste for what was then sometimes called "all-over" painting, in which individual elements were subordinated to a vision of laterally expanding, coherent picture plane. He seized upon the poetic ambiguities inherent in freely flowing, washed color, as had Miró in the '20s and Gorky in the early '40s, developing methods to suggest looming presences without any established system of spatial articulation. There was something basically theatrical in his passion, which could account for his preference for gauzy textures and suggestions of scrims, dropcloths and occasional sharply artificial light. And there was an echo of sumptuous art nouveau curves.

Frankenthaler's approach was more buoyant, more relaxed, given to free movements of greatly thinned washes that floated to the edges of her unprimed canvases. Her impulse was toward free-form shapes, and she drew back before the implications of "all-over" compositions.

The burgeoning of the staining technique continued in the '50s, and one of its most masterful practitioners was Sam Francis, whose formation took place in the context of California's avant garde. In the early

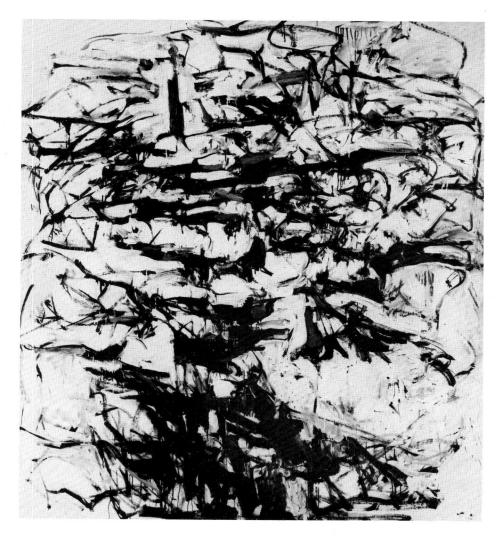

29 JOAN MITCHELL *Hemlock* 1956

'50s he removed himself to Paris where he startled his French colleagues with his huge canvases, figured with rounded biomorphic shapes that seemed to flow downward in a kind of organic metaphor. Francis's predilection for huge surfaces and his later tendency to open out the center of his work with dazzling white areas made a strong impact. He composed his forms asymmetrically, leaving large central voids, expressing a feeling for the horizontally unfurling spaces that had also haunted Robert Motherwell. The oceanic rhythms appearing in works by Louis, Frankenthaler, Francis, and others at this time had benefited from Pollock's impulses.

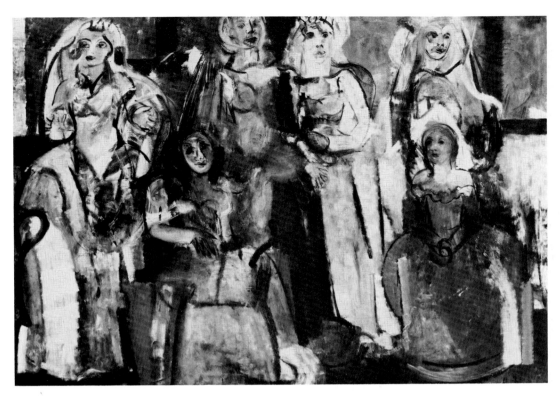

30 GRACE HARTIGAN *Grand Street Brides* 1954

There were others who were more attracted to the implications of de Kooning's work, with its emphasis on the expressive brush-stroke that served both as compositional element and bearer of emotional pitch. Joan Mitchell, after a sound training in Cubist principles, broke free around 1950 and, in her first show in 1952, showed large, sketchy, lyrical compositions that depended on the fluent linear flourishes of her brush. Gradually Mitchell enlarged her surfaces and broadened her strokes to form heaving compositions full of energy. The strokes were massed, or rode loosely on the surfaces, and were sometimes submitted to counter-rhythms in the form of short, jabbing marks, often in red. Mitchell's paintings suggested, in their crisp greens, dark blues and whites, a reference to nature, but a nature filtered through her nervous and strong temperament and coded in terms of elemental rhythms. Grace Hartigan, on the other hand, built upon de Kooning's new turning toward the human figure, blocking out her bold compositions with sturdy forms, and enlivening the interaction of forms with massive brush-strokes. De Kooning's landscape allusions were more notable in the early paintings of Richard Diebenkorn, who first

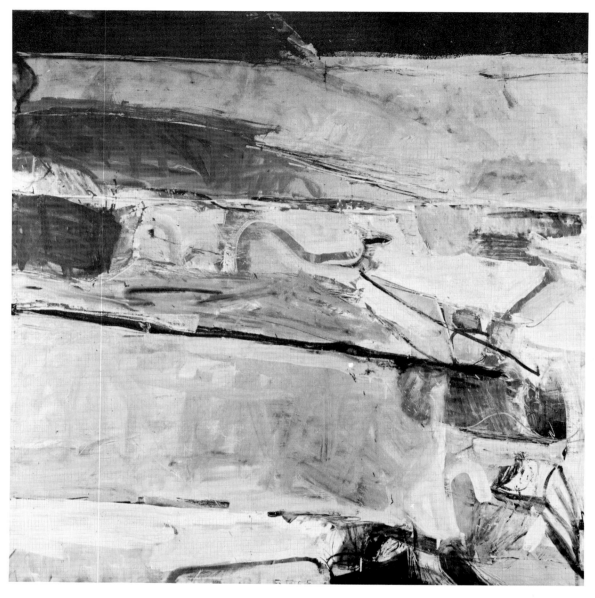

31 RICHARD DIEBENKORN *Berkeley No. 54* 1955

showed in New York in 1956. Essentially landscape images with strong horizontal accents, Diebenkorn's paintings in the high-keyed yellows, pinks and blues favored by de Kooning, were organized with an emphasis on the direction of the strokes and a dependence on linear accents. Not long after, Diebenkorn took the implications of de Kooning's figurative impulse further, adding rudely painted figures in

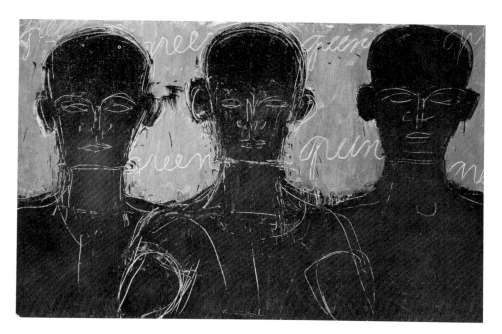

32 LESTER JOHNSON *Three Men, Green Writing* 1962

settings that were conceived with an intense awareness of their psychological effect. Each figure in the paintings he exhibited in 1958 summarily existed as a measure of its environment: he contemplated it and was at the same time engulfed by it. Diebenkorn took certain clues from Matisse in the way he composed his sparsely furnished interiors, and in the relationships between inside and outside, but the heavily impastoed stroking of sandy yellows, turbid greens, brilliant blues and reds was more closely identified with the Abstract Expressionist mode. His break, though, with abstraction was of signal importance to his confreres in San Francisco, such as David Park and Elmer Bischoff, with whom he made common cause for a time as a rebel against abstract traditions.

The open situation in the mid-'50s, in which the ramifications of Abstract Expressionism could be wholly explored, gave Diebenkorn and other figurative artists breathing space. At about the same time Diebenkorn was enthusiastically received, several other artists who had retrieved overt figuration after beginning as abstract artists were also being noticed. Lester Johnson's somber, heavily impastoed visions of loneliness, for instance, depended on the free translation of

55

FRONTE

OCCHIO

NARICE

CAPEZZOLO

GOMITO

GINOCCHIO

COSCIA

PUBES

33 LARRY RIVERS *Parts of the Body: Italian Vocabulary
Lesson* 1963

terms initiated by the Abstract Expressionists. Like Dubuffet and
Giacometti in Europe, Johnson turned his attention to the human
figure as he exists in his vertical stance, worn away by the forces around
him. He is not the center of the universe, solid and light-reflecting,
but is penetrated by atmosphere, swathed in it, set off from his fellows
by a thousand nuanced, unnameable elements. Johnson's studio in
lower New York City afforded him visions of forlorn urban dwellers,
lost in *anomie* that he translated in moody, often tonal, paintings in
which the gray-to-white values predominated.

Larry Rivers, on the other hand, used his flair for the quick sketch
to establish a kind of abbreviated style full of interruptions and half
statements that charmed a great many viewers. The feathered brush-
stroke, raw canvas and ambiguities he laid upon rather conventional

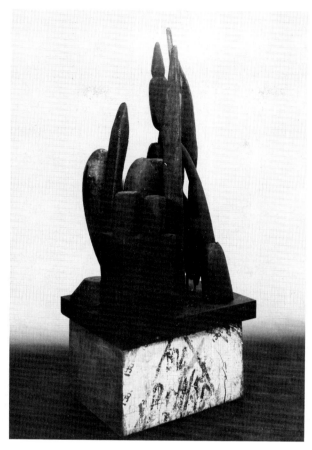

34 LOUISE BOURGEOIS *Garden at Night* 1953

interior scenes offered Rivers a journalistic running commentary, flexible and light-hearted as compared with the statements of the first generation. Philip Pearlstein also had turned from abstract motifs by the mid-'50s, beginning first to record his impressions of the rugged Maine landscape in works crowded with loving detail, and later to study the human figure with the same detached eye.

In sculpture, the attitudes of the Abstract Expressionists were dramatically reflected in the rapid conversion from conventions of carving and modeling to a spate of new techniques based on the principle of free adaptation of both materials and subjects.

As the panorama of painters grew ever broader, so did the prospects of the sculptors. Suddenly there seemed to be a possibility for sculpture in America to catch up with innovation in painting.

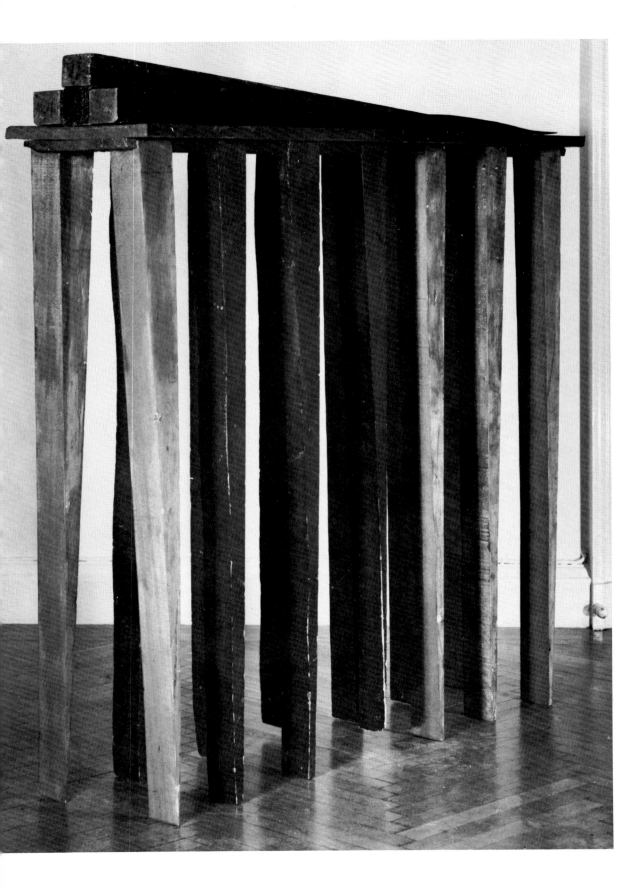

Sculptors of many backgrounds and ages began to come forward in exhibitions, revealing startling experimental techniques and images. Louise Bourgeois, who had had her first exhibition in New York in 1948, appeared with an anthology of fetishistic wood sculptures that she painted and set on crude stone bases in clusters. Their fragile profiles seemed to yearn to find balance in relation to each other. Leaning this way and that, they had both the animistic power of the Dogon totems and the frailness that suggested her consistent theme—alienation and loneliness. The vertical memories of the human form were transfigured into symbols. At times Bourgeois constructed strange wood objects out of common slats, as in "The Blind Leading the Blind," a table-like structure with two lines of legs that match uncertainly—some of the legs did not reach the floor—into infinity. Painted bright red and black, this piece was a dialogue about life. Referring to the precarious balance of its irregular legs, Bourgeois said, "Some of us get swept away." When she later worked in papier-mâché, and still later in stone, Bourgeois retained the searching character of her motifs, always relating to the emotional life in the existential terms of her generation.

Louise Nevelson, who had worked in conventional modeling processes in the '30s and '40s began, in 1950, to show her assembled wood tableaux, always around a theme. Her moonscapes of the early '50s were painted in matte black and grouped in narrative sequences. In 1956 she offered "The Royal Voyage," in which blocky rough-hewn forms, and found parts of old dadoes, table legs or even wooden radios, were assembled to suggest the king and queen at sea. Using separate units, Nevelson ranged them frontally, at times in tiers, emphasizing contour and volume. In 1959, Nevelson gave herself over entirely to a theatrical ensemble in "Sky-Columns-Presence" when she stacked tier upon tier of black vertical boxes with cryptic contents. Facing them she made tall totemic columns richly adorned with detail and thrown into lunar shadow. All the forms were then lighted specially in order to unite them, while at the same time heightening specific details. Nevelson's dramatic approach was conceived to emphasize the emotional and poetic values she insisted upon in those days. Her force derived from her ability to sense and fulfill emotional needs. The characteristically vertical boxes with their half-obscured contents and doors slightly ajar played on essential emotions grouped around secrecy, hidden riches and sorrows.

59

35 LOUISE BOURGEOIS *The Blind Leading the Blind* (second version) 1941–48

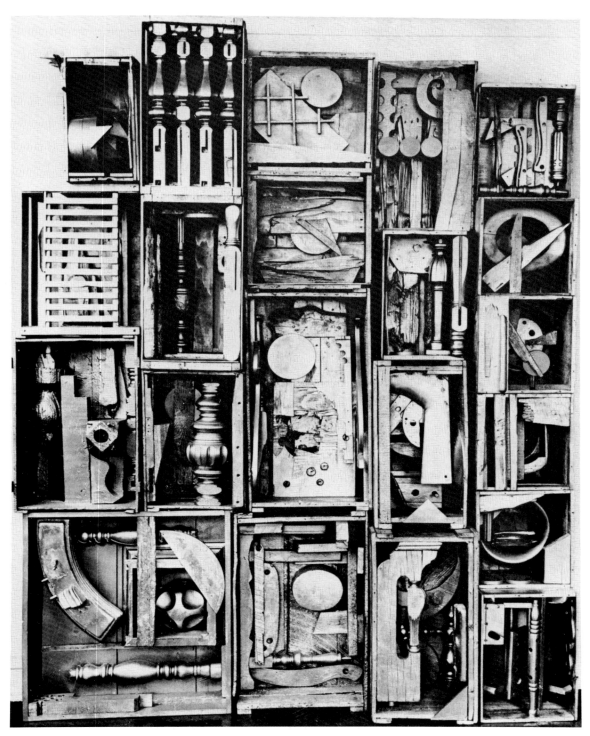

36 LOUISE NEVELSON *Royal Tide V* 1960

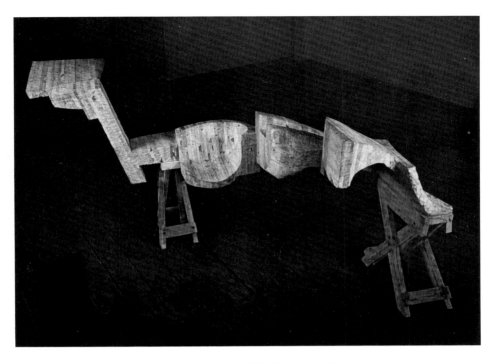

37 GEORGE SUGARMAN *Six Forms in Pine* 1959

Another artist of the Abstract Expressionist generation who began to use wood in unorthodox ways was George Sugarman. He had studied with Zadkine in Paris, returned to New York in 1955 and, fired by the general atmosphere, began to experiment with sections of wood which he carved in asymmetrical forms and suspended in utterly unorthodox positions, as in "Six Forms in Pine." Sugarman's ebullience led him further and he began painting his roughly carved forms in great clattering sequences that echoed the irregular forms in certain Abstract Expressionist paintings. His defiantly anti-gravitational sequences startled his viewers, as did his painterly audacity.

A friend of most of the painters of the New York School, and a close friend of David Smith, James Rosati emerged in the late '50s and was what art-critic Hilton Kramer called "something of an anomaly." Rosati clung to the time-honored techniques, unlike most sculptors in the '50s, working with equal ease in clay, cement, wood and stone. His imagery, however, often related to current themes despite their mythic titles. In the "Delphi" series Rosati modeled, carved and cast

61

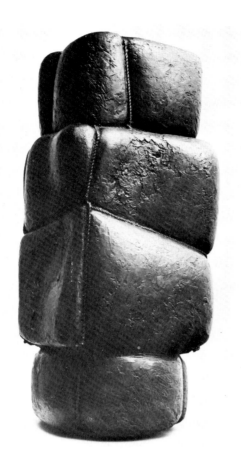

asymmetrical volumes which he bound up with ropes to suggest, in their bulging walls, a force that goes beyond the human. His later turning to assembled steel structures with monumental intentions was informed by these painstaking earlier experiments and made of Rosati one of the most refined and durable sculptors of the generation.

Even among the older established sculptors the excitement of the Abstract Expressionist esthetic made inroads. Reuben Nakian, for instance, abandoned his figurative bronzes and marbles in the late '40s for a wildly improvisational style. His rough maquettes for monumental abstract sculptures were often considered equivalents to the Abstract Expressionist "action" paintings of the period.

Many younger artists, among them Richard Stankiewicz, were caught up in the idiom of Abstract Expressionism and, aware of the

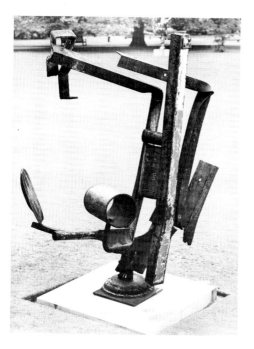

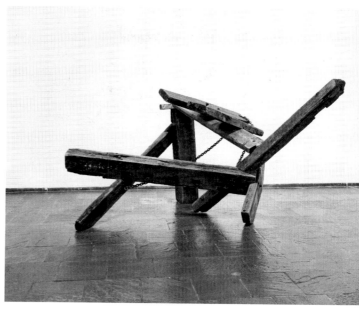

40 MARK DI SUVERO *Hankchampion* 1960

extravagant assembled fantasies of David Smith, made a virtue of composing sculptures of found parts. These were sometimes aggressive, as in Stankiewicz's case, sometimes humorous, as in the case of Mark di Suvero whose works spread into space with wild indifference to conventional boundaries. Stankiewicz specialized in the ratchets, gears, boilers, valves and casters that create the noisy life of industry. These he welded together in sculptural fantasies in which the rusty surfaces and blunt shapes of his materials never lost their original identity and yet were incorporated into wonderfully varied compositions. When, in subsequent years, Stankiewicz simplified his motifs and became almost a Constructivist sculptor of great force, the memory of the vitality in his earlier pieces remained.

Another young assembler who startled her audience with her unorthodox use of found materials was Lee Bontecou. During the '60s she gathered discarded army canvas, old steel rods and wires, with which she built deep reliefs of somber, disquieting images. These large, and often deep, compositions with their impenetrable dark apertures and tautly stretched surfaces sometimes suggested fearful experiences, particularly when Bontecou allowed prickly small extrusions of wire to protrude with their allusion to barbed wire.

63

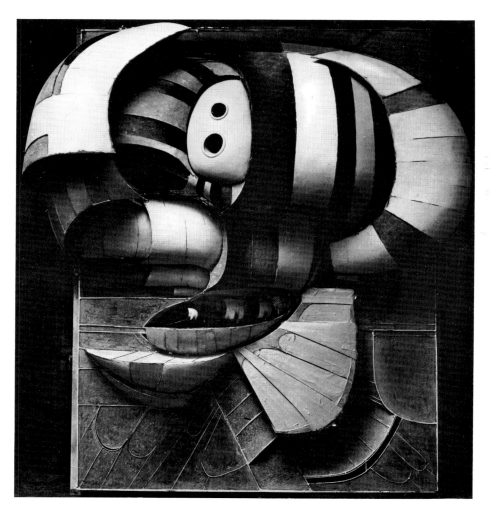

41 LEE BONTECOU Untitled 1966

Among sculptors the urge to satire and the attraction of the old
Dada iconoclasm seemed marked in the '50s. The Abstract Expression-
ist painters had opened the way in an anarchistic atmosphere that led
to an efflorescence of interests. The postwar atmosphere of conformism
– the strange complacency during the Korean war and the Eisenhower
years – had only served to goad American artists to declare their
stubborn independence and to protect their disaffiliated stance. As
Harold Rosenberg remarked often, the artists were not like other
intellectuals who were all too available for integration into the new
establishment. They looked with suspicion at the intellectuals who, as

Richard Pells noted, suspended their critical faculties, moving from "rebellion to 'responsibility', from dissent to affirmation, from an interest in the avant-garde to a fascination with the mass media, from a concern for ideology to an obsession with symbols and myths, from an unlimited investigation of social issues to a ritual glorification of America."[13] But if the Abstract Expressionists felt repugnance for the intellectual who eagerly joined the prosperous society as a complaisant clerk and successful professional, the next generation often saw the Abstract Expressionists themselves as pretentious, portentous and sentimental.

Accordingly, into the roiling broth of artistic life initiated by the older generation infiltrated the disciples of the absurd, but quite another absurd from Sartre and Camus' versions that had so moved the older generation. The new absurd was largely influenced by the composer and performer John Cage, and a little later by Marcel Duchamp, an avuncular, iconoclastic spirit residing in the heart of Manhattan. Cage's great charm and his spirited denial of all convention, his open-minded exploration of alternate modes of thought, most particularly Eastern philosophy, and his admirably ascetic way of life attracted numerous followers, beginning with the old days at the experimental college of Black Mountain in North Carolina. His presence among the artists and young composers was stimulating in many ways. His emphasis on silence, drawn from his understanding of Zen, attracted such painters as Philip Guston, who, in the mid-'50s, had sought to express the Void and the unnameable in paint. For others, however, Cage provided an entree into a kind of benevolent Dadaism that was fundamentally foreign to the Abstract Expressionists. Those who were most deeply marked by Cage's teachings in his desultory chats, both public and private, were students, first at Black Mountain College and later at the New School of Social Research in New York. At Black Mountain he had made an indelible impression on several young painters, the most notable being Robert Rauschenberg, who was present later, in 1952, when Cage organized the event that was to usher in the genre of performance art called Happenings. News of that summer's evening in the remote North Carolina mountains travelled with uncanny speed to New York.

Cage had opened the evening with a Zen lecture reiterating his principle that art must not be different from life "but an action within life." Performance should be a simultaneous presentation of unrelated events. On the famous evening in Black Mountain, spectators, each

holding a white cup, were seated in a square arena forming four triangles. Rauschenberg's white paintings were hung above them. Cage, formally dressed in black suit and tie, stood on a ladder reading a text about music and Zen Buddhism and Meister Eckart, and then performed a composition with a radio, while at the same time Rauschenberg played old records and David Tudor played on a "prepared piano." Later Tudor poured water from one bucket into another while, from the audience, Charles Olsen and Mary Caroline Richards read poetry. The dancer Merce Cunningham performed in the diagonal aisles while Rauschenberg flashed abstract slides.[14]

This signal event in the vanguard annals epitomized the efforts of certain artists, composers and poets to elude the increasingly institutional modes of presenting art to an unbiased public. These efforts were not confined to visual phenomena. The presence of Charles Olsen in Cage's Happening represented a cross-fertilizing influence. Like Cage, he was in permanent rebellion against tradition and particularly the Western tradition of modernism. He had absorbed Ezra Pound's most inflammatory messages and had developed an esthetic parallel to Cage's. Process rather than product would obliterate convention. His theory of "projective" or "open" verse, in which "a poem is energy transferred from where the poet got it," seemed to have common roots with the Abstract Expressionist attitude. Unlike the academic poets who, during the late '40s, had dug into a formal position, Olsen adamantly held to a youthful rejection of given forms. His poetics were prolix, deliberately undisciplined and appealed to young artists who scented the dangers of integration into the new hierarchy of professionals. Even painters among the older generation could identify with Olsen's message which corresponded in many ways to their own. "First," he used to say, "some simplicities that a man learns if he works in OPEN, or what can be called COMPOSITION BY FIELD as opposed to inherited line, stanza, over-all form, what is the 'old' base of the non-projective." Among his students, who could be enchanted with the work and conversation of Franz Kline, it was easy enough to accept the turbid rhetoric of Olsen's pronunciamentos such as "the poem itself must at all points be a high energy construct and, at all points, an energy discharge."[15]

When Allen Ginsberg read "Howl" in San Francisco in 1955, in an electric atmosphere that was not soon forgotten, many recognized the esthetic of energy discharge and composition by field, just as Ginsberg himself recognized his affinities with the Abstract Expressionists. He

turned up regularly at the artist's Club or the Cedar Bar with his own circle of "beat" poets. In the background of Ginsberg's heritage lay not only the effusions of Olsen, but the old Surrealist defiance that had taken root unshakably both in Europe and America in the '40s (although rarely acknowledged by either the Beats or the painters). In a contribution to the artists' magazine *It Is* (No. 3, Spring 1959) Ginsberg wrote of Gregory Corso's "abstract" poetry and suggested that it was not so abstract as it might seem, for it was built on "some kind of later explainable ellipse–the mind instinctively attracted to images coming from opposite ends of itself which, juxtaposed, present consciousness in all its irrational (un-figure-outable-in-advance) completeness." He mentions two young poets who were fellow-travelers in the Abstract Expressionist milieu, one of whom, Frank O'Hara, was to become an important critic and curator at the Museum of Modern Art. Of O'Hara and Kenneth Koch, Ginsberg said that they both wrote long, meaningless poems "to see what would happen, not maybe meaningless, but just composing, bulling along page after page." Ginsberg admired the experimental freedom of the two younger poets who risked writing nonsense in order to arrive at "the sense it finally comes to, whatever you think at first, or the final revelation of the irrational nonsense of Being."

Like the Surrealists before him, and like the visionaries in the past whom he admired–Blake and Whitman–Ginsberg recognized the absurdity of the mind that had ceased to bother with the grand questions. His reckless despair resembled that of another *enfant terrible*, Rimbaud, as Ginsberg wrote:

the way out of this corner was to arrive at a vision of sordidness and futility that made of them "spiritual facts" in their own right. The world might then be redeemed by a willingness to take it for what it is and to find its enchanting promise within the seemingly despiritualized waste.

Ginsberg and the other Beats wound their way back to Whitman who, as John Clellon Holmes recalled, had written, "Unscrew the locks from the doors! Unscrew the doors themselves from their jambs!" They were out to dismantle the safe structures that had been so painstakingly erected by the New Critics, the academics of the war years, the institutions flourishing all over by the '50s, in order to insist that "body, mind and soul are enmeshed, that corporeality is the 'field' from which spirit emanates like the weather that is the pro-

tagonist of Turner's paintings."[16] Like the older painters whom they admired, the Beats had a craving to find an American voice:

Most essentially these poets were *American* poets eschewing both the forms and attitudes that had characterized verse in English heretofore, and from which even Dickinson, Pound, Jeffers and Frost had never wholly gotten free. They used American rhythms of speech which, as Williams knew, were profoundly different from the British. They linked up again with the oldest American literary tradition – the rolling combers of Melville, the bardic inclusiveness of Whitman, the October tang of Thoreau, the lapidary apothegms of Emerson.[17]

In much of this the poets were indebted to the Abstract Expressionist painters who seemed to have found the epic mode already in the '40s. When Richard Howard evaluated Ginsberg's work, he noted that Ginsberg was not concerned with the poem as art but as a process, and found the best analogy in Jackson Pollock's famous statement:

When I am *in* my painting, I'm not aware of what I'm doing. It is only after ... that I see what I have been about. I have no fears about making changes, destroying the image etc. because the painting has a life of its own. . . .

Howard wrote that, in Ginsberg's case, "we are in the same universe of risk which Pollock besieged and bequeathed."[18]

The shared atmosphere of risk and rebellion was also remarked by another of the younger poets in the 1950s. Robert Creeley, recalling his formation during the Black Mountain years, wrote:

Possibly I hadn't as yet realized that a number of American painters had already made the shift I was myself so anxious to accomplish, that they had, in fact, already begun to move away from the insistently *pictorial* whether figurative or non-figurative, to a manifest directly of the *energy* inherent in the materials, literally, and their physical manipulation in the act of painting itself. *Process* in the sense that Olsen had found it in Whitehead, was clearly much on their minds.[19]

Creeley, like many of the painters to whom he alludes, had a special affection for William Carlos Williams and cites a poem which reflects the point of view of scores of artists in the '50s:

> From disorder (a chaos)
> order grows
> – grows fruitful.
> The chaos feeds it. Chaos
> feeds the tree.

42 ROBERT RAUSCHENBERG *Bypass* 1959 (p. 71)

43 JASPER JOHNS *Numbers in Color* 1959 (p. 74)

The younger generation, however much they might sympathize with the philosophy of the action painters, could not finally accept the sober Existentialist rhetoric. They liked John Cage, who had strongly disagreed with de Kooning because he frankly aspired to be a master. Cage's insistence that there must be no "causality" in a work of art, and his insistent echo of the pre-First World War doctrine of simultaneity, found its counterpart in the works of younger artists in the mid-to-late '50s, Robert Rauschenberg, for instance. In his case, it is almost as if he had followed the doctrines or anti-doctrines of Cage point by point. In his first exhibition at the Betty Parsons Gallery in May 1951, he had included thickly painted black-and-white works with collage elements that sharply underlined the importance of "process." Shortly after, he wrote to Parsons of new works in terms that sound like illustrations of Cage's non-lectures:

They are large white (one white as God) canvases organized and selected with the experience of time and presented with the innocence of a virgin. Dealing with the suspense, excitement, and body of an organic silence, the restriction and freedom of absence, the plastic fulness of nothing, the point a circle begins and ends. They are a natural response to the current pressures and the faithless and a promoter of institutional optimism. It is completely irrelevant that I am making them. *Today* is their creator.

"Today" was definitely the creator of many of Rauschenberg's works in which he developed his "combine" technique. His often quoted statement, "Painting relates to both art and life. Neither can be made. (I try to act in that gap between the two)," was in fact the cornerstone of his point of view in the '50s. If painting could not be made, nor life either, he would take elements from both and combine them in startling and ambiguous juxtapositions, and pose a question, just as Cage's non-lectures are seeded with innumerable questions. By taking real objects, such as an old paint-smeared quilt, a hand-painted necktie, or a real electric fan blowing at the painting, he disrupts the conventional view of painting. On the other hand, by making painterly gestures with opulent paint over newsprint, he disrupts the conventional view of collage. The shock value of many of Rauschenberg's choices was important, helping to distinguish his work from that of the Abstract Expressionists. When he selected a photograph from a newspaper to affix to his canvas (which he silkscreened, thereby enabling himself to play with scale), it often had a topical motif of a disturbing association. Bits and pieces of urban detritus, as well as the famous

44 ROBERT RAUSCHENBERG *Almanac* 1962

45 ROBERT RAUSCHENBERG *Canto XX : Illustration for Dante's
Inferno* 1959–60

long-haired goat with his belly encircled by a rubber tire, brought his
viewers abruptly into a realm of free association that was definitely
disquieting. When he made so bold as to take on Dante's Inferno in a
deluxe edition of prints based on a transfer process he himself devel-
oped, he did not hesitate to use photographs of contemporary political
leaders as the denizens of Inferno. This innate iconoclasm gained
Rauschenberg many adherents. From the goat to Dante, from Rubens
to the New York *Daily News* – most of Rauschenberg's commentaries
were inflected with the urgency of the moment. Looking back to the
works of the period, a viewer is frequently left with a strong impression
of the topicality, and sometimes, like yesterday's news, the work fades.
Rauschenberg's impact was based on the thrust into the world of

46 JASPER JOHNS *Target with Four Faces* 1955

everyday – a thrust begun in the first decade of the century by the
Russian Futurists, carried forward by Picasso with his use of found
materials in collages and sculptures, and by Schwitters with his use
of printed materials. Rauschenberg carried through to the extreme of
attaching such things as chairs to his canvases, and later even radios
that offered an aural supplement. The phenomenal world did not
invade his canvases so much as it was applied to them.

Like Rauschenberg, Jasper Johns valued the topical, and like him
he attached real objects to his canvases. He had come to New York in
1953 after his discharge from the army and by 1954 began to seek his
way out of the powerful precedents of the Abstract Expressionists. He
painted his encaustic flags first, then targets, then numbers in order
to deal "with things the mind already knows and things which are

47 JASPER JOHNS *Tennyson* 1958

seen and not looked at."[20] His work was seen as a riposte to the older
generation who had looked more to the distant horizons and the
unknown. By 1958, when he had his first one-man show at the Castelli
Gallery, he was playing with Magritte-like puns on objects such as
flashlights and light bulbs. After meeting his idol Marcel Duchamp in
1960, Johns made a Duchampian gesture: he cast beer cans in bronze
and then painted them to look exactly like real beer cans. His hybrid
works were seen as provocative gestures and there were many to
respond enthusiastically. The flags, targets, maps, alphabets and
numerals Johns painted so expertly were perceived by Nicolas Calas,
for instance, as "vehicles for a delayed reading: pictures in encaustic
with collaged newsprint and hide-and-seek words and sentences.
Intentionally or not, the question of whether one can define the

75

American flag by pointing to a monochrome star-spangled-banner serves to illustrate his most striking technique . . ."[21] In Johns's predilection for signs and systems of signs, many saw a clear break with all the premises of Abstract Expressionism, despite his retention of the Expressionists' painting techniques and their tendency to mix metaphors. Like Rauschenberg, he had been stimulated by Cage's discourse and drawn to the Duchampian conundrums that in their irony were far removed from the action painters' goals. The works Johns and Rauschenberg produced were sufficiently insistent on the day-to-day values so much stressed by Cage that both of them were to be regarded shortly afterward as Pop artists despite their vigorous disclaimers. All the same, Lawrence Alloway, in his American Pop Art exhibition at the Whitney Museum in 1972, featured Jasper Johns's "Target With Four Faces" on the cover of the catalog and wrote of him and Rauschenberg:

Johns' art is predicted on ambiguity, that of Rauschenberg on heterogeneity. The mixture of objects in Rauschenberg's combine paintings and of photographs in his silk-screened paintings testify to his interest in scattered sources, and also, in process abbreviation. His working method is to deal, as far as possible, with whole forms, which involves reducing the number of procedures by which the work of art is constructed. In the combines he tended to use objects unchanged, so that the original function of the hardware remained clear within the completed work. The silk-screened paintings are the result of combinations of ready-made images printed, all-in-one, on the canvas. The integrity of the found status of both object and photograph is carefully preserved as the constituents of his heterogeneity.[22]

Heterogeneity was a distinct desideratum in the latter half of the '50s. All over the U.S. young artists were abandoning the plane surface of the canvas to incorporate objects in their works. They walked into everyday life and took over the junk and waste of a rich society in order to assert their distinctness. In California, Edward Kienholz startled his viewers with coarse combinations of made and found objects, painted surfaces and boxes, and by 1960 had hit upon his most powerful idiom—the tableau. In a series of occasionally shocking tableaux, Kienholz combined real props—often relics of a period such as the '30s or '40s—with grotesque figures that half-alluded to a specific aspect of American life. His allusions to abortion, lovemaking in automobiles and the sordid environment of a low-class bordello earned him a reputation of being both a social critic and an unsavory icono-

48 EDWARD KIENHOLZ *The Beanery* (detail) 1965

clast. Kienholz's preoccupation with time emerged in his frequent
choice of dated scraps of newspaper, or faded letters signed and dated,
stuck away in some corner of the tableaux. His *tour de force*, "The
Beanery" of 1965, presented a near-perfect replica of a sleazy eating
place with its regular denizens dressed in mechanics' suits, or moth-
eaten furs, and its ashtrays overflowing with real butts. The lifelike
figures, however, are supplied with clockfaces, not faces; and a hint
at the intention behind Kienholz's elaborate assemblage occurs in the

newsstand outside where there is a newspaper headline that reads, "Children Kill Children in Vietnam." Kienholz's occasional commentaries on American events, such as the Vietnam debacle, or the abortion laws, were enough to identify him with the generalized protests implicit in the Beat poetry. His use of found objects with their lived associations was matched by another West Coast artist, Bruce Conner, whose turn toward the shocking and morbid was even more emphatic and whose imagery returned insistently to the motif of death.

These artists, like the protagonists in the Happenings movement, were eager to emphasize their indifference to the traditional perception of art. They were aware of the turmoil and violence of American life. They took account of the daily news of vile incidents during the civil rights struggle in the South and they were all too familiar with death as it was visited savagely on innocents. In many ways they sustained the old Dada discourse, altered, naturally, by the times and circumstances, but still essentially moralistic. There was an uncompromising will to condemn everything associated with a corrupt past.

49 BRUCE CONNER *Couch* 1963

It emerged especially in the proliferation of Happenings, whose *chef d'école* was Allan Kaprow. He had quickly assimilated the Dada aspects of John Cage's teaching and, after having exhibited messy, painted and chaotic environments, was inspired to move out into the space of the world in the hybrid events called Happenings. Kaprow was a well-trained scholar whose gestures were always defended in sober prose. In 1959 he felt confident enough to write an essay, "The Principles of Modern Art," in the artists' review *It Is*, No. 4, in which he echoes Cage:

The everyday world is the most astonishing inspiration conceivable. A walk down 14th Street is more amazing than any masterpiece of art. If reality makes any sense at all, it is here. Endless, unpredictable, infinitely rich, it proclaims THE MOMENT as man's sole means of grasping the nature of ALL TIME . . . thus one grasps, dimly at first, later more clearly, that all events are available, are at least potentially equivalent in value, and none would be out of place in art.

Erudite and well-versed in the history of hybrid artistic events since Wagner first appropriated Jean-Paul Richter's idea of the *Gesamtkunst-werk*, Kaprow and his fellow believers Jim Dine, Robert Whitman and Red Grooms, among others, initiated a series of Happenings crowded into loft spaces and storefront theatres. These events were often mad-cap affairs that stridently asserted their spontaneity and tended to aim at antagonizing audiences. Films, dance, paintings and people appeared in seemingly unrelated sequences, puzzling the uninitiated and often boring and irritating them. The movement toward the performed event was not impeded by negative responses. The premise that everyday life is the stuff of American art appealed to large sections of the art community. All over America students were soon performing their own Happenings and assimilating themselves to "art" as once they had to politics. The total lack of restrictions in the concept of the Happening opened the gates to amateurs whose attraction to theatre or dance or the visual arts in general was as vague as the notion of Happenings itself. Later, several of the notable figures in the New York movement were to alter their own approaches to include elaborate and fairly formal planning, as in the case of Robert Whitman, and even detailed scripts, as did Kaprow. But the Happening, as a populist notion, flourished in its formlessness and would feed into later more organized attempts to break down the established ways of apprehending and defining works of art.

3

The rising tide of rhetoric during the later '50s, sometimes reaching shrill and bitter pitches, reflected a new willingness on the part of American aspirants to culture to recognize a previously minor caste: the chronicling or theorizing intellectual. Eisenhower may have thought of the intellectual as "a man who takes more words than is necessary to say more than he knows," but the newly stimulated middle-class public was willing enough to listen. The inevitable expansion of urban centers in the wake of postwar prosperity brought with it new cultural institutions, and with them the clerks (or, as Régis Debray has called them in order to invoke their historical relationship to power, the "scribes"), who would administer, document and originate the categories in which art could be thought about. Looking back on the years 1945 to 1960, the painter Louis Finkelstein summed up the impact of the commentators. He mentioned "two major formulations, systems of judgment," represented by critics Harold Rosenberg and Clement Greenberg. He thought Greenberg saw Abstract Expressionism as formal, "a style like other styles, with achievable standards of structural completeness," while Rosenberg saw it as a break with the very idea of style. The generations touched by the debate seem to descend in two lines consistent with the Rosenberg–Greenberg axis: There were staining formalists, minimalists and color-field painters on Greenberg's line, and the anti-esthetic Happenings, Pop and Street art derived from Rosenberg's line.[23] Years later, Nicolas Calas confirmed the hegemony of the two major critics, flatly stating that since World War II the allegiance of the artistic world had been divided between the theories of Greenberg and Rosenberg, pointing out that in each case the critic had demanded a kind of purity – Greenberg a purity of medium and Rosenberg a purity of individual intention.[24]

80

It was true that Greenberg, sometimes with the intensity of a Savonarola, exhorted his listeners to be pure. Already in 1955 in "American Type Painting," in the Spring issue of *Partisan Review*, he was shaping the rules that would later be fully codified in his invention of "Post-Painterly Abstraction." In 1955 he contented himself with suggesting that the entire modern tradition had been built on the recognition that anything not essential to the medium must be eliminated, above all suggestions of spatial depth inherited from Synthetic Cubism. He re-defined the importance of the Abstract Expressionists by stressing Clyfford Still and Barnett Newman and faintly damning Pollock for his revival of semi-figurative symbols in his last works, and de Kooning for never having made the break at all.

Younger critics were not so quick to condemn the older generation. As they were actively engaged in the milieu of the younger artists, they were able to encourage the free and heterogeneous developments after the first thrust of Abstract Expressionism. John Ashbery would write years later that, in 1950, "a painter like Pollock for instance was gambling everything on the fact that he *was* the greatest painter in America, for if he wasn't, he was nothing . . ."[25] Ashbery extolled the recklessness of such attitudes and could still say with respect that, even though Pollock was accepted by practically everybody from *Life* on down or up, his work remained unresolved—"the doubt is there."

There were few doubts, however, in the world at large. Art was becoming a viable commodity, as the now famous article in *Fortune* magazine declared in 1955. By converting artists into suppliers and works of art into blue chips, the article confirmed the absorption of American art into American business. Such public confirmations of their new importance made many artists very uneasy. Their resolve to stand their esthetic ground was fortified. Many were emboldened to seek their vindication in a climate of general excitement that appeared to acknowledge art—any style of art—as potentially valuable. When the Whitney Museum presented "The New Decade, 35 Painters and Sculptors" in 1955, Ad Reinhardt, who had long and obstinately argued with the prevailing Abstract Expressionists (but always from *within*, as a fellow traveler), took the occasion to write a manifesto in favor of abandoning Abstract Expressionist excesses:

Painting is special, separate, a matter of meditation and contemplation, for me, no physical action or social sport. "As much consciousness as possible." Clarity, completeness, quintessence, quiet. No noise, no schmutz, no schmerz, no fauve schwärmerei . . .

50 AD REINHARDT *Brick Painting*
1951–52

51 FRITZ GLARNER *Relational* ▷
Painting Tondo No. 20 1951–54

Four years later Reinhardt's quietism was fully expressed in an exhibition of paintings so subtle in their black-to-near-black surfaces that an aura of sanctuary hovered over the Betty Parsons Gallery. Reinhardt's severe division of his surfaces into cruciform patterns, nine-square, minimized the engagement of the eye and forced it into the meditation and contemplation he had advocated. Even the geometric divisions faded in importance as the slowly moving variations of matte black affected the viewer. With this exhibition Reinhardt heralded a change in attitude. By the normal laws of change, or surfeit, or uncomplicated boredom, the values that had been submerged during the huge excitement of Abstract Expressionism began to emerge again. Artists who had never forsaken their conviction that, as Reinhardt wrote, clarity,

completeness and quintessence were the epitome of modern art began to attract attention again. Veteran painters from the '30s who had developed personal variations based on the theorems of de Stijl exhibited (often at the Rose Fried Gallery) and were respectfully received. Fritz Glarner, a Swiss-born painter who had come to America in the mid-'30s and participated in all the artistic activities, both of the abstract artists' groups and of the later Abstract Expresionists, was rediscovered as a painter who had managed to wrest from the dogma of de Stijl an elegant variation in which grays were incorporated with the primaries, producing a spatial ambiguity unknown to the earlier de Stijl exponents. Ilya Bolotowsky was seen with new respect, as was Burgoyne Diller whose delicate, spare canvases in-

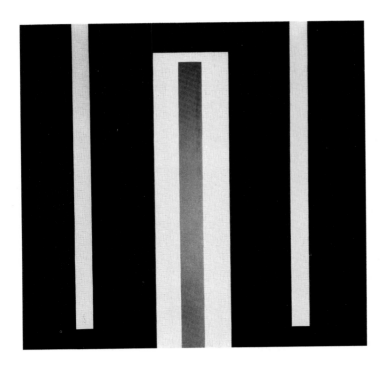

52 BURGOYNE DILLER *First Theme: Number 10* 1963

53 JOHN MCLAUGHLIN *No. 18* (diptych) 1974

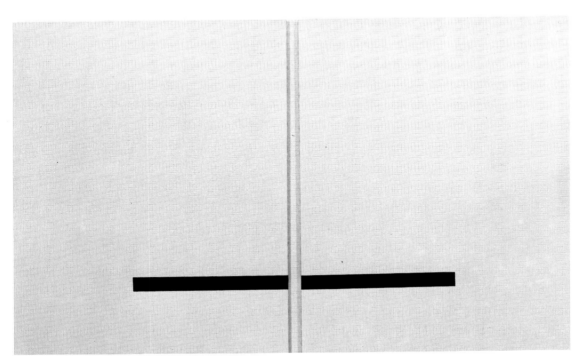

jected a note of lyricism into the de Stijl orthodoxy. On the West Coast the critic Jules Langsner, with notable independence, championed non-objective artists such as John McLaughlin and Lorser Feitelson. In 1959 he organized an exhibition of "abstract classicist" painting in which the forms "are finite, flat, rimmed by a hard clean edge . . . They are autonomous shapes, sufficient unto themselves as shapes . . . presented in uniform flat color running border to border . . . Color and shape are one and the same entity."[26] In London the critic Lawrence Alloway quickly capitalized on Langsner's careful analysis, isolating the phrase "hard edge" to introduce the exhibition.

The increasing interest in flat or geometric painting, deriving from earlier 20th-century non-objective schools, was often seen as a rejection of Abstract Expressionist doctrine. When Josef Albers was exhibited at the Sidney Janis Gallery where some of the most important Abstract Expressionists had shown, he declared in an access of delight at his opening, "Abstract Expressionism kaputt!" Albers did not reckon with the eternal ambiguities inherent in Abstract Expressionism. When Clement Greenberg became artistic director of the newly established modern art gallery at French & Company in 1959, one of his first moves was to present the works of Barnett Newman from 1946 to 1952. Documenting Newman's shift from Surrealist-tinged symbolism to the vast monochromatic canvases divided off with one or two strips, Greenberg established "tensions" as the subject-matter of the paintings, noting that "such tensions form an almost entirely new area of interest for our tradition of painting."[27] Younger artists seeking an alternative to gesture painting found in Newman's heroic-sized canvases a new manifesto. Since Newman firmly declared that there was nothing "relational" about his painting, that the seeming divisions had nothing to do with geometry or arithmetic or anything that had previously been associated with flat painting of rectilinear proportions, there seemed to be a new conception there, one that could preserve the anarchist principles of Abstract Expressionism and at the same time establish some kind of new order.

After the initial success of the Newman show, Greenberg was to pursue his role as mentor with increasing zeal, laying claim to a territory that he declared was truly avant-garde as he put forward a number of younger painters under a new and exclusive banner. Curiously enough, many of the younger exponents of the leaner style were not touched by the partisan fervors of the older generation. Such artists as Al Held and Ellsworth Kelly had spent time in Paris during

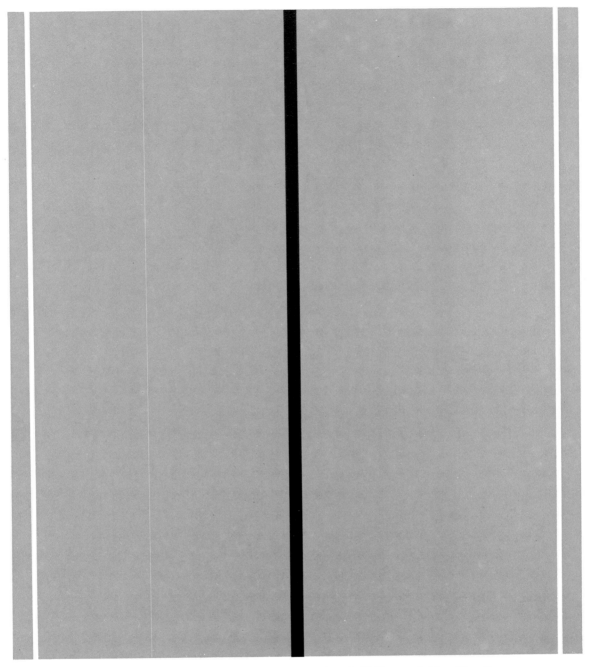

54 BARNETT NEWMAN *Who's Afraid of Red, Yellow and Blue II* 1967

55 ELLSWORTH KELLY *Yellow-Blue* 1963 (p. 89) ▷

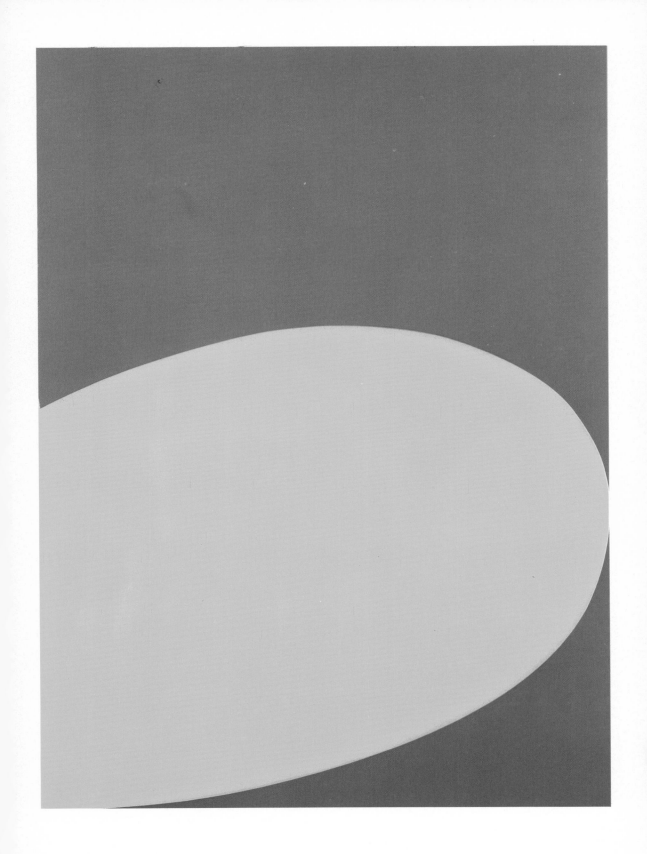

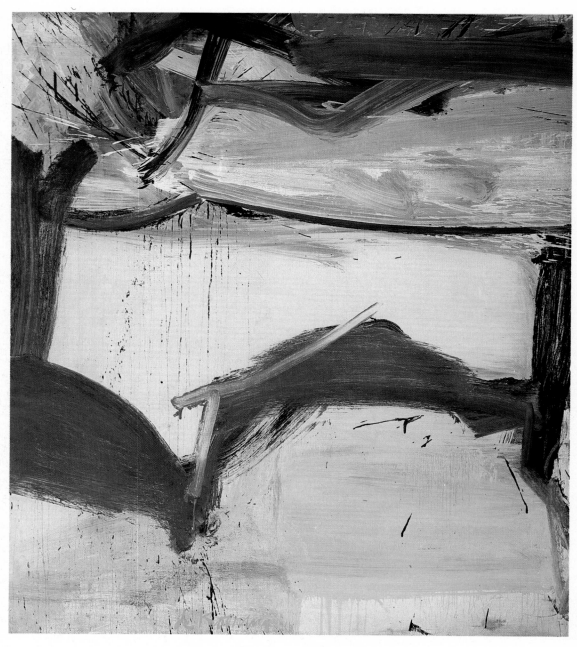

56 WILLEM DE KOONING Untitled 1963 (p. 103)

the '50s and had returned to New York after a broad exposure to many voices. They simply accepted the vanguard philosophy of the older generation while seeking to develop along their own lines. Kelly had already established his flat and non-gestural principles in Paris where, as he later wrote, he realized that "All art since the Renaissance seemed too man-oriented. I like object quality."[28] He found it in the non-objective traditions of Paris as well as in Matisse. He did not find it in Abstract Expressionism, and writes:

My work is about structure. It has never been a reaction to Abstract Expressionism. I saw the Abstract Expressionists for the first time in 1954. My line of influence has been the "structure" of things I liked: French Romanesque architecture, Byzantine, Egyptian and Oriental art, Van Gogh, Cézanne, Monet, Klee, Picasso, Beckmann . . .

Kelly soon embarked on his puritanical course after returning to New York, simplifying his compositions and striving for the maximum effect of a drenched plane of color. He denied that he was a "hard-edge" painter, saying that he was interested in mass and color. The firm edges occur, he explained, because the "forms get to be as quiet as they can be."[29] His friend of the Paris years, Jack Youngerman, shared similar ideals. Upon his return to New York Youngerman was eager to explore flat painting, but with an emphasis on the way shapes can emerge—not naturalistic shapes so much as those that grew from his inventive ink drawings. Youngerman's fusion of curvilinear elements with the flatness of planar composition characteristic of non-objective painting brought into the discourse of the period another approach. A third painter who returned from Paris in the early '50s, Al Held, was to move from a thickly-impastoed, all-over method of composition heavily influenced by Picasso to a curious blend of Abstract Expressionist asymmetry and geometric imagery. Held began to work on an epic scale, and by the '60s had worked out his eccentric vocabulary of geometric references that owed little to previous explorers of that ideal realm. Others, such as Ray Parker, whose paintings also came to stress mass and colour in their least illusionistic guise, moved from what he called improvisational abstract painting to "simple painting," by which pigment on ground would let color tell the whole story. His way of working—tacking primed canvas on the wall and letting color expand freely—showed him faithful to the ideals of Abstract Expressionism, but the results—the two or three oblong or vertical, often rounded, shapes—were, despite their kinship

◁ 57 ELLSWORTH KELLY *White-Dark Blue* 1962

58 JACK YOUNGERMAN *Totem Black* 1967

59 AL HELD *Echo* 1966

60 RAY PARKER Untitled 1959

to Robert Motherwell's paintings, strongly on the side of flatness and simply bounded images.

There was decidedly a new current flowing away from the more extravagant recent traditions. There were even informal groups. Jack Youngerman, Ellsworth Kelly, Robert Indiana and Agnes Martin had settled in the port area of Lower Manhattan at Coenties Slip, where they participated in an informal but protracted conversation, seeking possibilities not only in the immediate past of the New York School, but also in the entire spectrum of the modern tradition. It was easier for those who moved into New York during the '50s to relax and acknowledge their patrimony than it had been for their psychologically embattled elders. Kelly and Youngerman brought from Paris a deep respect for the achievements of Matisse, particularly the late pasted paper works, and did not hesitate to assimilate his discoveries. Agnes Martin, on the other hand, carried with her from the Southwest where she had settled in the '40s an unalterable will to find her own way. Her years in New York, beginning in 1957, were devoted to recapturing memories of the unlimited spaces of the West. She moved from lightly figured abstractions, in which an insistent rhythm paralleled nature, to the pure and lyrical paintings of the '60s in which a delicate grid supported her musical variations, and color was blanched out to the palest of lights—the transparent lights that fall over great plains and deserts.

The liberal attitudes of the artists following in the wake of the Abstract Expressionists were often in contrast to their polemicists. Most artists were not shocked, as were so many critics, to see a resurgence of interest in figurative art. Kelly, for instance, was not embarrassed to show his fluent drawings of plants and flowers together with his reduced suites of single-colored panels. In the fall of 1959, Peter Selz, the energetic new curator of painting at the Museum of Modern Art, installed "The New Image of Man," in which significant representations of the works of Giacometti, Dubuffet, Bacon and other European masters were exhibited along with Americans. Many critics were repelled by the works of the so-called Monster School of Chicago, although they admired the selection of de Kooning. In general, the response to the exhibition was troubled, particularly because the magnitude of the show seemed a gauge of a retrograde position on the part of the authorities. Yet there were those who welcomed the new image and whose incipient figurative impulse was nourished. It might be true, as Irving Sandler noted, that the art

61 ALEX KATZ *The Red Smile* 1963

community in New York was much more excited by the exhibition that winter of Sixteen Americans in which

the museum conferred its recognition on the no-and-anti gestural styles of Kelly and Stella (whose black pictures provoked immediate controversy) and on the so-called Neo-Dadas Johns, Rauschenberg and Stankiewicz, and related assemblagist Louise Nevelson.[30]

But the image of man was clearly on the minds of ambitious painters such as Diebenkorn, Philip Pearlstein, Alex Katz and a host of other younger artists. Pearlstein, who had earlier made studies of rugged mountain walls, rock-faces, tangled underbrush, in which details were not subordinated to a whole but spoke throughout the entire surface, began in the early '60s to study the figure. He determined to do so with uncompromising severity, striving to retain only the most literal detail with the sharpest objective eye. He reduced the range of his palette to contrasting tones and rendered his subjects as though they were inanimate, in postures that were often cropped at the canvas edge. Flatness was favored, making his figure studies anomalous. Pearlstein's decision to retrieve his right to paint in the great realist tradition was regarded as extraordinary at the time and earned him the role of *chef d'école* of the "new realism," as he still is.

62 PHILIP PEARLSTEIN *Female Model on an African Stool* 1976

4

After World War II a self-conscious sense of historicism seized the world. Cultural historians, philosophers and Marxists have been debating this curious turning, trying to probe its source ever since. The new historicizing attitude led to a great many attempts to characterize the '60s, during which national life seemed to have changed radically. Writing in 1964, Ted Solotaroff epitomized the period in his title: *The Red Hot Vacuum*. As a literary critic, he said, he had noticed

an increase in the vacuity and confusion of literary opinion, the loss of serious community and authority, the merely reactive tendencies of the "cultural explosion" and the concomitant preoccupations with the issue or style of the moment, as well as with sales and reviews and writers who get in columns.[31]

All of this could easily be transposed to characterize the condition of the visual arts. Solotaroff's prescription also would serve:

Perhaps the best that can be asked is that we become aware of the vacuity of literary culture, that we cease trying so hard to jump with the Zeitgeist or to beat it at its own fragmenting and frantic game and begin again to restate the cultural tradition from the perspective of the present.

Such an approach, he felt, could free American cultural life from

the trap of the merely topical and chic revolt, with its tendency to bury genuine elements of dissent and experiment like quicksand, and from the trap of academicism, with its undue reverence for the settled judgments of the last generation.

But the red hot vacuum did not exist in a social vacuum. The '60s were riddled with unnerving public events that allowed little breathing space. The calm appraisal Solotaroff called for was not easily

undertaken. At the time he wrote, the Kennedy assassination was still troubling many Americans who were forced to wonder whether it might be a harbinger of darkness never before known to them. A year later, fire hoses and police dogs dominated the television screens as they were turned upon Southern blacks when the civil rights movement reached a climax. At the same period, in 1965, the growing uneasiness over the war in Vietnam began to reach college campuses. Numerous teach-ins took place that year, mobilizing rebellious youths and providing the climate in which new formations appeared. A sizable proportion of youths were eager to condemn the America of the prosperous '50s and '60s, and to find, as they repeatedly said, new alternatives. The declared disaffection became almost a mass movement as people gathered in anti-war demonstrations, or in such public events as rock festivals. When, during the Chicago Democratic Party Convention in 1968, the police rioted, savagely cutting down demonstrators, most Americans were shocked. But, as polls later established, they were shocked not so much by the police brutality as by the frightening number of dissidents. An executive of NBC news reported after the 1968 riots:

The average middle-class American has gone through many wrenching experiences. His tranquillity has been shattered . . . what he has seen on television has shaken him physically and morally, made him fear for his safety, his savings, his children, his status.[32]

When Joan Didion recalled her days in San Francisco during the late '60s, where she watched flower children drug themselves, sometimes to death, and communes merge with the underworld, she saw disaster. The reputation of this hectic new subculture was overlaid with glamour, but underneath she saw an unutterably dismal society. All the rhetoric of the disaffected youth did not disguise the emptiness of their lives and the thinness of their ideals. It moved Didion to turn back to Yeats for her title, remembering his prophecy: The center cannot hold.[33]

And the center *did* not hold. Not in the world in which most ordinary citizens function, and not in the world of the visual arts where there was no longer a really discernible center at all. Rather, there was a host of hastily contrived centers that rushed repeatedly into the vacuum. Wars, riots and political murders did not significantly slacken the pace of national economic growth and, with it, cultural institutions. Despite predictions of recession, many new museums

opened their doors all over the country. In 1972 it was estimated that there were 1,821 bona fide museums and institutes of contemporary art in America, and in 1979, it was estimated that building programs since 1950, including additions to existing institutions, was adding exhibition space equal to 1,643.7 football fields.[34] It was true, as Karl E. Meyer has pointed out, that beginning in the '60s art museums along with other cultural institutions had to cope with steeply rising costs and declining private and municipal support.[35] Eventually it was seen that the "growth principle" these institutions borrowed from business was perhaps deleterious to art museums, but the enthusiasm of newly expanded cities throughout the country for their own cultural centers prevailed. With the rapid growth of institutions came an increase in documentors, administrators, fund-raisers and explicators. Art magazines began a new era with greatly enlarged circulations. Increasingly, advertising techniques were accepted as a means of spreading culture. Some museums even hired public relations firms to look after their "image" and others enlarged and made more sophisticated their own public relations staffs. The old generation's fear of contamination, as evident in statements of Rothko and Still, for instance, was no longer apparent, at least among the young who ridiculed their pompousness and who readily accepted the attention of the chic world reached by high-class advertising. A younger critic looking back in the late '70s remarked that the New York artist of the '50s saw himself as a loner and a pioneer, but things changed in the following decade. The ambitious artists of the '60s rejected the role of pioneer in a cultural wilderness in order to become stars:

Instead of lone individuals working out difficult destinies, the major figures of the sixties were the highly publicized leaders of the latest art movement. . . . These groupings were defined with the help of critics, historians, curators, and those dealers who understood how much easier it is to sell a product when it comes complete with a label to inspire brand loyalty.[36]

As for the esthetics of the '60s, Irving Sandler discerned the major tendencies:

One, inspired by the Duchamp-Cage impurist aesthetics, led artists beyond the realm of the traditional visual arts toward theater and the other arts, and toward "non-art" or "life", even though it continued to fertilize painting, sculpture and collage. The other tended to emphasize the art object as an impersonal thing in itself rather than

as an object expressive of its creator, although many were that, if inadvertently.[37]

Such neat compartmentalizing of a decade was not difficult in the '60s, one of the most self-consciously historical decades of all. It was a decade of advocacy, of polemicizing and categorizing. The new critics were well endowed, having been through the academic training of greatly expanded art history departments throughout the country. They knew how to debate and were eager to follow Clement Greenberg's thunderous tradition (only with a somewhat more pedantic concern for detail). Greenberg himself made an important announcement in *Art International* in October, 1962: there was now an "After Abstract Expressionism" characterized by its exclusive interest in the field-like surface of a painting and something he called "color-space." He articulated a new canon:

By now it has been established, it would seem, that the irreducible essence of pictorial art consists in but two constitutive conventions or norms: flatness, and the delimitation of flatness; and that observance of merely these two norms is enough to create an object which can be experienced as a picture . . . Not skill, training or anything else having to do with execution or performance, but conception alone. . . .

Greenberg's work in laying the ground for "post-painterly abstraction" was followed up by the young critic Barbara Rose who signalled the artists to be included in the new hierarchy in "The Primacy of Color." She said that they would "eschew image or symbolical allusion for pure, non-gestural chromatic abstraction." This new all-over composition, she wrote, is one in which the canvas is conceived either as a limitless field or an object. As it had been for Greenberg, conception was the most important aspect. The new art would be seen as "Order, logic, coherence, system, repetition, internal necessity and perhaps what one might term a Calvinistic sense of conceptual predestination. . . ."[38]

Rose's distinctions were fairly general, but as the decade wore on they became finer and finer. There were attempts to impose the status of "movement" on each seeming deviation from the canon. Arguments began to emanate both from Academe and from the institutions where academically trained curators prevailed. (The scholastic philosophy, as Lewis Mumford has pointed out, could not have developed without the rise of the university which perfected its students in the technical arts of formulating ideas and establishing

98

verbal proof. "Scholasticism was a machine for sifting evidence, for collating authorities, for manufacturing proof."[39] There was more than a hint of scholasticism in the many "isms" that were enunciated during the '60s and in the diction of their formulators.

The quick succession of newly established "movements" did not obscure the major achievements of the decade on the part of older artists, although there was some feeling that they could be set aside – frozen in amber – and not really thought about. All the same it was a period during which several older artists reached ambitious goals. Mark Rothko, for instance, embarked on the ensemble of huge paintings meant for Mies van der Rohe's Seagram building (never delivered for want of an appropriate space) in 1958, and worked on them for several years. In the early '60s he was commissioned by The Society of Fellows at Harvard to provide murals for their meeting room, and in 1964 a triptych and two other panels were installed there. These remarkable paintings revealed themselves slowly, changing with the light of the day. The triptych on the longest wall, with its plum reds barely visible beneath black surfaces and its irregularities of form and value, could change from a silvery effulgence to a densely textured, mysterious mass of cryptic shadows in the late afternoon. Contrasting with the languorous mystery of two darker panels was a fiery orange-red form suspended like a flaming hoop in purple space – a magical apparition that appears in its own theater with its own transforming inner lights. This panel, so susceptible to a reading in time, reveals a low rectangular knot – a plaquette suspended on a horizontal line – as a glowing coal. Thicker brush marks and vermilion splashes are like lambent sparks. These murals, imbued with conventional values of chiaroscuro posed in unconventional terms, were concerned with the almost indefinable area between obscurity and light that was to become Rothko's principal idea when, between 1965 and 1967, he undertook the murals of the Houston Chapel, installed only after his death in 1970. There, in the rather severe octagonal structure, Rothko's meditative temperament expressed its most subtle emotions, lingering in an almost impenetrable darkness that is measured out with infinite care in fourteen panels.

Another artist of the Abstract Expressionist generation who surprised his viewers with a darkened mood was Philip Guston who, in his 1962 retrospective at the Solomon E. Guggenheim Museum in New York, showed works in which grays and blacks threatened to engulf his former rusty oranges and dark reds. Later he darkened his

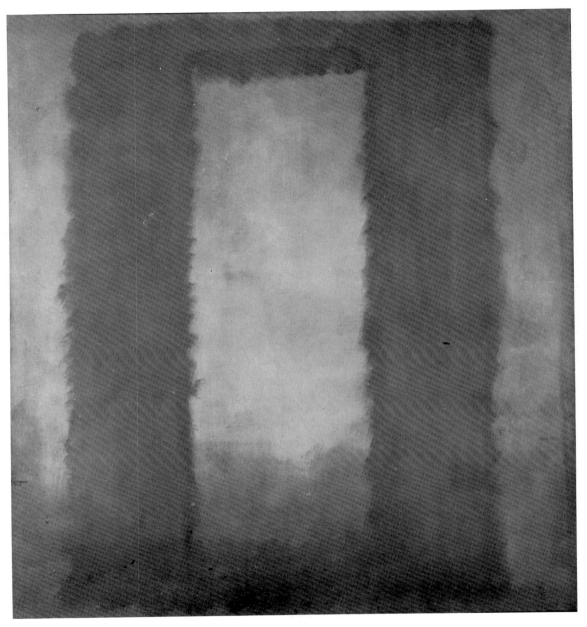

63 MARK ROTHKO *Red on Maroon* 1959

64 MARK ROTHKO Paintings in the interior of the Rothko Chapel, Houston, Texas, 1965–67

palette still more; forms became fewer and denser, hanging together in clumps of twos or threes in a thickly woven matrix of dark strokes. By 1966, when he had his controversial exhibition of some eighty works at the Jewish Museum, Guston's stormy, hermetic abstractions began to show signs of dealing with real things–heads, cups, jars. His childhood interest in cartoons and satirical drawing revived in savage views of himself as a great, amorphous, disembodied head–the same head that in later years would be specifically self-indicting. Now, he said,

I've become involved in images and the location of those images, usually a single form, or a few forms. It becomes more important to me to simply locate the form . . . But this form has to emerge, to grow, out of the working of it, so there's a paradox . . . You are trying to bring your forces, so to speak, to converge all at once into some point.

65 PHILIP GUSTON *The Inhabitor* 1965

Guston's paradoxical interests both disturbed and inspired younger artists, although few knew quite how to place them. The Expressionist impulse surged up ever more strongly in the older generation while the younger gravitated increasingly toward its opposite. Even Robert Motherwell, whose imagery had always hovered near the realm of symbolism, shocked viewers of his 1965 retrospective exhibition at the Museum of Modern Art with the intensely heightened emotional character of the works he had recently completed. The great looming shapes, as in "Africa," straddling huge spaces, revealed Motherwell as true to his repeated assertions that only strong feeling counts for him. The brooding themes he had undertaken years before–themes

of death and personal tragedy—took on monumental guises. In the catalog preface the poet Frank O'Hara wrote respectfully of the "steadily rising emotional power" in the works of Motherwell and some of his colleagues, and commented that a work such as "Africa" communicates human passion in a truly abstract way, while never losing its specific identity as a pictorial statement. "The exposure is one of sensibility rather than of literal imagistic intent, and therefore engages the viewer in its meaning rather than declaring it."

Not long after, in 1968, the Museum of Modern Art offered a long-postponed retrospective of the works of Willem de Kooning in which his range of idiom was, for the first time, apparent. Those who had so cavalierly adopted the term "action painter" or "gesture painter" were forced to reflect on de Kooning's subtleties, and the stylistic adjustments he undertook during the late '50s and '60s. A number of new paintings showed him clearing away his spaces, bringing landscape references into new spatial visions. Large areas and horizontal emphases made associations with his sea-surrounded milieu in East Hampton inevitable. But de Kooning in the '60s was doing more than responding to sky and sea. His play with color, for instance, in "Untitled" (1963, in the Hirshhorn collection), indicates an inquisitiveness concerning the nature of surfaces as they are revealed in natural light, as well as a different sense of the role of incident—in this case heightened in the upper left corner—in the overall closeup vision of his canvas surface. In works of the late '60s, a kind of topological

66 ROBERT MOTHERWELL *Africa* 1965

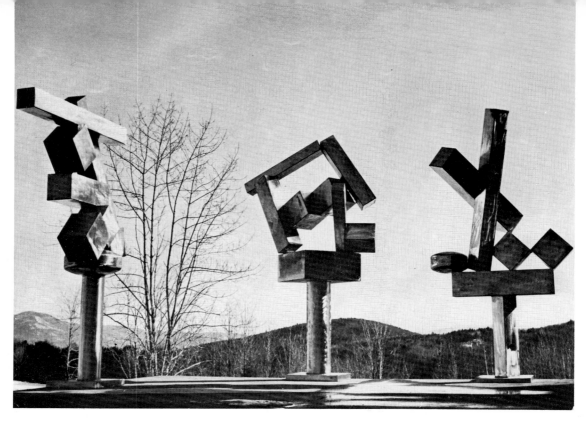

67 DAVID SMITH (l–r) *Cubi XIX* 1964, *Cubi XVII* 1963, *Cubi XVIII* 1964

approach to the figure showed a subtle but radical shift in his pictorial conception. The surfaces, pulled and stretched to straddle the entire canvas, were no longer ranged in the logical sequences of Cubist space, but moved sinuously in and out of a narrow area just behind the picture plane. The new figures when examined in detail were fundamentally different from the Women of the '50s, and indicated how rich and profound de Kooning's painterly exploration of the universe could be.

Still another major figure, David Smith, presented radically different works in the '60s that indicated his imaginative stature definitively. Before his accidental death in 1965, Smith had produced two groups of works that were widely noticed. Invited in 1962 to work in Italy at Spoleto, Smith spent a little more than a month in an abandoned factory in Voltri, where he produced almost a work a day, revelling in the luxury of unlimited old iron parts and workers who knew how to respond to his needs. These sculptures were continued the following year in the United States, where Smith invented scores of images ranging from chariots to engines, from worktables to abstractions, always with the great force of his teeming sculptural

imagination. In 1963, Smith entered a new phase with his highly polished and scumbled stainless-steel "Cubi" series. They were simplified to the extent that Smith limited his formal inventions to the possibilities offered by the cube, but they were complex statements of his vision of the meaning of surface (he said that the polished surfaces were "colored by the sky and the surroundings") and its implication of dynamic volume.

Although major exhibitions of such forceful artists made their impression, critics tended to be remote, blandly affirmative, and unstirred by the real achievements inherent in the later works of such artists as Guston, Motherwell, Rothko, Smith, *et al.* Commentators were not sensitive to the idea of slow emergence, having had by the mid-'6os an exposure to many spectacular announcements of new directions. Museums accelerated exhibiting programs, pouring forth news of quickly-succeeding shows with unabated enthusiasm. No matter what the inherent value of new exhibitions was, they were promoted with hyperbolic giddiness. Even though Peter Selz and his associate William Seitz attempted, through the serious publications of the Museum of Modern Art, to make some hierarchical distinctions, the general perception of events during the later '6os was invariably geared to a kind of bubbling insouciance familiar to an audience hectored constantly by the electronic media and even the daily press. Yet despite the frivolity attendant on all events in the art world, a few exhibitions managed to leave a permanent mark.

One of the most significant was compiled by William Seitz. In "The Art of Assemblage" at the Museum of Modern Art in 1961, Seitz drew together all the strands of the modern traditions around the initial act of Picasso and Braque when they dismantled a five-hundred-year-old tradition of painting by creating the collage. Seitz, who was both a painter and writer, created a model exhibition, laying out the entire history of works assembled rather than painted, modeled or carved. He included Cubist and Dadaist collage, Futurist collages, Surrealist *objets trouvés* and a large selection of works by Marcel Duchamp, whom de Kooning had once called a one-man movement. In a scholarly introduction, Seitz alluded to the recent wave of assemblage that had disturbed supporters of both figurative and abstract art. He observed that

The themes beginning to pass through the doors of art museums are (once again, as in the days of Courbet) those described by Gide as

68 JOSEPH CORNELL
*Hôtel du Nord c.*1953

"the squalor of reality." Or, in the more current–and perhaps there-
fore more apt–phrase, Allan Kaprow speaks of "the nameless sludge
and whirl of urban events" . . . The vernacular repertoire includes
beat Zen and hot rods, mescalin experiences and faded flowers,
photographs, bumps and grinds, the *poubelle* (i.e. trash can), juke
boxes, and hydrogen explosions.[40]

Seitz was aware that in some cases the trash and photographs were
meant to inspire horror of such things as Nagasaki, the disenfranchise-
ment of Blacks and the abuse of national power. In other cases, a more
whimsical identification with popular culture led artists to incorporate
elements which the spectator could move or shape. In still others the
assemblage technique was combined with movement, as in the case of
Jean Tinguely whom Seitz quoted: "resist the anxious fear to fix the
instantaneous, to kill that which is living."[41] Perhaps the most
significant aspect of Seitz's rendering of certain tendencies that had
originated during the first decade of the century was his intelligent

internationalism. He juxtaposed works by artists from almost every European country with American works in the same genre. In this way he was able to focus on the main issues and spotlight the nature of the recent variations on hallowed anti-traditions, and to account for such international phenomena as the Fluxus movement, only just getting under way with poets, composers and visual artists sharing certain concerns. "Fluxus," wrote Henry Martin, "concerned itself with the trivial, the marginal, the overlooked, things that were silly and irrational tics and fetishes, useless ideas, unnecessary inventions, large banalities, various forms of minor sacrilege."[42] The poet Dick Higgins gave it an "inter-media" connotation, by which he meant that the Fluxus experience dealt with the left-overs of experience that classical art media could not encompass. Seitz's serious appraisal of the breakdown of conventional categories cleared the way for increasing attention to genres of art that had previously been seen only in isolated contexts. A subsequent exhibition at the Museum of Modern Art, called popularly "Machine Art,"[43] further investigated the disjunctures in the early part of the century that led to new conceptions of the art object. In the catalog essay, the Swedish art historian and museum director, Pontus Hultén, went deeply into the genesis of certain aspects of assemblage, most particularly those that either mocked or imitated industrial models. The implications of the show in 1968 were all too apparent to those who were assaulted daily by headlines of domestic upheaval and mechanical failure. Hultén regarded his exhibition as an emphatic closing of the mechanical age, and pointed to a future in which there would be extensive revisions of the nature of art and its media.

Many artists agreed with him. Inspired by the Swedish-born electrical engineer Billy Klüver, a number of them had met in 1966 to form Experiments in Art and Technology, or E.A.T. as it was popularly known, in order "to catalyze the inevitable active involvement of industry, technology and the arts." Johns, Rauschenberg, John Cage, Robert Whitman, Robert Breer and scores of vanguard artists enthusiastically pursued the ideal which was realized in the Fall of 1966 in "Nine Evenings: Theatre and Engineering," a chaotic series of events at the 69th Street Armory in New York. Although most of the performances were marred by the inevitable technical breakdowns and lack of coordination between science and artistic temperament, the idea of engaging the expertise of industry continued to appeal to many artists and institutions.

69 KENNETH NOLAND *Tropical Zone* 1964

Both Seitz and Hultén documented the tendency of the arts in Europe, America, and Japan, to move out into the world and truncate the space supposedly separating art and life. They noted that recent artists carried forward the discourse of such early precursors as the Russian Futurists and the European Dadaists, and they carefully provided a tradition for seemingly disparate tendencies that had so spectacularly appeared in the '60s. The same was being done for artists who, on the contrary, were moving far from the arena of everyday life, and whose works were seen as distinct from their immediate predecessors. In 1963, for instance, the Jewish Museum presented a brave manifesto exhibition called "Toward a New Abstraction." The show consisted mostly of works by artists of whom Greenberg approved, but was augmented with more idiosyncratic statements, such as those by Al Held and Miriam Schapiro. Both Kenneth Noland and Frank Stella were presented and discussed in the diction of the new "cool" and analytic criticism that seemed to dominate the decade. Noland was characterized by Alan Solomon, the museum's director, as a painter seeking to avoid artfulness by using targets, lozenges and chevrons that could still be subject to visual ambiguities. The mere act of avoidance was given a value that many would have considered trivial in previous years. What was rejected became the starting point for most discussions of these artist's works. Michael Fried, for instance, stressed that Frank Stella's paintings "arise out of an unprecedented awareness of their own perimeters as well as out of the painter's conviction of just how relevant this awareness is to the contemporary situation in New York." Fried's phenomenological critical technique

permitted him to describe the surfaces of Stella's paintings extensively, and to claim that what Stella had done was

to extend the painter's domain of self-awareness, and hence of decision and control, from the flat picture surface to the boundary of the canvas. This was true even in the earliest black paintings, where the different right-angled configurations of stripes amounted to variations within the relatively unchangeable rectangle of the canvas.[44]

Stella's self-consciousness about the framing edge, Fried maintained, could be seen as a statement about what had happened to "advanced" sensibility over the past five years. Shortly after, he was to argue that

70 FRANK STELLA *Six Mile Bottom* 1960

Stella, Noland, Louis and a few others were involved in "deductive" structuring, in which the point of the painting is that it is "deduced" from the shape of the bearer. Fried's accommodation of the disclaiming aspect of the new painting became almost a manifesto, confirmed by Stella himself in a 1966 interview in *Art News*.[45] He said that people who want to retain old values in painting always end up asserting that there "is something there besides the paint on the canvas." He, on the other hand, felt that his painting was "based on the fact that only what can be seen *is* there . . . Any painting is an object and anyone who gets involved enough in this finally has to face up to the objectness of whatever it is that he is doing." Stella's determined will to expunge all the areas of ambiguity that had shadowed the Abstract Expressionist mystique contributed to the rhetoric devised by critics to deal with his work and, by extension, with all works that came to be grouped under the rubric of "minimalism." (He himself, however, did not linger in the climate of deductive composing and later broke up his compositions into shaped configurations, eccentric schemes and complicated games of geometric figures that were far from the "conceptual purity" for which he was first admired.)

The work of art as an object divorced from emotional or interior or invisible values got another boost from the Museum of Modern Art when, in 1965, it presented "The Responsive Eye," a compendium of works of art in which the primary, and in most cases the sole, value consisted in their activation of the sensory mechanism of the eye. Works by Vasarely, Albers, Kelly and Louis were augmented by those of younger artists such as Bridget Riley and Larry Poons. The exhibition served to encourage the growing belief that color could be the sole means in painting, and that the object fashioned by the artist could subsist with a minimum of corollary effects. This was further stressed in the following year when the Guggenheim Museum presented a thesis show based on Lawrence Alloway's theory of "systemic art." Alloway, in an elaborate catalog essay, traced the shifting sensibilities of the '60s away from Expressionism toward a formal, hard image, as in the works of Barnett Newman, Frank Stella and Kenneth Noland. Newman was Alloway's trump card, for he saw him as having made a series of "essentializing moves," producing "a saddlepoint between art predicated on expression and art as an object." He maintained that the artist's conceptual order is just as personal as autographic tracks, and called in Duchamp to prove that choice sets the limits of the system regardless of how much or how little

manual evidence is carried by the painting. Like many others in the '60s, Alloway was keen to add new terminology, and came up with One-Image art which "abolishes the lingering notion of History Painting, that invention is the test of the artist."

Here form becomes meaningful, not because of ingenuity or surprise but because of repetition and extension . . . the run of the image constitutes a system, with limits set up by the artist himself, which we learn empirically by seeing enough of the work. . . . When a work of art is defined as an object we clearly stress its materiality and factualness, but its repetition, on this basis, returns meaning to the syntax.

Along with others, Alloway maintained that a system is not antithetical to the values suggested by such words as humanist, organic and process. It is just that trial and error, instead of being incorporated into the painting, occur off the canvas. Still others, particularly among the younger artists participating in the detached non-objective painting movements of the later '60s, were only too eager to bury the terminology of humanist art approaches beneath a stream of discourse threaded through with allusions to philosophy, physics and mathematics. It was around this time that American artists discovered the delights of Wittgenstein's games theories and quickly injected his aphorisms whenever all else failed.

Many artists of the new generation offered an equivocal response to the increasing evidence of corruption in late industrial society. They held in contempt bourgeois values, such as the importance of the unique painting. There was even, perhaps, a certain expression of contempt in the works of "environmental" character which were to engulf and at times entrap the viewer. Painters who work in series of dozens of canvases obviously ask to be considered articulators of the living spaces of their viewers rather than symbol-makers. Their need to reduce, cool and simplify ran directly counter to the chaos bedevilling national life. Among those who tried to see the broadest significance of the tendency toward unemotional art was Professor E. C. Goossen who made an effort to sum it all up in an exhibition at the Museum of Modern Art in 1968 called 'The Art of the Real." The "real" as posited by this new art, he wrote, has nothing to do with metaphor, or symbolism or any kind of metaphysics. Today's "real" offers itself in the form of the simple, irreducible, irrefutable object. Goossen's general thesis was that the contemporary artist no longer regarded perceptual experience as a means to an end, but as the end

itself. In the new art, "hierarchical passions and dynamics are left behind and we are faced with the self-evident, crystalline structure, the objectively (instead of subjectively) real."

Sculptors were even more susceptible to the objectives of "cool art" or "systemic art" or "minimal art." They were given their polemical platform in 1966 when the Jewish Museum offered "Primary Structures," including works by younger American and British sculptors. The catalog essay by Kynaston McShine again stressed the detachment of most of the artists, and their use of the standard fabricated unit giving their work "an anonymity which, presumably, could be repeated or duplicated by any outsider. Their work thus gains an availability and accessibility which removes sculpture from any connotation of the precious 'fine arts' object." The highlights in the

71 RONALD BLADEN *3 Elements* 1965

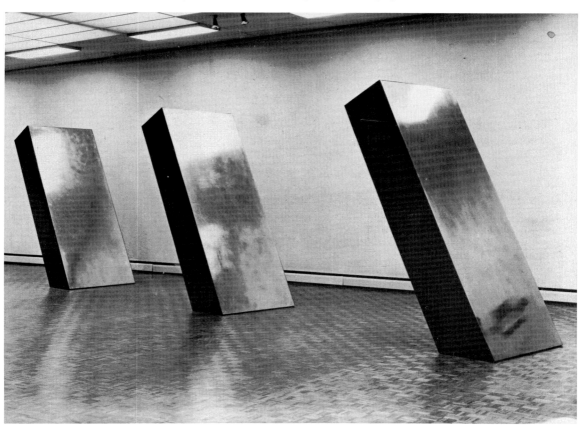

exhibition were the monumental works. Ronald Bladen's powerful diagonal forms, like great notes in an oversized antiphonal, with their burnished aluminum faces and dark sides, marched authoritatively through the gallery while Robert Grosvenor's huge red and black check-like form hung from the ceiling with commanding unease. Robert Morris, Sol LeWitt, Donald Judd and Michael Todd were also seen in their first important museum shows, as was Tony Smith. Many of the works exhibited demonstrated a coolness of logic that gave the general esthetic a Platonic cast. The artists were extremely conscious of such factors as weight, measure and numerical intervals, and in many cases worked in terms of absolute symmetry. Rejecting the old Francis Bacon saw that nothing is beautiful in which there is no strangeness in proportion, they attempted to show, by repeating shapes of identical proportions, that absolute symmetry has a beauty of its own, as indeed it does in Sol LeWitt's transparent sculptures.

One of the most active spokesmen for the sculptors who adhered to the esthetic of the blunt, unadorned object was Donald Judd, who liked to refer to the "wholistic" nature of the new art. Judd repeatedly attacked what he called European art for its "relational qualities." In his own shiny metal boxes, sometimes on the floor, sometimes on the wall, he avoided what he thought of as the big problem: "anything that is not absolutely plain begins to have parts in some way." Even those artists who could not entirely dispense with "parts" tried to keep their elements at a minimum, as did Tony Smith, whose blocky sculptures were always rectilinear and tended toward a geometric rigor. The strong impulse toward an utterly simple solution to the manifold problems presented after the mid-century reached its apogee in the '6os, as Richard Wollheim recognized. He opened his discussion in *Arts*, January, 1965:

If we survey the art situation of recent times, as it has come to take shape, over, let us say, the last fifty years, we find that increasingly acceptance has been afforded to a class of objects that, though disparate in many ways—in looks, intention, in moral impact—have also an identifiable feature or aspect in common. And this might be expressed by saying that they have a minimal art-content: in that either they are to an extreme degree undifferentiated in themselves and therefore possess very low content of any kind, or else the differentiation they do exhibit, which may in some cases be very considerable, comes not from the artist but from a nonartistic source, like nature, or the factory.

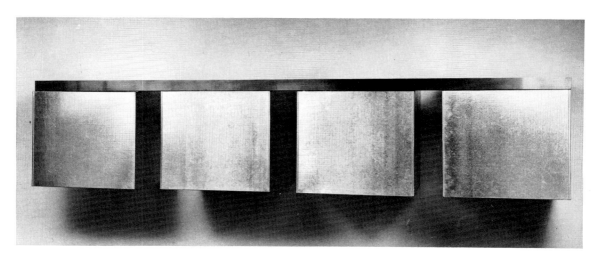

72 DONALD JUDD *Untitled* 1965

73 TONY SMITH *Gracehoper* 1972

5

Of all Wollheim's "nonartistic" sources, the comic strip was the most obvious in the work of those artists who, in the early '60s, burst upon the scene with a loud fanfare. Chroniclers give the date 1961 for its emergence. Its advent was so much appreciated in some quarters that by the end of 1961 there was already a book about Pop art. The effrontery of the Pop artists was enough to stir excited responses of a rather complicated nature. Their use of the American vernacular, which in the electronic age was formed and dictated by the mass media, was seen by some as a positive step in the direction of populist democracy in art. The British critic Lawrence Alloway, by this time resident in the U.S., had already dealt with similar outcroppings in England where the class structure was still so visible that any such rebellion would have seemed part of the salutary attempt to break it down. Other critics, resigned to the theory that art reflects its time and society, saw in Pop a response to the mandarinism sponsored by such critics as Greenberg and Rosenberg. Greenberg had been an implacable enemy of kitsch and all attempts to incorporate demotic language in high art. He was sensitive to the long American tradition of illustration and commercial capitalization of the printed, painted image and adamantly opposed. Rosenberg was always alert to the invidious packaged product and stood firm in his insistence on emotional content in art. These critics and others were still mindful of the more terrible effusions of the '30s when a "peoples'" art was called for and serious artistic discourse was debased. They looked with uneasy contempt at the sophisticated purveyors of popular culture. A younger critic, Lucy Lippard, showed strong interest, but her reservations were apparent in her definition: "Hard-core Pop Art is essentially a product of America's long-finned, big-breasted, one-born-every-minute society, its advantages of being more involved with the future than the past."[46] Lippard responded to the wilder

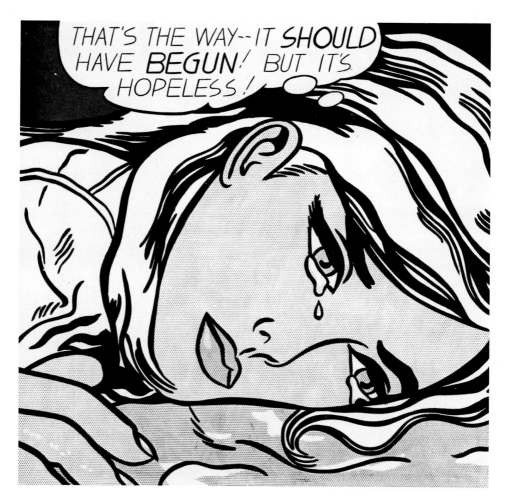

74 ROY LICHTENSTEIN *Hopeless* 1963

claims of Pop art. Such artists as Claes Oldenburg and Tom Wessel-
man insistently called attention to America's conspicuously consump-
tive habits. Oldenburg wryly announced that he was for "Kool-Art,
7-Up Art, Sunkist Art, 39 cents Art and 9.99 Art" while Wesselmann
painted Great American Nudes in the time-honored style of *Saturday
Evening Post* illustrators.

Curiously enough, a number of commentators looked on Pop art as
a kind of social critique. They interpreted Andy Warhol's Brillo boxes,
or Roy Lichtenstein's cartoons with balloon commentaries, as ironic
or parodic manifestations of disgust—the same kind of disgust that had
propelled the Dadaists and Surrealists in their refusals. The artists in
the Pop movement, however, knew better. Their refusal was not a

refusal of the values of society so much as a refusal to follow in the footsteps of older artists. They felt they shared in the Zeitgeist which had turned to "formal" concerns, and were comfortable with the descriptions of objectivity assigned to the minimal artists. Lichtenstein always maintained that he used comic strips and characters from popular media for purely formal reasons (with a touch of irony, no doubt, but also with a good part of sincerity). When he was asked just what Pop art was, however, another note crept in. For him, he said, it was "the use of commercial art as subject matter in painting. . . . It was hard to get a painting that was despicable enough so that no one would hang it–everybody was hanging everything. . . ."[47] This response is not so much to the raw abuses in American society as to the kind of luxurious expansion of consumption in the art world itself. It also betrayed irritation with the avuncular attitude of authorities who welcomed uncritically everything that appeared. The tolerance displayed to the diversity of things presented as art was notable during the '60s. Almost any group of artists could find a sympathetic critic, a gallery, or at least a storefront where there would be approval from someone. The fatherly attitude of Lloyd Goodrich, for many years director of the Whitney Museum, was more annoying than welcome to many artists: "This pluralistic art of ours is the fitting expression of a democratic society, free and fluid, allowing wide scope to individualism."[48]

The re-cycled spirit of Dada accounted for some of the artists tossed into the Pop art category. Duchamp, that one-man fountain of ideas, had slowly but surely inserted himself into the discourse of the '60s. The Transcendent Satrap, as he was called in the Collège de Pataphysique, had become active in both New York and Europe, and was celebrated in a full-length monograph by Robert Lebel and a translation of the notes in the Green Box by George Heard Hamilton in 1960. By the time he had his first major American exhibition, "Not Seen and/or Less Seen of/ by Marcel Duchamp/Rrose Selavy 1904–1964" in January, 1965, at the Cordier-Ekstrom Gallery, Duchamp had galvanized the attention not only of Robert Rauschenberg, Jasper Johns and Robert Morris, but also of scores of still younger artists who were eager to get away from the premises of Abstract Expressionism. Duchamp's early rejection of the idea of the art object as a unique exemplar fitted in nicely with the new rage to inundate the world with machine-made objects. One of Pop art's prime tenets was that art is never, necessarily, unique. Repeatable images–images that are

derived from industrial techniques in printing–delighted Pop artists, and the fact that their work related to commercial techniques such as advertising was seen as a moral good. Artistic purity was not nearly as alluring to the Pop artists as were popular associations from the other communications industries. Alloway in his book *American Pop Art* appropriately draws upon communications theory as well as structuralist scientific logic in order to make a list of the characteristics of Pop. A Pop work would always include at least one of the characteristics on his list. The variables "are syntactic complexity, range or extension of media, familiarity of subject matter or literal presence of the object, and connections with technology." Alloway's list is instructive in more ways than one. It is redolent of the erudite academic rhetoric that in the '60s seemed to be applied to just about anything:

1. Syntactic complexity: under this heading belong the interplay of written and pictorial forms, such as Johns' letters, numerals or words and Indiana's numbers and sentences.
2. Range of media: Rauschenberg's combine-paintings (which relate to assemblage and to Happenings in their incorporation of diverse objects); extensions of medium, as in the case of Rosenquist introducing billboard techniques into experimental easel painting.
3. Familiarity of subjects (Lichtenstein's comics or Warhol's newsprint sources); the literal presence of the object (Wesselmann's bathrooms and Dine's objects attached to canvases).
4. Connections with technology: Rauschenberg in particular, but machines are also an essential term of Oldenburg's metamorphic forms.[49]

The first two artists to declare themselves had been Warhol and Lichtenstein. An erstwhile commercial artist whose flair for the stunning appeared first in the effigies of Campbell Soup cans repeated in series, and later in repetitions of newspaper photographs of grisly events such as car crashes and electrocutions, Warhol later used the silk-screen repeat method on popular figures such as Marilyn Monroe and Elizabeth Taylor. To the images on walls Warhol added himself and his carefully documented eccentric behavior, as well as pronouncements in a dumb (ironically?) flat diction, such as:

Someone said that Bertolt Brecht wanted everybody to think alike. But Brecht wanted to do it through Communism, in a way. Russia is doing it under government. It's happening here by itself without being a strict government, so if it's working without trying, why can't it work without being Communist? Everybody looks alike and acts

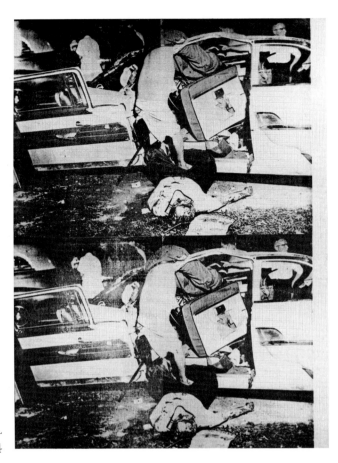

75 ANDY WARHOL
Saturday Disaster 1964

alike, and we're getting more and more that way. I think that every-
body should be a machine.[50]

Lichtenstein came forward first with his meticulously drawn exag-
gerations of cartoons and advertising in which he imitated by hand the
industrial printing technique of Ben Day dots. Later he turned to more
efficient industrial techniques and parodic subjects, such as his mock-
ing imitations of Art Deco, and his elegant parodies of the great
masters in the modern tradition. His commentary was succinct and
widely available to interpretation which was not long in appearing.
His style and formal attitudes were soberly discussed, as were the
others in the Pop movement. Usually these discussions failed to notice
that the Pop artists were feeding off a system of illustration that had

76 ROY LICHTENSTEIN *Modern Painting with Arc* 1966

77 JAMES ROSENQUIST *F-111* (detail) 1965

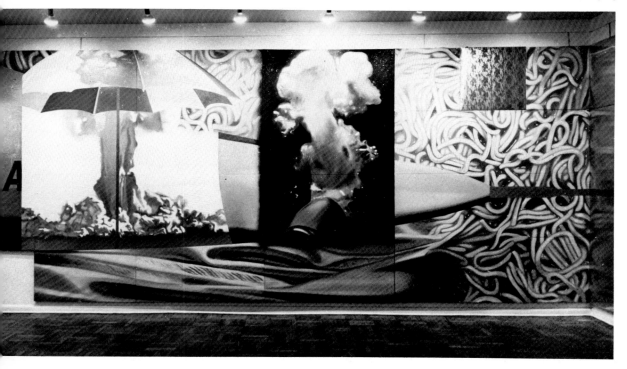

already established its stylistic mores and in which hordes of highly competent commercial artists had already abstracted essentials from popular culture. When James Rosenquist, for instance, took the techniques he had learned as a billboard painter and applied them to his synoptic compositions, he altered mainly the content or message, never the technique or even the style. On the other hand, Rosenquist was one of the few among the Pop artists who did appear to express a kind of social critique. In certain works he exposed distasteful American consumerism (enormous plates of spaghetti) and the American lust, so well disguised, for wanton violence (the gigantic mural based on the F-111 aircraft controversy).

Of all the artists associated with Pop, certainly Claes Oldenburg satisfied the largest number of criteria, whether social, technical or artistic. His Rabelaisian iconoclasm, expressed in so many varied forms, had the ring of an authentic tradition – the tradition of ironic anti-art; a tradition that had shadowed the high arts for centuries. All the acerbic laughter from Aristophanes through Dubuffet stood behind Oldenburg who, despite his commitment to the topical, has never wholly conceded to the technological psyche that lives only for a putative future. Oldenburg came from a cultured background and, if he mocked, he knew what he was mocking. He was an *enfant terrible* in the grand tradition, not merely a topical or formal gadfly. Theatrical, implacably contentious, Oldenburg had arrived in New York from Chicago in 1956 where he quickly found his milieu. Three years later, along with Jim Dine, he founded the Judson Gallery in order to call attention to their iconoclastic antics. He lived in the Lower East Side and revelled in its seamy disorder, its seething street life and even its sad domain of human shipwrecks, the Bowery. His first important statement was divided between the collective manifestos of the Happenings makers, and his own staged environments of dingy-looking figures in burlap and cardboard, written commentaries, odds and ends of papier-mâché. His "Ray Gun Show," with its implied commentary on the giant toy industry, was followed by "The Street," in which a bewildering variety of half-realized and ambiguous objects, handled, as many critics noticed, with an emphasis on primordial matter – that is, mud – as Dubuffet had suggested, were seen in a disconcertingly wild ensemble. This achievement was widely disseminated and Oldenburg quickly followed up with "The Store," in which hard and soft objects of consumption such as hamburgers, shirts, pants, steaks and ice-cream cones were rendered in stuffed-cloth in huge

78 CLAES OLDENBURG *Giant Toothpaste Tube* 1964

proportions, or in papier-mâché, always with brilliant, juicy colors reminiscent of the opulent advertising in magazines. After "The Store," Oldenburg concentrated for a time on the production of greatly inflated soft objects sewn and stuffed by his wife. The art world was delighted with such things as a typewriter, electrical appliances, light plugs, and the *tour de force* "Giant Soft Fan" in several versions. This unnerving large evocation, with its snaking wire and plug and its horribly wilting blades, comes close to being a Surrealist object with all that the imagination can conjure of strange inversions. Oldenburg's culture gave him the measure for his infusions of iconoclasm. Always he wrote, talk, demonstrated his wholeness as an artist in his time, but an artist who, having denied tradition, is somewhat impoverished. Nothing makes it so clear as the visual didactic pun in which he juxtaposes a drawing of a clothespin with a reproduction of Brancusi's "The Kiss."

Jim Dine, Oldenburg's friend and colleague, also showed exaggerated interest in the objects that clutter our lives. He enlarged and painted jackets, suspenders, vests and shirts in his first phase, and then turned to carpenter's tools, which he polychromed and suspended on walls. His most spectacular work combined his interest in Happenings with painting. The 1963 "Hatchet With Two Palettes" invited spectator participation and quickly got it when viewers used the hatchet to destroy the canvas behind it. Dine's later work turned away from the aggression that was inherent in certain aspects of Happenings, but never forsook the concentration on ordinary objects. In the late '70s he was still dreaming of bathrobes, although they were now strangely immured in a romantically painted environment of shadows and took on psychological connotations that the early Pop works emphatically denied. Rodin had struggled with Balzac's bathrobe, finally making a plaster cast of a real robe in order to study its properties, and Dine had finally transformed the ordinary by the reverse process.

There were artists on the fringe of Pop, or at least thought to be by enterprising critics, who reached into the American vernacular sources with different intentions. Richard Lindner, who came into prominence only in the '60s although he had been modestly exhibited long before, was often discussed in relation to Pop. Mistakenly, certainly, since Lindner's interest in the illustrational approach to popular mythology derived from his youth in Weimar Germany. He never really deviated, except in specific subjects, from his earliest sources, which he used to confect a cunning fusion of Neue Sachlichkeit and Grosz-like satire. His cast of characters – he was a singularly theatrical painter – did not fundamentally change. His women may have worn long skirts or short skirts, and may have consorted with men who moved from Dick Tracy's bow-tie to a mod leather jacket, but they remained the sirens Lindner's generation had admired in the theater of Frank Wedekind and in the Berlin cafés. The various accents Lindner had acquired from Germany, from the Paris of Léger and Picabia, from New York and its street life, simply inflected his work, which remained the peculiar, obsessional stream of consciousness of a displaced European.

Other artists such as Allan D'Arcangelo, George Segal and Marisol also found themselves discussed along with the Pop artists, although they found no common ground with the general run of Pop artists. D'Arcangelo, who began with the styleless imagery of the commercial

artists, used it to make sharp comments on such things as the civil rights horrors and the Vietnam war. He soon moved toward a more oblique expression. His long meditation on American highways produced paintings in the mid-'60s that were often compared to de Chirico's loneliest vistas. The highway series, for which he became

79 RICHARD LINDNER *The Street* 1963

80 ALLAN D'ARCANGELO *US Highway 1* 1963

internationally known, depicted in strong, flat compositions the telescoped impressions of the traveller through endlessly similar land-scapes. The expression of desolation and spaces that haunt the memory removed D'Arcangelo from the cheerful precincts of most Pop art and related him more nearly to an old American realist tradition tempered by romanticism.

George Segal, who began to exhibit his plaster cast figures in 1961, was ranked with the Pop artists largely because he made his tableaux

more lifelike by the addition of real objects from the environment such as a booth from a diner, a kitchen chair or a subway turnstile. But Segal's technique (wrapping real subjects in soaked plaster bandages) was used toward different ends. His need was to confront "real" space, rather than the traditional hypothesized space of sculpture, and to inject sentiments of a humanistic order. The simple tasks his figures perform, sometimes reminiscent of Degas, tell of his compassion for ordinary lives. Working in the glowing flat whites of plaster, he was able to exploit the paradoxical contrast between a disembodied impression and one of real bodies in real space. Finally his work seems more in line with the tradition from Daumier to Kollwitz than with the avowed detachment of the Pop artists.

81 GEORGE SEGAL *Bus Riders* 1964

June 13, 1970 *The Balance is Not So Far Away From the Good Old Daze* *Wm T. Wiley*

82 WILLIAM T. WILEY
The Balance is Not So Far Away From the Good Old Daze 1970

Ancillary to the Pop art activities was the so-called "Funk Art" of California. No one has ever come up with a satisfactory definition of funk, but to Californians it meant a demystification of art through the use of folk images and the vernacular. Allusions to the vocabulary of jazz musicians, farmers and cracker-barrel politicians showed up in the drawings of the funk artists, while farming tools and five-and-ten-cent store utensils were incorporated in their sculptures. The most extraordinary of the California spoofers was William T. Wiley, who had begun as an Expressionist painter fond of mysterious symbols such as pyramids and the eye on the dollar bill, but had moved on, in the mid-'60s, to a hybrid art filled with homely expositions, admonitions and adages. At times Wiley's drawings are strange amalgams of metaphysical objects and infinite spaces that relate more to Dürer and Piranesi than to contemporary mass media imagery. Baffling and moving drawings are at times coupled with joking titles, such as "The Balance is Not So Far Away From the Good Old Daze," where

127

Wiley's insistence on humor comes to the fore. But in both drawings and constructions, there is always something in Wiley's work that extends beyond the topical or corny into the realm of metaphysics.

Glances back at the '60s came quickly after their dramatic close, with many critics trying to make sense of the two dominant tendencies —minimal and Pop—by locating both in the boom era of industrial growth. As time passed, the two trends tended to be seen in tandem. Writing in 1979, a curator stressed the importance of industry, commerce and their partner, "the media" in both, and did not fail to take note of the continuous stock market growth from the late '40s until about 1965. In his eagerness to make things fit, L. M. Danoff follows older critics such as Robert Rosenblum and Barbara Rose in discerning similar formal tendencies.[51] By reducing the importance of particular images fashioned by Pop artists and accepting the word of Lichtenstein that what he was involved with was form, these critics were able to overlook the inherent differences among so many artists of the '60s and to streamline the art history of the period so as to leave no loose ends. It was true that both minimal and Pop artists liked to work in repetitive series, and that both were emphatic in regarding the object as supreme. Stella made his stretchers thick in order to emphasize the object-nature of his paintings and the Pop artists included industrially produced real objects in their work. Yet the object-oriented esthetic attitudes had more than formal underpinnings. Artists shared in a worldwide rejection of the psychological, introspective excesses of earlier periods. In Europe, the writer Alain Robbe-Grillet was damning the psychological novel by stressing description of the objects that fill up and surround human lives. The film-maker Michelangelo Antonioni told Jean-Luc Godard in an interview that his intention in *Red Desert* was to translate the beauty of the industrial world :

Our life, even if we don't take account of it, is dominated by "industry." And "industry" shouldn't be understood to be factories only, but also and above all, products. These products are everywhere, they enter our homes, made of plastics and other materials unknown barely a few years ago; they overtake us wherever we may be. With the help of publicity, which considers our psychology and our subconscious more and more carefully, they obsess us.[52]

Even if we take into account the changing attitudes toward industrial objects reflected throughout the Western world in the '60s, it is still unacceptable to see events, even art events, in the light only of the

formalist criticism that dominated the decade. The other events, those in the world of hunger, poverty and violence, made their claim on artists as well. The '60s saw many responses that could not be encompassed in the cool formula preferred by most critics. The assassination of John F. Kennedy, for instance, brought a spontaneous outburst of shock and despair from many painters and poets. Hans Hofmann painted a solemn symbol, a sorrowful image in his usual idiom, but others were more specific. Peter Schumann took his "Bread and Puppet Theater" to the streets of New York to alert citizens to the disasters of war. The huge masks and puppets in their funereal colors were a different kind of Happening that engaged the interest of many young artists. Schumann's Expressionist tableaux indicting the war in Vietnam formed one among many public expressions made by artists who heard daily news bulletins telling them that it was a crime punishable by death to speak of peace in Vietnam, or that the United States government had ordered 400,000 plastic corpse bags from Japan, or that the newly developed napalm would be more effectively "adherent." In Los Angeles, sculptor Mark di Suvero designed a "Peace Tower" to which hundreds of artists contributed, and in New York, an "Artists and Writers Protest Committee" expressed their solidarity.

In the midst of the grim turmoil of the '60s, moods shifted quickly. One could speculate that the chaos in public life induced many to seek order in the categories of art. The increasing historical consciousness, with its need to document and define, affected perceptions. Artists and critics alike became captives of the idea of art history, tending to see the immediate with eyes more used to seeing from a great distance. Stylistic characteristics were attributed all too readily to disparate groups and the language of art criticism became identical with the language of art history. The serial artists, for instance, lent themselves willingly to the attributions of impersonality, even anonymity of their works, making the old art historians' dream of an art history without artists almost come true.

6

As the '60s shaded into the '70s the red hot vacuum visibly cooled. The word "recession" began to haunt the art world and the well-oiled machines for marketing and merchandising occasionally broke down. The historicizing approach of the previous decade also seemed to work with less efficiency. From the early '70s on, the actors in the art drama seemed to be looking for themselves with a slightly bewildered air. The upheavals of the late '60s subsided when the war in Vietnam stopped, and for many it seemed that certain battles had been permanently won. Those who were professional watchers thought they detected a subtle social change in the newly won permissions: cops could wear long hair and beards like their former adversaries, and radio and television programs were no longer free of four-letter words. Censorship of sex and violence in movies was defunct. In 1979 (August 12), *The New York Times* took stock of the previous decade, harking back to the extraordinary youth gathering at Woodstock, billed as a rock concert in 1969. Robert Reinhold wrote that "in the minds of many there, it was a victory celebration, the culmination of a decadelong youth crusade for a freer style of life, for peace and tolerance." Even though much of the political heat had dissipated, Reinhold said, the counter culture had made a permanent mark on the nation. In Pittsburgh, for instance, a working-class city, there were only two bars for homosexuals in 1969 whereas ten years later there were a dozen, plus two churches and five activist groups catering to homosexuals. Natural food stores had spread from coast to coast. A poll taken in 1979 found that 55 per cent of the population saw nothing wrong with premarital sex. The proportion approving the full legalization of marijuana had doubled in the decade.

Such shifts in social attitudes inevitably make their impact on the arts. Before World War II it had been generally considered a disaster if a young person decided to be a painter or sculptor. Parents regarded

the arts as economically unfeasible and were wary of artists as non-productive, often freakish, outcasts from society. A long campaign in the art press for the validity of American art, plus the disturbances of the '60s, contributed to a change of attitude. It was no longer considered wasteful to study art. In fact, there was a possibility of fame and glory, even if for only five minutes, as Warhol said. All over the country, colleges and universities were adding art departments and museums. Even the book industry flourished with new divisions for art textbooks, and the lecture circuits buzzed with art lectures.

In the cultural discourse the value of heterogeneity was asserted with increasing fervor as standardization through the media became ever more apparent. The paroxysm of the '60s had induced the young to look upon the older generations with distant contempt. They were no longer talking about flowers and extolling communes, but they knew that the generation gap was definitive, and they had no less an authority than Margaret Mead, the eminent anthropologist, to assure them they were right. In 1969 at the New York Museum of Natural History, Miss Mead had outlined her theory of the generation gap (later published as *Culture and Commitment*), in which she asserted that "none of the young, neither the most idealistic nor the most cynical, is untouched by the sense that there are no adults anywhere in the world from whom they can learn what the next steps should be."

Among young artists a need to break out of the codified movements of the '60s was expressed in works that flaunted the avant-garde rules. They needed to repudiate the suffocating documentation and endless exegeses offered by critics and curators. Some of them responded to the academicization of art much as the Beats had once responded to The New Criticism, tilting full force against it. They watched with suspicion the successes of those slightly older. There had been a curious fluctuation of the art market in recent years that reflected both recession and inflation which, according to one analyst, "pressured art into the role of an international 'ersatz' currency," as illustrated by the sensational Scull auction in which Pop art dominated, and Jasper Johns' map painting fetched $240,000.[53] Younger artists found all this exceedingly disturbing.

One of the effects of the new uncertainty was the effort on the part of artists to wrest authority from critics, curators and dealers. Many artists began to write in the journals, serving as their own art critics, and some became keenly interested in theorizing. The change in the intellectual climate was pronounced. Once, artists had quoted philo-

sophers such as Alfred North Whitehead, whose romantic attitude toward the arts and emphasis on process had suited the Abstract Expressionist generation of rebels. "Philosophy is akin to poetry," he had written in 1930, "and both of them seek to express that ultimate good sense which we term civilization. In each case there is a reference to form beyond the direct meanings of the words."[54] The new generation was not convinced that there could be a form beyond the direct meaning of words or images. They were convinced, on the contrary, that the direct meanings were difficult enough to apprehend without calling upon that which is beyond. As for poets, their tastes diverged from the older generation who had looked to Wallace Stevens with such respect. His lecture at the Museum of Modern Art in 1951 on the relations between painting and poetry had been pondered and quoted for years after. But the new generation could not respond to such ideas as he proferred in that lecture:

the paramount relation between poetry and painting today, between modern man and modern art is simply this: that in an age in which disbelief is so profoundly prevalent, or, if not disbelief, indifference to questions of belief, poetry and painting, and the arts in general, are, in their measure, a compensation for what has been lost. . . . So regarded, the study of the imagination and the study of reality come to appear to be purified, aggrandized, fateful. How much stature, even vatic stature, this conception gives the poet! How much authenticity, even orphic authenticity, it gives to the painter! . . .[55]

Artists who had matured in the '60s were not given to orphic or vatic utterance. Usually, when they made allusions to the other arts or the humanities, they avoided poetry and veered toward scientifically oriented philosophy, systems theory, information theory, cybernetics or anthropological structuralism. If they cited philosophers, it was above all Wittgenstein, but not the side of Wittgenstein that almost verged on the metaphysical. In him they saw, rather, a realistic logician impatient with the ambiguities of romanticism. His "language games" fascinated them precisely because they seemed to eliminate those vague forms Whitehead could discern beyond the direct meanings of words. More than a few artists saw in Wittgenstein's idea of language as a game, and art as a language game, a valid esthetic, and cited him frequently in their statements.

Oyvind Fahlstrom, for instance, stated that his work was based on the "character-form" which is recognized when repeated, varied or

83 OYVIND FAHLSTROM *Exercise (Nixon)* 1971

"dressed." This approach, equating art to the structure of language, "implies a balance of partial significations amalgamating into a new and nameless yet prodding signification."[56] To act out the game Fahlstrom would sometimes take comic-strip "character-forms" that he cut out and magnetized, place them on a magnetic surface and invite the spectator to move them about or dress them. Despite his choice of popular imagery, Fahlstrom always proposed an underlying theme reflecting the human condition, or his observations of real events. He was often pointedly political and didactic. All styles and techniques, character-forms, real objects, words, sounds could be related to a formal game of character, but his concerns went beyond the game. In 1973 he wrote in a catalog for his shown at the Moore College of Art in Philadelphia:

Like many people, I began to understand during the late 1960s that words like "imperialism", "capitalism", "exploitation", "alienation"

133

were not mere ideas or political slogans, but stood for terrifying, absurd and inhumane conditions in the world. Living in LBJ's and Nixon's America during the Vietnam war–culminating in the Christmas '72 terror bombings and Watergate–it became impossible not to deal in my work–once I had the stylistic tools–with what was going on around me; Guernica multiplied a million times.

Moral preoccupations of a similar order motivated Hans Haacke who had turned to the sciences for his concept of art. In his works of the early '70s he showed a dependence on systems analysis, experimenting with water condensation, simulated rain, and light conducting in order to induce his viewers to experience natural systems outside the scientific laboratory. His search for an order outside traditional esthetics led him to such works as planting grass in a gallery and watching it grow for the duration of the show, or tethering a goat on a grassy site and recording the patterns as the goat cropped the grass day by day. Like a number of other artists, Haacke sought to remove his work from the art-world context and turned for a time to the wilderness. In this the artists showed the same distrust of urban corruption, both physical and moral, that had once prompted writers and artists to support agrarian movements in the South in the '30s. Artists increasingly took themselves to woods, streams and meadows, performing little rituals of altering (such as inscribing symbols on trees, suspending decorative ropes through forests, building little rock piles in meadows) that were meant to alert their viewers to their new perception of ecosystems, with all the implications–artistic, social and political–such visions entail. More and more the environment was seen as an arena in which to perform a significant act, and more and more the world was seen as a kind of huge fourth-dimensional chess game, where a move on any of the levels would affect the entire configuration. The deepening concern with environment was expressed in two ways. Sculptors in the "primary structure" mode, such as Bladen, Grosvenor, Walter de Maria, and the neon-light artist Dan Flavin, sought to convert public spaces into total environments in which the work would dictate the total perception of the space. Others worked in more delicate ways to encompass their viewers. Eva Hesse, for instance, worked with Fiberglas, polyesters, and latex, creating large diaphanous hangings that would softly inflect the light of enclosed spaces, while Richard Tuttle worked with small and few elements that he placed strategically in very large spaces, showing how he could tie up the whole cubic interior with invisible relationships.

84 ROBERT GROSVENOR (l–r) *Wedge* and *Tenerife*
Installation at The Dwan Gallery, Los Angeles, 1966

85 DAN FLAVIN *Greens Crossing Greens* Installation at The Dwan Gallery,
New York, 1967

86 EVA HESSE
Tomorrow's Apples
(5 in White) 1965

87 RICHARD TUTTLE
Installation, 2nd
change, at The
Whitney Museum of
American Art, New
York, 8 October 1975

88 ROBERT SMITHSON *Spiral Jetty* Great Salt Lake, Utah, 1970

A somewhat different environmental approach was advanced by Robert Smithson. He began with an avowed interest in changing the terms of art discourse. His serial pieces were grounded in mathematics and physics, from which he often borrowed terminology. He was particularly interested in the concept of entropy and referred to its effects in many of his statements. In a way, the works he presented to art audiences served him as instruments for an inquiry into the nature of time and the effects of entropy which he saw in the light of P. W. Bridgman's definition: "Like energy, entropy is in the first instance a measure of something that happens when one state is transformed into another." As a theoretician Smithson was deeply impressed by the archeologist-philosopher George Kubler, who suggested that metaphors drawn from physical science would be more suitable for de-

scribing the condition of art. (A young artist, Mel Bochner, would write later that "the entire language of botany in art may now be regarded as suspect," adding that such words as classic, romantic, expressive, analogy, individual and biomorphic "are not tools for probing but aspects of a system of moralistic restriction.")[57]

Smithson's assault on conventional definitions of art commenced in the mid-'60s with essays in which he repeatedly, but not systematically, called attention to the staleness of the modern esthetic vocabulary. He looked at New Jersey, with its wasteland of detritus forming a huge gulf between itself and New York, and saw in its wilderness moments of beauty. These moments he tied to an immemorial past, conjuring visions of mysterious ancient earthworks, such as that on Salisbury Plain, or the *nuraghe* in Sardinia, and suggesting that the entropy-ridden present would fade into a stony or ashy or earthy future resembling the immemorial past. His drawings frequently also resembled fantastic ruins from Bosch to English gardens. Or they alluded to Jorge Luis Borges' conundrums. There are in Smithson's visual vocabulary mazes, forked paths and spirals, as well as buildings that are like architecture, but vanish in mirror images, as did Borges'. Smithson's most memorable monument is the "Spiral Jetty" of 1970, in which he built a huge stone jetty in the Great Salt Lake which, to the delight of commentators, eventually rose up and concealed it. This jetty, like most of Smithson's outdoor works, was photographed from above and resembled the ancient mysteries that no archeologists can decipher. Called by another artist, Will Insley, a "second Atlantis," the "Spiral Jetty" soon became the rallying point for all the earth artists who sought to combat inherited conventions. Much of Smithson's meditation was in the direction of "anti," as for instance when he thought about anti-Gestalt. Speaking of a slate quarry, he said that "all boundaries and distinctions lost their meaning in this ocean of slate and collapsed all notions of gestalt unity." He was aware of the paradox that when he completed a work, he necessarily founded a new Gestalt, and it was with this paradox that his life closed in a plane crash in 1973.

Perhaps the most ambitious earthwork was completed in 1969 by Michael Heizer in the Nevada desert. Heizer selected two mesas for "Double Negative" and, as described by Rosalind Krauss, dug two slots each 40 feet deep and 100 feet long into their tops. The two mesas, sited opposite one another, are separated by a deep ravine. "Because of its enormous size, and its location, the only means of experiencing

89 MICHAEL HEIZER *Double Negative* Virgin River Mesa, Nevada, 1969–71

this work is to be in it—to inhabit it the way we think of ourselves as inhabiting the space of our bodies." But this is difficult, Krauss says,

for although it is symmetrical and has a center (the mid-point of the ravine separating the two slots), the center is one we cannot occupy. We can only stand in one slotted space and look across to the other. Indeed, it is only by looking at the other that we can form a picture of the space in which we stand.[58]

By extending the horizons of the viewer, Heizer introduced substantial questions into the discourse on "sculpture" during the '70s. For those who could not travel to the Nevada desert, there were documentary photographs. But photographs can only hint at the actual experience, as Krauss describes it. And photographs cannot stand alone, if the enterprise is one that will change the terms of discourse. Accordingly, there arose a flurry of discussion, much of it carried out in a new art magazine, *Avalanche*, that was founded in 1966 precisely to air the views of artists at work in far-flung, isolated places,

and to suggest the new terrain on which esthetic battles would be fought in the future. Needless to say, the financial circumstances of the nation at large had bearing on developments in the earth-art movement. Patrons who would underwrite the shifting of entire mesas on the desert in the '60s were slow to come forward once the economic recession made inroads.

While Smithson, Heizer, Richard Serra and Carl Andre were moving out into the field, finding unaccustomed sites to carry on their activities as artists, others were bringing the minimal esthetic to its apogee. The principle of entropy, with its seeping loss of energy, could just as well be represented in the conventional places, such as museums and art galleries, and in the conventional format of painting. Brice Marden, for instance, dimmed the energetic properties of color by

90 BRICE MARDEN *Conturbatio* 1978

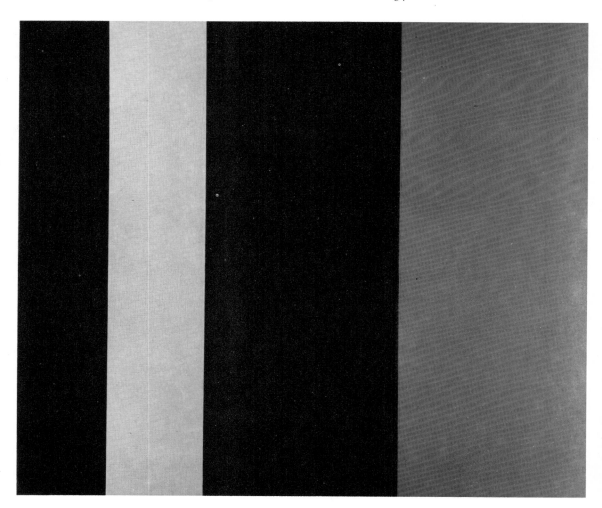

mixing it with wax, producing surfaces with only the barest hint that an activity had taken place. Marden's tonal paintings, in which he measured out microscopic doses of different quantities of light, were based on an esthetic of restraint. The minute and subtle contrasts between two nearly equally tonal canvases provided him with enough concentration to paint similar works for many years. The very elusiveness of his color (is it gray? green? tan? mauve?) provided him with a subject that he did not relinquish. Like other minimalists, Marden accepted the serial vision and often worked with a grid in his drawings. The same principles seemed to function in the works of Robert Ryman, who was haunted by Malevich's white-on-white polemic, and Robert Mangold. Harvey Quaytman, on the other hand, imposed shapes— usually two shaped canvases, one like the runner of a sleigh, the other upright like a cathedral window—on which he painted thick and organically active surfaces. His color was also minimized, but the heavy impasto surfaces were reminiscent of the sand, stones and earth that artists were bringing back from the wilderness and installing in sequences in galleries.

Certainly these attempts to dissociate the language of visual art from all previous assumptions, and most particularly from the humanists' vocabulary, helped to stimulate critical theory. The approach in which a theory is proposed as the basis for the process of creating a work of art soon found a label, "conceptualist art." There were those who protested. Harold Rosenberg in 1972 complained that contemporary criticism, "instead of deriving principles from what it sees, teaches the eye to 'see' principles."[59] Even in those arts such as painting, in which Rosenberg had seen process as endemic to expressivity, there was a tendency to adhere to *a priori* principles that could justify the emphasis on concept. In the beginning the term "conceptual art" covered a variety of manifestations, ranging from the wielding of words alone, which were then mounted on gallery walls, to the construction of carefully plotted sculptures on modular principles. In addition to Smithson and Judd, there were prominent artists stoking the theoretical fires—such as Robert Morris and Sol LeWitt, with an occasional aside by Carl Andre. Morris, who had once studied engineering and also had an advanced degree in art history, had begun his exhibiting career in the early '60s with objects that baffled viewers. His use of industrial materials from plastics to felt, and his combinations of hard and soft, word and object, were calculated to keep his viewers from divining the esthetic from which they issued.

91 ROBERT MORRIS Installation at Leo Castelli Gallery, New York, 1968

92 CARL ANDRE *Plain* 1969

This could only be known through his written commentary, which he commenced in the mid-'60s, drawing upon such sources as newly revised Gestalt theories and linguistics. Like Smithson, Morris was interested in time and history, and sometimes tended toward the mythical, as when he built a maze. But on the whole, his allusions were to modern sciences or pseudo-sciences. In his analysis of the works of the period he spoke also of his own work, reflecting the general attitude of minimalists, and attacking the interior relationships within works of art (as Smithson had attacked Gestalt):

The better new work takes relationships out of the work and makes them a function of space, light, and the viewer's field of vision. . . . One is more aware than before that he himself is establishing relationships as he apprehends the object from various positions and under varying conditions of light and spatial context. . . . For the space of the room itself is a structuring factor both in its cubic shape and in terms of the kinds of compression different sizes and proportioned rooms can effect upon the object-subject terms.

Morris saw in the new three-dimensional work common morphological elements such as symmetry, lack of traces of process, nonhierarchic distribution of parts, and, in keeping with his Gestalt argument, "general wholeness." For Morris, the forming of something which would then be called three-dimensional work was a manifestation of "behavior." Certain of his arguments were clearly based on wide reading in behaviorist psychology. "The detachment of art's energy from the craft of tedious object production has further implications," he wrote in 1974. "This reclamation of process refocuses art as an energy driving to change perception."[60]

Sol LeWitt, who was not averse to paradox, denied that the new art was in essence theoretical. Although his own modular sculptures were created in a rigidly prescribed order, based on a grid and the properties of a cube, he maintained that the nature of his own work was "intuitive":

In conceptual art the idea or concept is the most important aspect of the work. When an artist uses a conceptual form of art, it means that all of the planning and decisions are made beforehand and the execution is a perfunctory affair. The idea becomes a machine that makes the art. This kind of art is not theoretical or illustrative of theories; it is intuitive, it is involved with all types of mental processes and it is purposeless.

93 SOL LEWITT *Cube 15.25* 1967 (executed 1972)

Behind LeWitt's argument lurks the idea that the idea alone is worth consideration in terms of art—a permission that enabled many conceptualists to merely inscribe their "idea" on a paper, frame it and exhibit it. But LeWitt was primarily interested in process:

> If the artist carries through his idea and makes it into visible form, then all the steps in the process are of importance. The idea itself, even if not made visual, is as much a work of art as any finished product . . . Conceptual art is made to engage the mind of the viewer rather than his eye or emotions.[61]

Yet LeWitt's own work, with its delicate articulation of simple units, often painted a luminous white, engaged the eye and, one could even say, the esthetic emotions of his viewers. Later, when he undertook wall paintings in which he wrote detailed instructions for anyone, including school children, who wanted to make a LeWitt wall, he still tended to bedazzle the eye. The "concept" of the wall painting, or

144

94 ARAKAWA Study for the *I* 1978–79

certain of what he called his book works, was never as interesting as the visible results. He always spoke of carrying through his idea into visible form, but he influenced others whose preoccupations took them far from visible form. Artists concerned with art and language insistently saw the two forms of communication as interchangeable. They tended to use both as the materials with which to annotate contemporary trends in philosophy or language study.

Perhaps the most subtle and challenging practitioner of the fusion of linguistic symbols with the painted image is Arakawa. His paintings, in which solitary words or phrases are illuminated by mysterious linear projections, always pique the imagination and stimulate the eye. Arakawa's engagement with Wittgenstein's play-theory takes him far into the traditional realm of visionary painting.

In its sparest form, this type of conceptual art appeared in the printed texts that were framed and presented in galleries. Sometimes they were accompanied by snapshots and statistical data. In the

commentary published in art journals there were references to A. J. Ayer and Ludwig Wittgenstein. Artists such as Mel Bochner and Dorothea Rockburne not only leaned on the works of the philosophers, but also derived many motifs from the principles of advanced mathematics. Others introduced photographic narratives with legends that were meant to transcend national boundaries. Artists all over the world began to make extensive use of the Xerox machine, printing their messages and sending them off to all corners of the earth. Douglas Huebler, for instance, devised several projects in which certain acts would be performed by colleagues at the same moment in Paris, Amsterdam and California; would be duly registered with cameras and written documents; and would then be assembled as "the work." These international art-and-language games served not only to make a collective force against the absorption by art worlds, but also to politicize their practitioners. Easy access to such electronic marvels as the reproduction machine made it possible to undertake long-distance exchanges of ideas and works. In some countries, it was the indispensable tool of protest and a way for artists to remain in contact with the creative world when the frontiers of their own cultures were firmly closed.

Underlying much of the art and commentary of the '70s was a renewed interest in the social and political contexts of art. The feverish activities of the late '6os, in which many cultural phenomena were called into question by the New Left, had prepared the ground. Young writers in the crucial year of 1968 were deeply impressed by

95 MEL BOCHNER *The Theory of Sculpture.* Demonstration No. 6 (Commutativity) 1972

96 DOROTHEA ROCKBURNE *Drawing Which Makes Itself* (part of the series)
1973

Herbert Marcuse's revelation of one-dimensional man and sought to
incorporate his analysis in their assessments of American culture. In a
modest quarterly, *Radical America*, the issue of radicalism and culture
was discussed, with rousing exhortations to change even the traditional
Marxist analysis. One writer suggested that culture in the era of mass
media had become an instrument of oppression, and was no longer
an epiphenomenon of the struggle for a better society, but its very
center. He described the devolution of high culture into mass culture,
pointing out

1. that high culture has lost its transcendent spirituality
2. that it has been metamorphosed into a fetishized object
3. that it has become subject to the laws of the market, thereby losing
its autochthonous value
4. that it has become tangled in the web of technology in ways that
harm its very essence.[62]

Another writer opens his article with a quotation from Goethe:

Auch die Kultur, die alle Welt beleckt,
Hat auf den Teufel sich erstreckt.

(The culture that is licking away at the whole world
has also extended to the devil.) [63]

As the diabolic face of culture became increasingly apparent to artists in large American cities during the '70s, there was a revival of the spirit of the '30s, with small groups of artists meeting to discuss art and society, and critics reviving Marxist terminology. In broad terms they rejected the concept of an immanent art history in favor of an art history contingent on social and political structures. Even critics who had stayed within formal or impressionist boundaries seemed ready to broaden their framework of discourse during the '70s. It was noticed that no matter how much museums might quote their mounting attendance figures, there was still a striking gulf between contemporary art and the broad public. Lucy Lippard recognized the perturbation of the uninitiated when, for instance, they saw "a tall white room, high over Lower Manhattan, empty, even of light fixtures and window frames; wind, air, sky fill the space." She was reporting on an "exhibition" by Michael Asher, and said that, for her, the show was "moving, and beautiful, articulating interior and exterior spaces, their boundaries, mergings, light and shadow, into a particularly subtle experience." For the general public, however, "there is, indeed, nothing there." Even when, in the '60s, there were determined movements to elude the circuits of gallery, fashion, publicity, museums, the effects, Lippard admitted, were less than satisfactory:

For the most part, however, contemporary artists who have ventured "out there" and found sites and sights to revitalize their art have been more successful in bringing these awarenesses back to the art world than in bringing art out to the world. For example, when so-called Conceptual Art emerged around 1968, it was welcomes as a blow at the "precious object," but none of us took into account that these xeroxed texts or random snapshots documenting ideas or activities or works of art existing elsewhere would be of no interest whatsoever to a broader public. They were, in fact, smoothly absorbed into the art market and are now only slightly less expensive than oils and marbles. [64]

Aware of the all but unbridgeable gulf between the broader public and the well-meaning art community, a group of artists formed the Artists Meeting for Cultural Change in 1976 to "provide a forum for the examination of the political nature of culture–how it is used, how

it uses us." One of their accomplishments was the publication of "An *Anti* Catalog" in 1977, in which they protested the exhibition of the John D. Rockefeller III collection of American art in the Whitney Museum. In their statement, the group argued that the exhibition "reflects the class bias inherent in the institutions of 'official' culture" and that "these institutions – the Whitney, the Metropolitan Museum, the Museum of Modern Art – are controlled by a corporate-government elite." They denied that museums select their exhibitions on the basis of intrinsic merit, pointing out that official culture, through its monopoly of cultural institutions, defines what is and what is not art, and that "under the cover of the neutrality of art, official culture certifies the claim to power of those who now possess it." In the documentation presented, the issues of Black art and women's art were raised as well as the historical distortion in a collection in which the poor and disenfranchised are never represented. As the young radicals in the late '60s repeatedly said that culture must undergo a severe critique, so the artists in this 1977 publication asserted that "The critical examination of culture is thus a necessary step in gaining control over the meaning we give our lives."

While these discussions took place, an increasing despair that they could ever be resolved gripped some of their participants. Many understood that the critique required could not be undertaken in the old Marxist framework: after all, Marx wrote at a time when the printed word was the principal means of communication and did not have to take into consideration the corporate controls of television and motion pictures. They also understood that with each step in their individual careers they would be forced to make painful compromises. For many, the result was a return to the perpetual isolation that had characterized the modern artist since the early 19th century. Each time he stepped out, as in France in 1830, 1848 and 1870, the artist was thrust back by the vast disappointments that followed revolution. In the 1970s, many artists were aware that the forces which had contained the rebellion of the late '60s had managed to survive intact. No matter how enthusiastically artists had banded together in common causes, no matter how much street theater or public exhibitions were subsidized by the government, the same old elite seemed to control culture. In the face of such powers, many artists who had temporarily engaged themselves in the fight for cultural change returned disheartened to their studios and their solitary ideological battles.

7

Taking stock of the mid-'70s, the poet and literary critic Roger Shattuck commented harshly that contemporary art looked increasingly like a frame-up:

Trivial or ghastly objects are placed in an "art" context and are certified as works of art. When its most publicized events resemble a conspiracy to defraud the public of any continuity of understanding or canon of taste, art has little identity left. The avant-garde ideal that has sustained it for decades is as vulnerable to revision as kindred concepts of progress and growth.[65]

Six years later, Robert Hughes, art critic for *Time* magazine also noticed the eclipse of the avant-garde ideal, writing a concise history of its failure to resist bourgeois assaults on its integrity. "The Seventies are gone," he wrote in 1980, "and where is their art? Nobody knows."[66]

If the Sixties were years of orthodoxy and competing rigidities, the Seventies were pluralistic. Every kind of art was suddenly permitted to coexist, from videotapes to watercolours of Massachusetts ponds. This happened because artists stopped scrambling for a place where they would be visible as the latest incarnations of modernist history. The idea of a "mainstream", that narrow Jordan beloved of formalist criticism in the Sixties, vanished into the sand. . . . By 1979 the idea of the *avant-garde* had gone. This sudden metamorphosis of one of the popular clichés of art-writing into an unword took a great many people by surprise. For those who still believed that art had some practical revolutionary function, it was as baffling as the evaporation of the American radical Left after 1970.

But ideas exist for as long as people use them, and by 1976 "*avant-garde*" had been largely replaced by another vogue-word, of troublingly uncertain meaning: "*post Modernism*".

As Hughes understood, the post-modernist label had become just as much a cant word as avant-garde, and yet it did indicate a new

mood of indifference to a hundred years of drum-beating pro-
gressivism. The avant-garde was taking stock of its own shortcomings.
There were signs of complete disaffection with the rhetoric emanating
from museums and art publications, and many artists undertook sober
reflection concerning their possibilities. Eclecticism began to seem the
only way to escape from historical determinism. Although militant
artists during the '60s had tried to change the critical vocabulary, had
tried to eliminate the organic ideal and line up with forward-looking
sciences, had tried to remove themselves from the institutionalization
of art, it had not worked. The new vocabulary didn't stick. Science
and technology moved faster than artists. And even the Nevada desert
was not far enough away. Artists following in the wake of the theore-
ticians of the '60s could only look the other way. They sought to elude
the previous contexts and to assert their right to choose from countless
idioms and media, regardless of the tidy categories that had been
handed down to them. One of the many paradoxes they had witnessed
was that the very artists who had heralded a new era of independence
by removing their works from the confines of museums became prey
to an increasingly effective star system. There was little room for
newcomers during the '70s, when what Carter Ratcliffe referred to as
"blue chip dealers" had to consolidate their gains. There was a
recession during 1974–75 that made it imperative for these dealers to
pump up the reputations of the biggest names, leaving little margin
for the development of new "stars."

Recession also brought about a shift in museum policies. There were
fewer efforts to chronicle events in the avant-garde. Instead there were
august exhibitions of the great modern masters, or previously under-
explored modern movements. By means of large publicity campaigns,
tie-ins, and other practises borrowed from the communications tech-
niques of commerce, museums attempted to recoup their losses in
patronage. They also, like many art dealers, looked to avant-garde
traditions that had not yet been thoroughly exploited. One of the least
documented was the Russian avant-garde of pre- and post-Revolu-
tionary periods which, in the '70s, became a new field for exploitation.
For the first time, publications in English explained those phenomenal
developments, and museum exhibitions featured works by Lissitsky,
Malevich, Tatlin and other early Russian vanguardists. The lingering
interest in minimal art was converted into an interest in the theoretical
foundations of the past. In art reviews, new attention was given to the
Russian formalist critics who, while their interests had been primarily

literary, had mingled intimately with the visual artists, collaborated with them and helped to shape their conceptions of form. How such intense collaboration branched off into the idealism of Malevich in the visual arts, the near-Dadaism of Khlebnikoff and Khrushenick in poetry, and the scientific bias of structuralism in language became particularly interesting to the Americans. The articulation of certain of the conceptualists found authority in the Russian formalist Viktor Schklovsky, whose writings were published in English in the '70s. Schklovsky, with his complex and subtle theory of "defamiliarization" of objects, had already—as Robert Morris and Sol LeWitt did later—posited certain artistic effects in the act of perception. He maintained that art exists so that one may recover the sensation of life:

It exists to make one feel things, to make the stone *stony*. The purpose of art is to impart the sensations of things as they are perceived and not as they are known. The technique of art is to make objects "unfamiliar," to make forms difficult, to increase the difficulty and length of perception because the process of perception is an aesthetic end in itself and must be prolonged. *Art is a way of experiencing the artfulness of an object; the object is not important.* [67]

Such past theorizing consoled those who had felt that the disarray of the '70s was intolerable. There seemed, after all, to be a possibility of continuity. Although Shattuck complained that the public had been deprived of any continuity of understanding, or canon of taste, artists were casting about for the means to provide it for themselves. The decade of the '70s certainly showed that the retrieval of lost values was of prime concern, despite the triviality of so much that was visible in galleries and museums. Scavenging in art history has its scholastic hazards, but for many sensitive artists it was a means of affirmation in a bewildering welter of pseudo-theories. At the same time, such foraging in the past could also be perceived as reactionary, heralding a period of non-critical, spineless floundering. The Whitney Museum distracted attention from the deeper issues of such retrievals by staging a large exhibition, "Art About Art," that emphasized the new tendency to borrow and paraphrase. In a brave attempt to rescue deeper meanings, the art historian Leo Steinberg tried to give the show a positive significance by calling it "a blow struck for intergenerational fellowship." The blow, all the same, seemed feeble. As always, works in which sources were not paraphrased or parodied, but intimately ingested, were far more credible than those in which the commentators could develop elaborate sets of references.

152

Those experiencing the confusions of the '70s had the distinct feeling that a spirit quite different had overtaken the art world. In relinquishing the old modern ideal of vanguardism, the art community had gained, on the one hand, a kind of intellectual independence, and on the other, an uneasy sense of retrogression that undermined a cohesive position. There were positive aspects of the new, unmoored feeling. For one thing, there was a new willingness to consider works by artists who had never sought to enter the lists of the vanguardists. An artist such as Richard Diebenkorn, who had worked in the best of the modern traditions with a reverent eye on the greater Western painting tradition, had always found appreciation, but had never been celebrated in the same way as the avowed vanguardists of his generation. During the '70s, however, Diebenkorn attracted the serious attention his highly developed work merited.

Although Diebenkorn had turned to figurative imagery after his initial abstractions, he had never deviated from an essentially sensuous, pragmatic approach to painting. His way was to test his feelings against his knowledge; to work on the canvas with the honest searching that he had seen the Abstract Expressionists develop into a working esthetic. It was not inconsistent, then, for him to retrieve the ambitions of his early abstractions when, in the late '60s, he embarked on the ongoing group of works he called the "Ocean Park Series." These paintings allude in the generic title to a part of California in which the light, the sea and sky are memorably Southern. Yet these are more than landscape paintings. They are synopses of all the imagery, all the rumination, all the painting problems, and all the sensuous responses Diebenkorn had ever known. In their clarity and rich allusiveness, they recall Diebenkorn's conviction, stated in 1957, that "what is more important is a feeling of strength in reserve—tension beneath calm."[68]

In view of such an ideal, it is not surprising that the modern painter who most inspired Diebenkorn was Matisse. One feels his deep sense of affinity with Matisse not only in the way he seeks to re-define the light of day, as it penetrates interiors and as it lies upon the landscape, but in his development of symbolic spaces. Just as Matisse avoids a literal rendition of perceived space in order to suggest a greater unity, so Diebenkorn in the "Ocean Park" paintings evolves a symbolic order that expresses a complex hierarchy of points of view. Most of the works establish a dominant, large, clear but inflected space that one seems to see from far above. Yet perspectives shift. In adjusting a

153

97 AGNES MARTIN Untitled No. 12 1977

delicate charcoal line, or a vertical plane of color, Diebenkorn allows
for an ambiguous reading in spatial depth. There are overlaps of color
planes, or of linear accents, that suddenly cast the spectator into other
climates. Diebenkorn compounds the sensation by using small
sequences of events moving at the painting's edge. These can be
narrow rectangular or triangular planes of more intense color, or
quick sequences of flickering shadows beneath an otherwise tranquil

surface. Diebenkorn's unerring choice of color and his instinctive feeling for the embodiment of daylight as it graces various surfaces give his "Ocean Park" works a quiet splendor few American painters have achieved. He has spoken, in his medium, about a kind of space and light that is lyrical, infinitely changeable, and unmistakably his own.

Another artist, Agnes Martin, whose works gained far-reaching respect during the '70s, worked in a distinct, lyrical way with Western space and light. After removing herself from New York in 1967, returning to New Mexico where once she had known great excitement scanning the desert, Martin endured a period of silence. Gradually, she regathered her forces and when she began to paint again, the delicate but strictly patterned grids had given way to a radiant response to the color and light of her New Mexican mesa. For the paintings of the mid-'70s, she limited herself to two basic colors plus white. The colors ranged from rose-to-ochre-to-orange, the natural colors of the mesa, to azure-to-turquoise-to-milky blue. They were applied in broad horizontal bands measured out according to the specific mood Martin sought to invoke. Often she left broad expanses of gleaming white gessoed surface as intervals between colors, and these intervals assumed a light-giving importance that embodied her conviction that "anything is a mirror." Although Martin's paintings were not naturalistic, they nevertheless referred explicitly to emotional responses to the expansive nature of the desert, and were, despite their strictly rectilinear compositional division, far removed from the strict formalities that dominated the thinking of the '70s.

Among painters who had quietly followed their own bent and had found a more cordial reception during the '70s was Stephen Greene. An erstwhile student of Philip Guston, Greene had gradually sublimated the symbols apparent in his earlier works. His thinly brushed canvases evoked a faint memory of such motifs as the ladder and nails of the Crucifixions of the Renaissance, but Greene had brought to his new work a keen sense of the hazards and tragic overtones of modern life.

The increasing perception that, despite all the radical departures from traditional means, painting was still a viable expressive means allowed for a kind of efflorescence that tended to baffle the well-programmed public. Instead of annunciations of new "isms" there were signs that the reporters of art news were prepared to accept heterogeneity as a normal state of affairs. Younger artists were freed

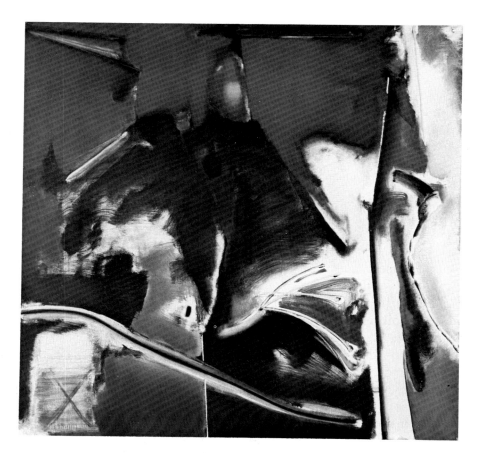

98 STEPHEN GREENE *Signature* 1979

from the imperative of a quickly identified style and several confidently
set about exploring domains that had only recently been looked upon
with disfavor. Painters in their thirties, who had seen the ravages of
historicist cataloging, struck out for their independence and won it far
more easily in the more tolerant '70s.

One of the most intrepid was the British painter John Walker, who
had set up his studio in New York and quickly entered the life of the
city's downtown regiment of painters. Walker's robust canvases, with
their heaving surfaces made up of various materials, including bits of
painted canvases and chalk, quickly established him as an artist
willing to re-examine the premises of Abstract Expressionism. He
readily admitted that the 1959 exhibition in England of New York
School painters, and most especially, Pollock's "Number 12," had
been the turning-point in his creative life. What he discerned was a
spiritual largeness that he has never ceased to regard as the most
important aspect of painting. Walker's immense energy brought him

through many exhaustive explorations: of Matisse's drawing and light, Rembrandt's shifting spaces, Velasquez's use of impasto, Manet's arabesque, Goya's somber symbolism, Pollock and Still's audacious refusals of tradition. But always with a keen sense of his own experience and temperament. Walker's example, in fearlessly adapting the masters of the great tradition, helped others to break free from received ideas and made of him something of the painters' painter that de Kooning had once been for others in downtown New York.

Jake Berthot, who had been schooled in the cool formalism of the '60s, also emerged in the '70s as a painter of independent habits. Abandoning his earlier mode, in which the grid and the graph were the principal means of organization, Berthot decided to begin at the beginning by grinding his own pigments and working as nearly as possible in the traditional techniques of oil painting. The shift from acrylic to oil necessarily dictated a different approach to the content of his work. Gradually he left behind the literal divisions of his rectilinear forms (he had used two or more stretched canvases within a single format) and began to experiment with depth illusion. Hints of landscape and horizon began to appear, along with surprising allusions to the great Romantic tradition as epitomized by Delacroix. These allusions to other times and spaces helped Berthot to fuse the seemingly warring impulses in him toward Expressionism and Classicism, and to work out procedures that enabled him to bring to fruition his deep intuitions concerning color and space.

99 JAKE BERTHOT *Walken's Ridge* 1975–76

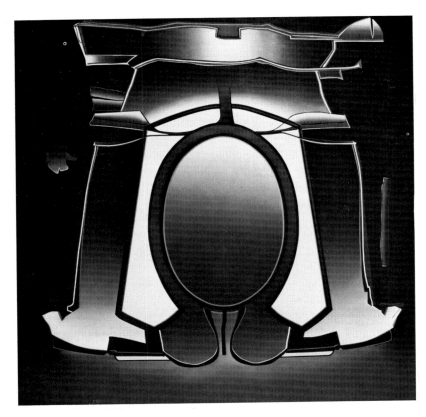

100 DEBORAH REMINGTON
Tudor 1971

101 PAUL ROTTERDAM
Substance 323 1979

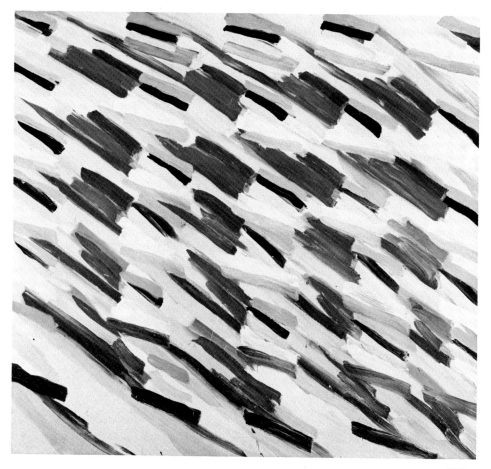

Others whose bold statements indicated their sense of freedom from stylistic strictures during the '70s were Deborah Remington, whose willingness to experiment with symmetry and symbolism that suggested the hard, artificial artifacts of modern life enabled her to develop a powerfully idiosyncratic style; Harvey Quaytman, whose experiments with shaped canvas and heavily encrusted surfaces gave way to an incisive condensation of pictorial events in the purist tradition; Paul Rotterdam, whose works of the '70s moved into austere tonalities, measured out and sometimes bounded by inserted elements; and Power Boothe, whose delicate studies of light through grid-like

lattices gradually changed into fully chromatic, highly charged and complex canvases that emphasized the sensuous, expressive potentials of oil painting.

Those watching how painting re-emerged in the '70s were startled by several seemingly radical shifts of position among better-known artists. Certainly the work of Philip Guston came upon the art world like a tornado, laying waste many comfortable assumptions. His opening sally occurred in 1970 when he exhibited the fruits of the nightmarish events of 1968: a group of savage indictments of violence, phrased in the quasi-satirical style that led so many commentators to recall his early beginnings as a caricaturist. As he continued with a long series of commentaries on everything from the corruption of the art world to the memory of the Holocaust, critics were forced to come to terms with his paintings and a few were able to see that Guston had brought together his abiding preoccupations, ranging from painterly construction to ethics, in a resounding, often theatrical statement.

103 PHILIP GUSTON *Source* 1976

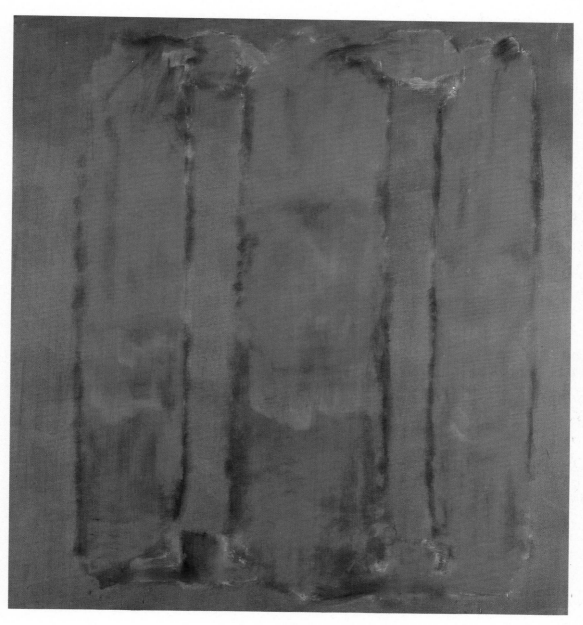

104 MARK ROTHKO Untitled 1960 (p. 99)

105 ROBERT MOTHERWELL *The Spanish House* (Open No. 97) 1969 (p. 105)

106 RICHARD DIEBENKORN *Ocean Park* No. 122 1980 (p. 153)

Toward the end of the decade, shortly before his death in 1980, Guston painted awesome, eschatological visions, an unending tale of terror and *terribilità*. He painted the edge of the world and the infinite. He painted himself sinking below the horizon like a spent sun, or his wife barely visible on a vast, unreachable horizon. He painted visions of the abyss, as in "Ravine," a darkling painting in siennas, umbers and wine reds that irresistibly recalls Goya. Here a squat mountain has a crest of animated shoes that slip and slide downward to the fearful vortex. In other works of the last years, Guston created a monstrous variety of heads that, like Samuel Beckett's talking heads on stage, are the most important member of the body. Sometimes they have mere winding sheets for bodies and sometimes no bodies at all, and always they speak of the despair that, as Guston reminded his viewers in a painting called "East Coker," T. S. Eliot had evoked in *The Four Quartets*. Harsh, unyielding visions that Guston's viewers were slow to assimilate: yet the intrusion of these paintings, so unlike anything New York had seen, finally began to seem important and Guston's solitary voice extended far.

Several painters of the next generation also startled the art world with notable shifts in style during the '70s. Al Held, who in the late '60s had begun to explore occult geometries in a lucid, draftsmanlike style, confidently produced huge black-and-white paintings that extended his researches into areas only timidly approached before. His "Black Nile" series was described by Marcia Tucker as translucent and atmospheric: "The geometry is so subtle that it no longer thrusts aggressively into space. Even the constant perceptual shifts and counterbalances are subdued."[69]

The subtleties available in abstruse geometries, with all their ambiguous implications of space and time, were expressed with great delicacy in Held's huge canvases of the later '70s. He had begun a series of "Solar Wind" paintings in which minute circles and triangles floated among the familiar geometric figures, producing illusions of endless space and complete disorientation in relation to earthly affairs. The dream of Kandinsky was realized in other terms: Held's carefully sanded surfaces become disembodied, while the linear plays on perceptual complexities are complicated by the random details. Held's interest in radioastronomy may have helped him to realize his new visions, for, as he pointed out, "non-perceptual, that is, physical objects can only be seen by being heard." The intonations are sensed throughout Held's paintings of the late '70s, where an authentic

◁ 107 PHILIP GUSTON *The Ladder* 1978 (pp. 160, 165)

165

◁ 108 FRANK STELLA *Guadalupe Island, Caracara* 1979 (p. 166)

109 AL HELD *Solar Wind III* 1974

romance, without Wagnerian overtones, engages his viewers with the cosmos.

If Al Held moved from warm to cool, Frank Stella unexpectedly moved from cool to hot. From a group of relatively formal low-relief constructions in the early '70s Stella shifted to a wildly Expressionist idiom, in which aluminum surfaces were painted in high colours, scribbled upon, incised, and generally filled with chaotic activity that

seemed very remote from his austere stripes of the late '50s. These constructions moved between painting and sculpture, and illusion and non-illusion, in disconcerting ways, leading Hilton Kramer to remark:

The paradox to be observed in Stella's new work is that it employs the impersonal methods and technology of the minimalists as a means of restoring the lyric element to abstract art. . . . In a sense, he had to abandon abstract painting in order to conserve and essentialize its very spirit. It is this accomplishment—so unexpected from the artist who once gave us those dour black stripes—that has made Stella the most interesting exponent of abstract art at the end of the 1970s.[70]

By contrast, Jim Dine restored the lyrical element to his painting by snatching back the prerogatives of the Abstract Expressionists. Toward the late '70s, he painted a series of still-lifes that resurrected both the old-master display of painterly bravura and the new-master display of irony. In 1979 Dine spent some time in Israel where he

110 JIM DINE *Jerusalem Nights* 1979

produced a large group of paintings called "Robes." They were, in fact, portraits of bathrobes, reminding us of his Pop art predilection for items of clothing many years before. But these robes were swathed in moody light, their folds highlighted with Rembrandtesque chiaroscuro, their surrounds darkly speaking of emotional secrets worthy of the Abstract Expressionists. While there is humorous tension between the banality of his subject and its romantic handling, there is little else in these paintings to relate to Dine's earlier work. His break with his own tradition is far more salient.

Traditionalists took heart in the '70s, and often spoke of "postmodernism" as a return to figurative traditions. The temporary vogue for what came to be called "photorealism," with its airbrushed imitations of photographs, often of banal subjects worthy of the Pop artists, gave way to an earnest discussion of realism as a contemporary alternative. Philip Pearlstein led the discussion, along with the brilliant art historian and critic, Linda Nochlin, and channeled it into respectable areas of discourse. Pearlstein's speculation that a new aggressiveness on the part of realists was based on "a rejection of Existentialism, the politically liberal middle-class philosophy of life we had grown up with," was associated with a kind of Hamletism in his mind.[71] The Abstract Expressionist painter lived with doubt and indecision, whereas the new realists set great store by knowing what they wanted to do and doing it with great precision. (Pearlstein may have overstated his case. Several realists of the Abstract Expressionist group knew what they wanted to do and did it with precision. Elaine de Kooning in her later portraits sustained her Expressionist impulse while being very precise in her configurations, as in her portrait of the Abstract Expressionist painter Aristedemis Kaldis.)

Pearlstein's vision of realism as a rejection of the values of the '40s and '50s was accurate, as applied to some of the best of the figurative painters. But perhaps the argument was too lofty in relation to the vulgar representationalism that flooded the galleries in the latter '70s. This inundation probably found its source in the eternal American problem known in art and politics as populism. The urge to find and use imagery with a broad popular appeal was particularly strong in the U.S. from its earliest epochs. Calendar art and *Saturday Evening Post* illustration exercised a permanent appeal, as the episode of the American scene painting during the '30s demonstrated. Much of the slick photorealism of the '70s fitted more readily with populist ideals than did serious realist painting of the kind Pearlstein was defending.

III JACK BEAL *The Harvest* 1979–80

Jack Beal, one of the most prominent realists, offered another specula-
tion concerning the shift toward realism:

I see a clear parallel between the current situation and the situation
that prevailed in Europe during the Mannerist period. Art at that
time became dominated by aesthetics, and painters allowed style and
sensationalism to dominate their work. Then along came the Carracci
and Caravaggio, to make art closer to life again. Oedipal avantgarde
Modernism is the Mannerism of our time – Pontormo revisited. Corot,
Courbet, and the Barbizon painters likewise rescued art from the
clutches of the French Academy.[72]

Unquestionably the more serious artists among the ranks of the
figurative painters worked with a keen sense of what Beal defined as

112 STEPHEN POSEN *Boundary* 1977–78

Mannerism and its invidious implications. A painter such as Stephen Posen, who was erroneously celebrated among the photorealists, was obviously working from a strong sense of opposition to unexamined avant-garde clichés. When Posen set about exploring the implications of photographic perception as opposed to the perception of paintings, his expectations lay in the realm of aesthetics. By juxtaposing a photographic image with real objects, Posen questioned the paradox of illusion. He set up what was, in effect, a still-life: a photographic black-and-white mural, sometimes of idyllic rough landscapes with random rock formations, sometimes of sections of the city, to which he affixed fragments of cloth, either in silken ribbons or billowing lengths of rich stuffs as if from a late Venetian baroque painting. This still-life was then studied minutely, and rendered on his canvas surface inch by inch from eye level. Posen worked like the Renaissance muralists whom he had studied and admired during a sojourn in Italy. In rendering the brilliant surfaces of satins, silks and velvets, using the classical system of local color, Posen set up a troubling illusion that played against the tonal rendition of his basic subject—the black-and-white photo. To locate the picture plane between these two systems of perception became almost impossible. The tension then, between two modes of perceiving light and space, became for Posen the most engrossing of esthetic mysteries, to which he devoted his eye with surpassing patience. What is left of "realism" in the unsettling images Posen paints is only a faint reference to recognizable data. Once the painting takes over, the viewer becomes engrossed in the contradictions, paradoxes, illusions, sleights of hand that have always characterized serious paintings and cannot be tied to the mere recognition of objects.

In sculpture, the realists found fewer adherents. Even sculptors who moved toward a figurative orientation were not often tempted by conventional realism. Stephen de Staebler, for instance, had worked with terracotta in abstract terms for some years before he undertook a large group of terracotta sculptures in which recognizable portions of human anatomy were carefully inserted. De Staebler's unique work, widely acknowledged on the West Coast but not well known in the East, combined a deep sense of history with a contemporary spirit. His largest pieces carried symbolic overtones, in which Egyptian pyramid carvings and Giacometti-like fragmentation are recalled, but never explicitly. Frozen and encased as they are, de Staebler's figures, moored in their earthy materials, seem a part of the dark thought of

171

the time; an expression of a specific malaise familiar to everyone alive after World War II. He has succeeded in making true symbols – a feat most artists find increasingly difficult.

Apart from George Segal's increasingly anecdotal effigies and Duane Hanson's waxwork figures, that made huge audiences gape with incredulity as they tripped over what seemed to be real-life characters in museums, there was little to note among orthodox figurative sculptors. Rather, sculptors broke loose from the strictures laid down during the '60s and worked with ever more freedom in abstract idioms. If anything, younger sculptors were determinedly interested in extending the implications of the sculptural revolution stimulated by Picasso just before World War I. Christopher Wilmarth, for instance, began to work with heavy plate-glass and steel, developing a delicate and intensely emotional style within the Constructivist tradition. His earlier work included many wall reliefs, in which the green-hued glass was etched to a cloudy, opaque surface, then laid against dark, unburnished steel planes. Often he "drew" on the glass surfaces with heavy steel wire that served both to maintain the tension between surface and base and to articulate the composition. These works, hovering between painting, drawing and sculpture, gave way to free-standing sculptures in which the weighty steel members were played against the evanescence of the glass planes. In the later '70s Wilmarth began a long series of works that he grouped under the title "Gnomon," in which he brought the conception of relief sculpture into a new domain. These large and commanding works were meant to move out from the wall into the room-space and yet to remain, altar-like, a function of the wall. For these, Wilmarth set himself strict rules. He cut the steel members in each case from a single large rectangle which he then bent and turned ingeniously. The single glass element, usually a large rectangular plane vertically suspended, became both a foil and an ambiguously moving counterforce. In juxtaposing these generously fashioned elements Wilmarth set up hundreds of virtual compositions within each sculpture thanks to the elaborate play of light and shadow. He had succeeded in fusing the formal concerns of the Constructivist with a great and personal lyricism.

Another startlingly lyrical sculptor, William Tucker, originally British, settled in the United States and began to work with deceptively simple, seemingly geometric forms to overthrow the simplistic vocabulary of the steel sculptors of the '60s. Tucker's use of eccentric geometries showed great invention. He would take, for instance, a

113 DUANE HANSON *Race Riot* 1969–71

114 WILLIAM TUCKER *Arc* 1977–78

simple "Arc," and play with its sweeping lines to convey not only associations with real things but also arcane allusions to geometry. The skeletal form stretching across a broad horizontal space can be read like a geometer's twisting ribbon or like the carcass of an ancient barque. It can pull the eye along its strophic hull into the spaces of the solar system, and it can hold the viewer fixed before its spatial shifts and fascinated by its six-inch point of equilibrium. Tucker's use of heavy timbers in some of the largest pieces also freed him from the vocabulary of the minimal steel sculptors, and enabled him to suggest lofty monuments in circumscribed spaces. The nature of Tucker's sculpture eludes categorization. He defines it as he goes along, thrusting out into two kinds of space—psychological and real. Although he works with few, carefully selected elements, each piece is an exploration of the possibility for a thing such as sculpture to have multiple meanings. Each new sculpture tests the limits, invents the limits of those things assigned by us to the space of sculpture.

Herbert George also tests limits, always cognizant of the elusive character of real space. His work of the mid-'70s consisted of often long, scaffold-like structures in which he suspended slender sheets of wood bent into partial ellipses, the understructures being elegant modifications of triangles. These were seen either as one paced their flanks, or like a tunnelling, illusory canyon as one stood at their ends. Later, George began to use billowing sheets of aluminum that were

115 HERBERT GEORGE *Visit and the Apparition* 1980

116 RAFAEL FERRER
Mr Equis 1978

cradled in their slender wood structures almost like musical instru-
ments. The movement of the parts then became almost fugal, suggest-
ing hallucinatory gliding into unaccustomed spaces. Still later, George
boldly incorporated small objects, such as a china teacup, that were
meant to establish scale as a key establishes scale in music. Or, as in
one large ensemble of 1980, he created a complex system of references
to the properties of classical Greek sculpture, most of them abstract
allusions to scale, perspective and just proportion, but vivified by the
inclusion of plaster reliefs of real Greek pedimental sculptures. This
mixture of history, figuration and abstract sculptural relationships not
only worked, but injected a note of liberation into sculptural discourse
that was very much wanted in the '70s.

176

The element of fantasy, in fact, gained enthusiastic proponents in the '70s, both in the domain of studio sculpture, easily exhibited in the new spacious galleries of SoHo in New York City, and in that of "site sculpture," a term used to cover a host of experimental and occasional works usually undertaken outdoors, in public spaces. Rafael Ferrer, whose relationship to the rhythms of Puerto Rico is stressed in his individual works and his installations, came forward with an art of mixed metaphors, a "messy" art as he said, in which structures such as tents, kayaks, and even a Latin café were exhibited in gallery contexts. Ferrer's seemingly naive art, with its rough surfaces, scribbles, garish colors and fetish-like objects, sprang from a temperament that regarded the imagination as essentially subversive. He occasionally spoke about his work, as for instance when he alluded to Antonin Artaud:

Further away than science will ever reach, there where the arrows of reason break against the clouds, this labyrinth exists, a central point where all the forces of being and the ultimate nerves of the Spirit converge.[73]

Ferrer's blast at the conformities of cosmopolitan art in some ways paralleled the efforts of Lucas Samaras, who characterized himself as a "slightly sadistic entertainer," and who regaled the world with thousands of works, some three-dimensional, such as his house of mirrors in which the spectator could enter and lose himself in the thousands of fragmented reflections of himself, and some two-dimensional, such as his pastels of isolated fragments, and his polaroid montages. Like Ferrer, Samaras insists on an element of autobiography that stresses his origin in another culture–Greece–and in oblique ways indicts the contemporary American culture in which it is unfolding.

Other artists whose fantasies were released during the '70s include Will Insley, whose hermetic models and drawings of a desolate Utopia repeatedly invoked metaphors of a dying culture. In his vision, the world is a silent, unpeopled place, closed off, cold and yet filled with a crystalline poetry that his elegant hand creates with sharp geometric references. Joel Shapiro, on the other hand, scattered his small effigies of houses on galleries' floors in a way to induce a sense of another world and other spaces that were not uncongenial or forbidding. Mixing both recognizable house-forms with abstract figures, Shapiro does

more than measure out spaces. He qualifies the spaces with subtle allusions whose content cannot be ignored.

When artists began to move out of galleries into leftover spaces, such as New York's Battery Park, or an island in the East River, or the landscaped estate that is the Nassau County Museum, there appeared the temporary form called "site sculpture," in which artists could erect pieces in a given environment according to their taste. Probably the exigencies of temporary installations in the outdoors inspired the use of temporary materials. Tom Clancy, for instance, once used blocks of ice which, as they melted, created sculptural patterns, and on other occasions used assembled plumbing pipes or slatted wood. Several artists adapted wood in order to make structures that appeared almost architectural, but were in fact essentially sculptural, as in the case of Jackie Ferrara, whose pyramidal ascents and descents recall ancient monuments, or Alice Aycock whose elaborate wood constructions suggest astronomical observatories. Such enterprises, involving public spaces, became more frequent during the latter part of the '70s thanks to increasing public funding, and earned sculpture at least a public tolerance that had not previously existed.

118 WILL INSLEY *Passage Spiral Hill Slip, vanishing point perspective, interior view* 1975–76

119 JOEL SHAPIRO Installation at the Paula Cooper Gallery, New York, November 1980

120 TOM CLANCY *Memoriam*
Installation in the central
mall of The Pratt Institute,
New York, April 1980

121 JACKIE FERRARA *A198
Tower : Bridge for Castle
Clinton* 1979

122 JAKE BERTHOT *Belfast* 1981 (p. 157) ▷

123 ISAMU NOGUCHI Hart Plaza, Detroit 1980 (p. 185) (color)

124 STEPHEN DE STAEBLER (l–r) *Standing Figure with Bow Leg* 1979 *Standing Figure with Yellow Breast* 1979 (p. 171)

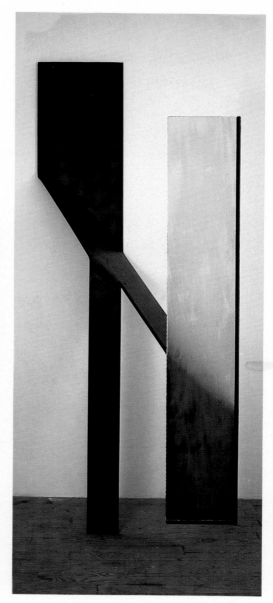

125 CHRISTOPHER WILMARTH *Gnomon's Parade (Peace)* 1980 (p. 172)

126 AGNES MARTIN Untitled No. 9 1980 (p. 92)

Among several large-scale public enterprises undertaken during the '70s was a superb work by the veteran Isamu Noguchi, who for years was one of the few artists who understood the function of public monuments, and who consistently strove to relate his sculpture to community life. In the Detroit Civic Center Plaza—a riverfront space with a backdrop of steely-faced skyscrapers—Noguchi created an amazing ensemble of symbolic forms that dominated such public amenities as a circular amphitheater, a small outdoor movie theater, a series of spaces that could serve as a bazaar or a festival row of stands, and multilevel terraces that lead to the waterside. The central space is a broad terrazzo circular plaza in which Noguchi has set a powerful stainless steel form which is at once a tough and expressive sculpture and a remarkable fountain. Water is cycled to burst forth from a central ring 30 feet in diameter and 18 feet above a granite tub, with plays that range from a glorious fog-like cloud to a powerful column-like geyser to a gentle umbrella-like spray. Through its prismatic configurations the viewer can see, at some distance, a tall aluminum pylon that seems to turn on its axis in different lights. Noguchi, in pacing out the spaces between fountain and pylon, intended to invoke a work that "emerges out of classical symmetry toward a controlled asymmetry." This large-scale work, with its complex details, was singularly successful. Visitors and the local populace alike have come to identify Detroit with its symbolic plaza. The problem, so earnestly discussed in many different circles, of relating art to the public, is admirably solved in Noguchi's work.

8

When Nietzsche surveyed the art of his time he found it wanting. He deplored, above all, the modern artist's dependence on spectacle and watched with distaste as audiences, gorged with Wagner's effects at Bayreuth, fell into a mass swoon. The modern artist, Nietzsche thundered, was counterfeiting. He must find a public that loves unconditionally, and he must always augment the element of spectacle in his work in order to do so. The artist

harangues the obscure instincts of the dissatisfied, ambitious, self-disguised spirits in a democratic age. [He] transfers the procedures from one art to the other arts, confounds the objectives of art with those of knowledge or the church or nationalism or philosophy—he pulls all the stops at once, and awakens the dark suspicion that he may be a god.[74]

While today's artist, steeped in irony, may not awaken dark suspicions concerning his godliness, he is often tempted to resort to spectacle to call attention to his talents. He is heir to Wagner's theory of the *Gesamtkunstwerk*, and also heir to Wagner's keen sense of the uses of publicity. Since Wagner's day the possibilities of diffusion have been vastly magnified and the temptations are ever greater. In the large area charted by artists who perform, sometimes called "intermedia art" and sometimes "performance art," there are obviously many differing attitudes, ambitions and esthetics, but Nietzsche's charge of counterfeiting cannot be entirely dispelled.

As a largely undefined category, the area of performance ranges from full-scale productions, in which visual artists join forces with artists in other disciplines, to videotape performances; from loft events, with various artists participating, to gallery exhibitions in which an artist performs rituals in person. Elements of the dance are incorporated into so-called "body art," while elements of music, videotapes and films are used in works performed in the tradition of Happenings.

127 ROBERT WILSON and PHILIP GLASS *Einstein on the Beach* 'Opera'
Photo Babette Mangolte

The most spectacular event during the '70s was Robert Wilson's
and Philip Glass's "opera"–a work faithful to the *Gesamtkunstwerk*
theory, incorporating the talents of artists in several fields. Wilson
himself doubles as a visual artist and theater man, and conceived of
"Einstein on the Beach" in a series of drawings. Glass, in turn, com-
posed the music from those initial drawings. The vast production
became an avant-garde event of momentous proportions when the
opera was performed at the Metropolitan Opera House on November
21, 1977 to a well-prepared audience of 4,000 people. The nearly
five-hour work, which as one writer quipped required a *Helden*
audience, was described by the *New York Times*'s critic:

Einstein has nothing to do, literally, with a beach (except for the
frequent presence on stage of a large white conch shell). On the beach
is meant in the apocalyptical sense. This is a dreamlike pattern of

landscapes and images suggested by Einstein's life and times. The play parallels his life span—from steam engine to rocket ship—and symbols and signs are drawn from his biography (such as his fondness for trains and boats) but this is an impressionistic portrait in which drama is only one of many ingredients. As with all works by Wilson, Einstein is an anthology of the arts.

The vastly expensive production made full use of the Metropolitan's equipment, including trapdoors and levitating wires, and was adorned with elaborate sets, designed by Wilson, ranging from a direct allusion to Magritte to the latest minimal modes in the new art centers of SoHo. Wilson's use of unassociated materials—fragments of dance, sculptural props hinting at symbolism, a handsome steam engine reminiscent of the halls of the Smithsonian Institution—tended more toward pastiche than an authentic *Gesamtkunstwerk*, but a hungry corps of journalists and critics were not unduly critical. Although the notion of a "dream play" was suggested, no one responded to the tradition traceable to Strindberg. Wilson's magpie mentality, his elegant and superficial adaptations of avant-garde clichés going back more than a century, were not noticed. A host of associations with past events remained unuttered in the hysterically rapt response on the part of *tout* New York. Critics might have mentioned Laban's dance innovations, Gertrude Stein's novel approach to opera, Schoenberg's *Sprechgesang* (in relation to Glass's use of solfeggio and numbers in place of words in his arias), Max Reinhardt's grandiose theater effects, the Living Theater's experiments in the '60s, and many other precedents, if only to be able to "place" Wilson's work and dispel the charms that had been cast by assiduous publicity long before the work was ever seen. Wilson's mystification and gorgeous spectacle were compelling in the very way Nietzsche had warned us modern art would be.

On a still more grandiose scale was an event that reaped vast space in the media—Christo's "Running Fence." The 18-foot high, 24-mile long white nylon curtain that spanned the coastal hills of Marin and Sonoma counties in California had taken three years to negotiate and complete. When it opened in September, 1976, its fourteen-day sojourn represented an incredible organization of forces and a staggering outlay of dollars that shocked the more puritanical residents of California. Christo's tactic, which he had invented for an earlier outdoor piece in Colorado, was to persuade, cajole and pay various members of the communities involved to believe that his event would be not only esthetically satisfying, but good for everyone involved.

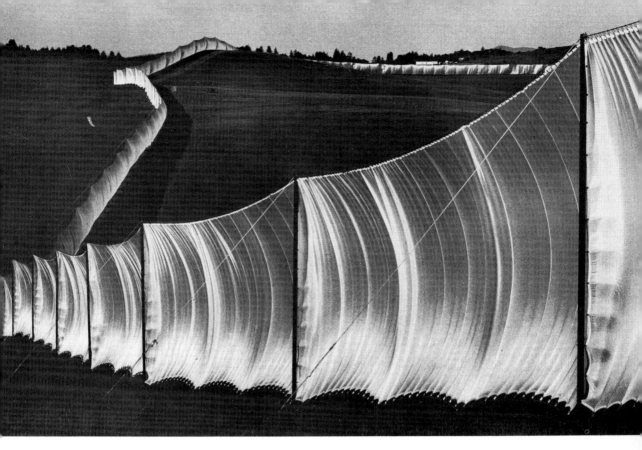

128 CHRISTO *Running Fence* 1972 Sonoma and Marin Counties, California

The running fence would bring tourists and tourist industry; would edify whole segments of the population; and would draw attention to the area in the extended coverage on television and the national press on which Christo could always rely. Christo's esthetic purpose, as he explained to various art interviewers, was to make the fabric ribbon of the running fence not a barrier, but a "catalyst." In referring to his rural outdoor projects, he spoke repeatedly about the "catalysis of the site" and about the two phases of his work. Initially, it exists only through his drawings and in the minds of people who are either trying to help him (numerous rich collectors and excitement-hungry donors of the upper bourgeoisie) or trying to hinder him (ecologists and irate artists, in the case of Marin and Sonoma counties)'. The second phase is always the making of the physical form, which also involves many people, as well as spectators who jeer or cheer. The "Running Fence" adventure, which involved complicated legal procedures, showed Christo to be a showman of stature whose ability to

function within the capitalist structure was unparalleled. Implicit in his approach is the desire to reach far larger audiences than most contemporary artists can hope for. His political impulses are far less evident than those of another surpassing showman, the German Joseph Beuys, but when they appear, they stay well within the boundaries set by capitalist mores. Basically his approach is sociological. He assesses the society in which he wishes to perform and he gauges its receptivity. He then sets out to change hostile attitudes by means of personal persuasion, holding out the promise of a fiesta which he usually fulfills. But such fiestas are, as Nietzsche would have said, counterfeit. They do not spring up from the deep sources beneath the surface of American social life, and they do not represent an authentic ritualistic need. The need is created by artificial means, and sustained in an elaborate structure that depends heavily on money.

129 ROBERT ISRAEL and PHILIP GLASS *Satyagraha* 'Opera', Rotterdam, 1980

There is no hungry, self-sacrificing community working for an ideal, as in the case of other spectacle makers such as The Bread and Puppet Theater, but rather professionals at work in every sense, and in every stage of the game.

Probably the most valid spectacle in which a visual artist can develop remains in the realm of almost conventional theater. One American sculptor, Robert Israel, early discovered the possibilities inherent in theater for his development as a "visual designer," and all during the '70s proved his case, designing productions of everything from Shakespeare to Alban Berg as total works in which every detail, from lighting and projected film clips to the smallest handheld prop, were elements in a single work. His most stunning creation was in collaboration with Philip Glass, an original opera performed in Amsterdam in 1980 to astounded and greatly excited audiences. Israel's participation echoes situations of the early 20th century, when, for instance, in Russia, prominent visual artists such as Malevich and Lissitsky saw the theater as an ideal arena for the expansion of their esthetic ideals.

A frequently observed tendency to spectacle occurs in the works of dozens of artists who depend heavily on the appearance of their persons in their events. A leader in this branch of intermedia art is Vito Acconci, whose events all through the '70s attracted attention. A marginal poet in the '60s, Acconci began his career as a visual artist with a series of photographs of himself doing various tasks, moving on, in the early '70s, to performance on film which he called "performing himself." Later his "self" appeared in more ambitious projects designed to engage the viewer as participant, sometimes in aggressive ways, such as when, in a 1972 piece, Acconci was hidden beneath a ramp in the gallery, masturbating and whispering sexual fantasies which the uneasy spectator could not quite locate. In later installations Acconci removed his "self" and produced ensembles of objects, often with menacing connotations. Certain of these pieces were announced as addressing problems of culture and society with motifs drawn from formal systems of knowledge such as sociology and philosophy, and popular sources such as New Wave music and punk rock. Acconci's rather vague political and social views are usually tailored to his sites. For instance, the abbreviated scenario for a piece in Milan in 1978 is

From now on we marry the fascists (or: the communist sex-machine)/ Balls on springs, aimed at entrances/my voice in Italian, pairs of

contrasts stopped by a middle-term/whistle, voice-mix of Italian and English: "Kissinger says: O Yes."

True to Nietzsche's prediction, Acconci transfers the procedures of one art to another and "pulls all the stops." His allusions to systems of thought and other disciplines, which once enfolded him within the ranks of the "conceptualists," are dark and obscure, but insistent enough to convince at least a portion of his public of their profundity.

The element of exhibitionism endemic to Acconci's art is not always a genuine search apparent among many so-called "conceptualists" and performance artists for ways to incorporate their intellectual understanding of the world with sensuous expression. Taking film, photography and language as materials, these artists compose works that are intended both to pique the minds of their viewers and to

130 VITO ACCONCI *The People Machine*
Installation at the Sonnabend Gallery, New York, April 1979

131 LEANDRO KATZ *The Lunar Typewriter* (from *The Lunar Alphabet Series*)
1979

arouse in them sensuous responses traditionally associated with the visual arts. Such artists often evince interest in philosophical propositions, attempting to translate them into a metalanguage that can resist the very logic of the basic propositions. Often they pick up hints from the works of predecessors, such as Duchamp with his arcane notations in the Green Box, or Giacometti and Magritte, both of whom played with disjunctions in meaning between nouns and things. The element of language play is pronounced, particularly in the work of Leandro Katz who has invented several alphabets, among them a typewriter whose keys are coded with phases of the moon, and in whose language Katz, an erstwhile poet, has composed pieces. Katz has made films, designed installations with audio effects, and used photographs in conjunction with words to illuminate his intimation that "outside the seduction techniques and mechanisms of the institution of syntax and sentence formation, elements of language are presented, with their constants and variables, as a system whose rules are always changing."[75]

While Katz and others are seeking meanings in fresh juxtapositions of language and imagery that are psychological and intuitive, seeking to tap the same affective resources that traditional visual artists

addressed themselves to, there are numerous other artists utilizing similar materials (made available by sophisticated technology) to purvey information, relate narratives, and broaden the cultural reference of their viewers. Certain of these artists, chafing under the restrictions of a narrow, *art pour l'art* esthetic, have tried to open windows to vistas that were previously all but forbidden thanks to their unsavory connotations. The attempt to find ways to integrate political information in works of art without stooping to propagandistic stereotype led invariably to mixed media. Language, printed, spoken or written, was essential to those artists whose sense of social responsibility was highly developed. New materials, often brought from the advanced world of technology, offered a freshness and an open-ended approach that traditional means seemed to have exhausted. It is true that such artists as Leon Golub, Rudolf Baranik and, to a lesser degree, May Stevens, still depended largely on the strength of their imagery in paintings and collages to express their indignation. And it is true that prominent causes, such as feminism, found expression frequently within the traditional areas of painting, sculpture and poster-making. But by far the most effective essays in the genre of social critique were produced by those artists who were willing to move outside the boundaries of given art forms.

Hans Haacke, for instance, developed his informational techniques in a cool, logical sequence that depended not only on techniques developed originally for use in the very industries he attacked, but also on theories, such as systems analysis, that were thought to be the exclusive domain of science and industry. Although he began with analyses of ecosystems, Haacke moved definitively into the realm of political and social commentary during the '70s. Almost all his projects had specific targets in the real world, and all were designed to disturb or disrupt the smooth functions of the institutionalized art world. Certain of his attitudes had been formed through his reading of the biologist Ludwig von Bertalanffy, who maintained that every living thing is by nature an open system, dependent for its stability on the inflow and outflow of materials and energy. The significance of Haacke's adaptation of Bertalanffy's theory to art lies, according to Jack Burnham, in "his ability to break down boundaries of existing art relationships":

There is a double bind in his strategy. Haacke is producing a fresh and perhaps historically inevitable art just as he is undermining the institutions responsible for the selling or collecting of fine art.[76]

132 RUDOLF BARANIK *Napalm Elegy 5* 1969

133 MAY STEVENS *Rosa* (from *The Rosa Luxemburg Series*) 1980

134 HANS HAACKE *Thank You, Paine Webber* 1979

Haacke's tactic is to use presentation techniques familiar to his audience through their daily encounters with high-powered publicity design and propaganda. When he presents a wall of statistics, they are designed with a brisk, businesslike authority. When he presents an anthology of the fatuous and hypocritical credos of tycoons, he engraves them on magnesium plaques, just as they would be done by the tycoons themselves for their upstairs quarters. When he offers information about the trafficking in high art, as he did both in Germany and New York in the mid-'70s, he mimics the grave documentary techniques of museums themselves. His documentation of the fate of a single painting, Manet's "Bunch of Asparagus," which passed from hand to hand, beginning with the hands of artists and real connoisseurs and winding up in the hands of German industrialists, was meant for a museum in Cologne that, after great consternation and scandal, rejected it. Haacke's program – to "present the social and economic position of the persons who have owned the painting over the years and the prices paid for it" – proved to be too revealing. The scandal and the rejection are often a part of Haacke's work, as are the dialogues that inevitably ensue after one of his installations. Charges that these are not works of art do not bother Haacke or others working in the same direction, since they maintain that their works unfold in an art context, and are therefore an organic part of the art system. Any responses they elicit may be considered responses provoked on

196

the general grounds of art. Haacke's thoughtful and deliberate course is charted in a venerable modern tradition that has its wellsprings still in the atmosphere created by the early revolutionary years, when artists moved out into the world, or "real time," as Haacke has said, in order to affect it directly. One thinks of John Heartfield's searing photomontages during the Weimar years. It is significant that when Burnham asked Haacke to describe the situation of the socially concerned artist, Haacke quoted Bertolt Brecht's 1934 statement, "Five Difficulties in Writing the Truth":

They [include] the need for "the courage to write the truth, although it is being suppressed; the intelligence to recognize it, although it is being covered up; the judgment to choose those in whose hands it becomes effective; the cunning to spread it among them."

An example of the effectiveness of an artist's dedicating himself to the disclosure of carefully concealed truths is Margia Kramer's remarkable "work," an ongoing series of lectures, films and artistic installations calling attention to the horrifying persecution of the actress Jean Seberg by the FBI. Although the Freedom of Information Act had enabled journalists to make public the stages and effects of the FBI's unremitting smear campaign against the well-meaning but somewhat naive film actress, the press was not capable of providing the dramatic impact required to make the account significant in all its details. Kramer, by blowing up reproductions of the FBI's almost daily directives and exchanges, and mixing them with photographs and structures designed to dramatize them, chilled her viewers and instigated serious discussions. When she made an installation concerning the FBI's attempt to discredit Seberg professionally by informing the press that the actress was about to bear the black child of a Black Panther leader, Kramer used a quotation from Seberg which she spelled out in a carpet of red, yellow and black gravel:

I began cracking up . . . without knowing it. I decided to bury my baby in my hometown. We opened the coffin and took 180 photographs and everybody in Marshalltown who was curious what color the baby was got a chance to check it out. A lot of them came to look.

Kramer designed the installation so that in order to see the entire inscription one had to climb a wooden ladder. "The climb to the top and the police room lighting combine to create a judicial atmosphere

which reinforces the FBI theme." A reporter for the *Village Voice* in New York summed up the typical response:

From a scary height near the ceiling you look down on a carpet of black sand . . . the visual and physical contortions necessary to lean over and read the inscription obliterate any sense of well-being and force you to stare uncomfortably into this black morass of nausea and self-disgust. You feel that you too, could easily topple over the edge and fall into a nightmare. (January 21, 1980)

Like Haacke, Kramer has thought through her position, and is capable of defending the use of non-artistic materials toward an artistic end. She regards herself as a documentary artist, and cites John Grierson's definition of the word documentary as "the creative treatment of actuality" and his belief that "a mirror held up to nature is not as important as . . . the hammer which shapes it." She denies that she is engaged in art propaganda on the grounds that in her work

a familiar media story is reformed, investigated, placed in a dramatic human context, blown up, slowed down, appropriately framed, and personalized by identification with a famous person, so that its almost unbelievable, outrageous, frightening reality is comprehensible.

Finally, Kramer interjects a convincing argument that the designs of her constructed spaces developed from moral imperatives that were derived directly from specific issues. This way of working, she maintains, is no different from the way religious architects worked through liturgical imperatives.

The urgent need to express moral and ethical preoccupations has always found partisans in the United States. During the 19th century strong statements were largely confined to political cartoons, but in the 20th century there has not been a moment in which some artists have not strained to express rage, indignation and cosmic nausea. The Abstract Expressionists regard their endeavor as a kind of metaphysical purge, an ethical gesture in the face of a disastrous world view. The artists stimulated by the sinister events of the late '60s turned to other modes, but were no less passionate in their insistence on the ethical dimension possible in the visual arts.

135 MARGIA KRAMER *Secret I* (detail from *The Freedom of Information Act Work*) Installation at The Artists Space Gallery, New York, January 1980

9

One of the frequently remarked characteristics of the modern temper is its sense that time has accelerated. In recent years there have been many indications that the swift changes brought about by the use of advanced technology—changes not only in the practical daily life of individuals all over the world, but also in political systems altered by both devastating weaponry and such seemingly innocent objects as the tape recorder, as in Iran—are becoming intolerable. In the arts the rebellion against this uneasy sense of accelerated time may be gauged by the increasing number of ritualized actions, and the strong nostalgia expressed for others times when, it is imagined, time was closer in pace to man's pulse. During the '70s there were many experiments with videotaped rituals, in which the artists worked in excessively slow motion. On a more obvious level, film-maker Jean Luc Godard literally slowed his camera and stopped it in order to bring out the strongly disorienting effects of the hectic pace in which those in his profession lived out their lives. His title *Sauve Qui Peut* ("Each man for himself") accented his message. Even in the realm of literature a distinct effort to infuse lived time with a lulling, delaying effect was undertaken first by Alain Robbe-Grillet and later by countless imitators. In poetry, Allen Ginsberg led the way by shifting from the rolling, often breathless, pace of his Beat days to the slow, liturgical tone of incantation. His long recitals of the repeated syllable "Om" were meant not only to brake the modern sense of time, but to introduce another perception of time borrowed from the ancient East. Ginsberg's new approach to public reading was paralleled by Philip Glass's approach to the public concert. Throngs of young people attended his concerts in order to sway and bob slowly sometimes for five or six hours to the repetitious, amplified sounds Glass abstracted from his experience with Eastern musical modes. Unquestionably the

introduction of rhythms homologous to natural body rhythms in so many different art forms reflected a rebellion against modern time, and a dissent from the view that time is fundamentally different, accelerated for modern man. The religious revivals that became notable during the '70s could also be interpreted as a rejection of modern time.

And yet it is a fact that time is accelerated in the modern world, at least in the practical realm. Professor Neil Harris has pointed out that the methods of the cultural historian are often inadequate in the face of such rapid cultural change. "It is more difficult to preserve archeologically new or current institutions because their shape is dictated by current requirements–the need to modernize."[77] He gives as an example his attempt to document the development of the enclosed mall, which has undergone many evolutionary phases since 1950. Travelling around the United States, he was barely able to see and record the various phases since, as he says, phase one simply exists no longer anywhere. "With cathedrals it was different," he remarks, and points to one of the few modern architectural forms that reaches the monumental: the airport. Huge constellations are built in many cities that are "outdated" within ten years and abandoned. Often their buildings are razed to make way for the new, leaving citizens with faint, or non-existent memories of how it once was.

The obliteration of the objects that help determine one's sense of time produces psychological effects that many feel are deleterious to the creative process. It is easy to equate the breakneck speed of life in the post-industrial age with rapid changes in artistic styles that have characterized the 20th century. On the surface, it would seem that if every aspect of practical life is hastened by technological progress it is natural enough for the arts to reflect the ephemeral character of the life in which they take their place. But when scrutinized closely, the situation has evoked other and more disquieting speculations. Many commentators have perceived the uncomfortable parallels between works of art and the objects purveyed to a docile consumer society. "Nothing in the private capitalist system can avoid commodity status," Douglas Davis wrote in 1977:

The seventies are a decade in which appalling truths have finally become clear to large masses of people, from the poisonous quality of the air we breathe to the stupendous revelations of corruption that accompanied Nixon's resignation.[78]

136 MIRIAM SCHAPIRO *Silver Theatre* 1979

These appalling truths led Davis, once a columnist for a national weekly news magazine, to concentrate on his own art form, the video-tape, and to write increasingly alarmist texts, borrowing more and more from basic Marxist writings. He quotes Marx, "Das Sein bestimmt das Bewusstsein" (your situation in life determines your thinking), as a serviceable tool in the face of the disturbing new phenomena in the art world. For him, the way to change his "situation in life" is to explore the media that can reach the many with a dissenting message. It is at once a defensive and active strategy in the ongoing modernist battle against quick absorption by bourgeois society.

Certainly the pressures, including the pressures of time in the face of revelations of future ecological disaster and the ever-growing stock-piles of nuclear bombs, had much to do with the growing trends toward circumstantial art on the one hand—the ephemeral events in public spaces—and art encompassed by some programmatic ideal, on the other. When the feminist movement got under way, one of its immediate effects was to turn many women artists toward the expression of the cause. Miriam Schapiro, one of the most important leaders of the movement in art, specifically referred to herself as a "reformer." And when her own work shifted toward feminist themes, it showed signs of nostalgia for other, less hectic times. Her doll's house was followed by motifs, such as the kimono, that specifically invoked other cultures and times when ritualized life was paced in a more civilized manner.

Regroupings within the arts did not always augur stylistic change. When the need to respond to American bigotry grew strong enough, Black artists attempted to assert themselves through pressures on institutions and written manifestos. The "program" was quasi-political, but only in rare cases was the art. The movement included old masters such as Romare Bearden, whose collage technique was drawn from the modern tradition but whose themes were persistently nostalgic and documentary—memories of his childhood in the South and in New York's Harlem. But it also included young abstract artists such as William T. Williams and Sam Gilliam, neither of whom wished to be seen as propagandists.

Other shifts during the '70s also reflected the conflicts with both modern time and the tendency Davis so firmly described when he said that nothing can avoid commodity status in the private capitalist system. His recall of Marx's dictum was not so far from the mark if one considers the sudden appearance, during the late '70s, of architects in

137 ROMARE BEARDEN *Conjure Woman* 1971

138 WILLIAM T. WILLIAMS *Deli-Bud* 1979

their guise as artists. From one point of view the spate of exhibitions of architects' drawings in art galleries can be seen as a cynical move to offset the ravages of recession. Since building during the late '70s fell off precipitously, some architects took to the drawing board to produce works that could easily achieve commodity status in the gallery system. Frequently these watercolors and drawings were styled

139 SAM GILLIAM *Balloons, Shutes, Days* 1980

140 BERNARD TSCHUMI *The Park Sequence No. 20*
(from *The Manhattan Transcripts*) 1978

as "fantastic" architecture in the great tradition, although their patent thinness belied this. The architect Bernard Tschumi, whose own work can authentically be placed within the tradition of visionary architecture, noted the hollowness of so many gallery exhibitions:

The present phenomenon is hardly new. The 20th century contains numerous reductive policies aimed at mass media dissemination, to the extent that we now have two different versions of 20th century architecture. One, a maximalist version, aims at overall social, cultural, political, programmatic concerns, while the other, minimalist, concentrates on sectors called style, technique, etc.... Today the most vocal representatives of architectural "postmodernism" use the same approach, but in reverse. By focusing their attack on the International Style, they make entertaining polemics and pungent journalism, but offer little new to a cultural context that has long included the same historical allusions, ambiguous signs and sensuousness they discover today... The narrowing of architecture as a form of knowledge into architecture as mere knowledge of form is matched only by the scaling down of generous research strategies into operational power broker tactics.[79]

Tschumi points out that the conflict in contemporary architectural polemics is real and corresponds on a theoretical level to "practical

battles that occur in everyday life within new commercial markets of architectural trivia, older corporate establishments and ambitious university intelligentsia." These tactical battles, he says, are also not new, but were hidden behind reductionist ideologies of modernism—formalism, functionalism and rationalism—all of which contained contradictions. Tschumi thinks there is no reason to strip architecture again of its social, spatial, conceptual concerns and to restrict it to a territory of "wit and irony," "conscious schizophrenia," "dual coding" and "twice-broken split pediments"—terms, one presumes, he culled from reviews of gallery exhibitions.

Such reduction occurs in other, less obvious ways. The art world's fascination with architectural matters, evident in the obsessive number of "architectural reference" and "architectural sculpture" exhibitions, is well matched by the current vogue among architects for advertising in reputable galleries. . . . To call "architectural" those sculptures that superficially borrow from a vocabulary of gables and stairs is as naive as to call "paintings" some architects' tepid watercolors of the P.R. renderings of commercial firms.

Tschumi makes distinctions among the architects whose expression moves toward the limits of architecture. He admires John Hejduk whose mysterious and poetic drawings and paintings remain identifiable as the language of architecture. Hejduk's work, according to Hejduk himself, is purely programmatic—as he says, "a search for an authentic program for our time." His use of allegory, of poetic motifs drawn from literature and history, and of highly abstract formulations does not detract from the essential architectural language of plan, elevation and model. Although the elegance of his drawings invites comparison with works by the more imaginative easel painters moving toward fantasy or even surrealism, Hejduk's visions remain grounded in the traditional grammar of the given forms of the architect.

The more dubious production of architects' drawings designated for living rooms, however, suggests the new needs of the consumer society. One of its measures is space. These drawings, with their articulations of eccentric spaces, almost always presume the existence of those who can afford them, especially in urban circumstances. In New York City, for instance, the '70s saw a dramatic inflation of real estate rates and a rush on the part of the middle class to colonize the larger spaces. The phenomenal development of lower Manhattan, with its enclave of cast-iron buildings in SoHo, is a classic story.

Artists, always hungry for working space, first settled in the large lofts of this formerly manufacturing district. Once established as a bohemian quarter, the district proved fatally attractive to the professional classes who, in a marginal way, were the artists' patrons. The elegantly appointed loft became a status symbol. Those artists who were not pushed out entered an enormous competition in order to stay in their quarter. They identified themselves with the same mythology as their patrons and, in some cases, developed identical needs (such as the need to consume imported wines and cheeses and other exotic commodities). Such needs heightened the perception of art as, in effect, a business like any other.

Although earlier generations of artists had been exceedingly wary of the processes that had converted their works into saleable commodities, new generations tended not to look too closely in an era that appeared to be so much more open to their works. Hearing constantly of the ever-growing public for the arts, and the steadily rising rate of state subsidies for the arts, many contemporary artists rejoiced. But there were those who interpreted the new statistics differently. In a sober article in the *New York Times*, July 23, 1978, the director of a music foundation, Paul Fromm, sounded an alarm:

Our arts today, if I may paraphrase Hamlet, are weary, stale and flat—but not unprofitable. What has happened is that we have finally discovered the business potential of the arts. . . . Consequently, the creative ferment of the '60s has subsided. The daring innovations—living theater, electronic and aleatoric music, action painting, multi-media works—have gone stale or vanished. Instead, we get mass entertainments tailored for the largest possible markets.

Fromm attacked arts organizations for having transformed themselves into businesses. "They learned to evaluate artistic activity like any other product—for its impact on the consumer rather than for any intrinsic merit." Anyone watching the museums during the late '70s could affirm Fromm's observation. The success of blockbuster exhibitions, such as the Tutankhamun show, was measured not only in terms of the box-office, but by the level of sales of debased and vulgar souvenirs. Even the extraordinary exhibition of Cézanne's last works at the Museum of Modern Art was announced in the hectoring tone of the advertising industry, and the box-office receipts were counted with evident satisfaction by the museum.

208

It is not surprising that the lofty arts institutions ."learned," as Fromm says, from the world of business. Because of the recession-inflation situation, they had been forced to accept the avuncular counsels and, above all, the subsidies of huge corporations. Despite the perils so often cited by thoughtful social critics, and even critics in the arts, museums in the '70s recklessly embarked on programs so ambitious that only American business could bail them out. In an ignominious statement in a book about the Philip Morris Company's adventures in art, the director of the Whitney Museum, Thomas Armstrong, fulsomely defended the practise:

Too few people realize that today the art of the United States and the activities of our cultural institutions are the dominant international creative force. For the first time in our history we have the opportunity to celebrate the pre-eminence of this society at the time of its greatness. In this dynamic period, however, operating budgets for most arts institutions have far exceeded the income provided by established endowments, individual patronage, or the traditional allotments from cities that support such institutions. . . . For many of us the most willing new patrons have been federal and state governments and American business. . . . The elitists who feared contamination of the arts by the followers of Mammon have been proved wrong. . . . Even the problem of companies seeking to maximize public attention to their support of the arts carries with it no basic conflict.[80]

While Armstrong and too many others have seen no basic conflict in the equating of their show business with business, the men who write the copy for the great corporations' copious propaganda in the news media are cannier. In a 1976 campaign to establish that big business was the real backbone of the arts, Allied Chemical issued a significant warning. The business community, it explained in an advertisement titled "The Road to Culture is Paved With Profits," practises something called a "corporate philosophy" which entails making large contributions to the arts. It does this because "Cultural endeavors provide opportunities for people to express themselves. And corporations are made up of people." But, it seems, people persist in thinking that corporations make more profits than they actually do. Allied Chemical maintained that the average manufacturing corporation makes less than five cents on the dollar. This situation, the ad implied, must be altered if the arts are to flourish. "People" had better revise their attitudes. "The artist in America has traveled a rocky

road. It's going to take more profits, not just good intentions, to take some bumps out of the road.''

Not all corporations are quite so blunt as Allied Chemical. Those who allocate direct subsidies for major projects in museums tend to be more beguiling, using the patriotic diction that Mr Armstrong favors. In the advertisement for an excellent exhibition of German Expressionism at the Guggenheim Museum and elsewhere, the veteran Philip Morris Company announced that

In our business as in yours, we need to be reminded that the language of human feeling is far older and far more valuable than the language of computers. Sponsorship of art that reminds us of this is not patronage. It's a business and human necessity.

Once in a while there is a savory irony in such situations. When the Philip Morris Company sponsored a concert of Arnold Schoenberg's *Pierrot Lunaire* to accompany the Guggenheim presentation, the musical director included a parody of *Pierrot Lunaire* composed by Hanns Eisler, a former student of Schoenberg's who had fled Nazi Germany in 1933, worked in Hollywood as musical assistant to Charlie Chaplin, and was so savagely persecuted as a Communist that he was forced to flee America in 1947 during the worst of the red witch hunts. Eisler's brilliant parody, composed to the poems of another rebellious German, Christian Morgenstern, went unnoticed by both the corporation and those reporting the event. But while directors of museums insist that the benign supercompanies never attempt to influence judgments in high artistic matters, had Philip Morris only known . . .

In his last published interview before his death, Harold Rosenberg warned of the inherent traps in corporate and state involvement in the arts. One of the worst, he pointed out, is the creeping tendency toward nationalism (admirably borne out by Armstrong's puff):

At the present time I don't know of a single show of any magnitude in the United States in any big museum not sponsored by some combination of the National Endowment for the Arts, a state council of the arts, and one of the big corporations–Xerox, Philip Morris, and so on. You might say it's almost inevitable that agencies such as government and big business would have a nationalist orientation, and this has begun to slowly seep into the exhibition, interpretation, and production of art . . .[81]

When the interviewer remarked that Rosenberg's prognosis sounded similar to the situation Rosenberg had said prevailed in Communist countries, he answered,

That's right. And that means ultimately everything becomes a matter of mass media, whether one is dealing with paintings or movies. Everything is preplanned in accordance with policy. The artist as individual has nothing to say and nothing to contribute. He becomes a technician of the regime, whatever the regime happens to be. And if anybody thinks that's farfetched, he has only to look at what's happened in several countries during the twentieth century.

The interlocking elements of the new situation in the art world emerge in reports of increased corporate investment in painting and sculpture as a hedge against inflation, and a new interest on the part of individual buyers in the business value of art. For a long time there have been wry comments in the artists' milieu about a kind of elegant decorative painting that can be called art-for-banks. Now those banks are advising individual clients to follow their example. In the December, 1980, issue of *Artworkers News*, two headlines greeted artist readers: "Banks and Corporations Move More Money Into Art Purchases and Dominate Buying Trends" and "Investors Looking to Hedge Inflation Spurred a Hectic 1979 in New York's Galleries." With such news, American artists and appreciators would do well to heed Rosenberg's warning. If the Douglas Davis/Marx dictum that one's situation in life determines one's thinking is right, the artist had better look to his situation with great critical care, for American art, with all its diversity, or, as commentators like to say, its pluralism, is on the threshold of crisis—not economic but moral.

Notes

1 Richard H. Pells, *Radical Visions and American Dreams* (New York, 1973)

2 Pells, *op. cit.*

3 Adolph Gottlieb, "Artist and Society," *College Art Journal* (Winter, 1935)

4 Harold Rosenberg, "The American Action Painters," in *The Tradition of the New* (New York, 1959)

5 Interview in *The New York Sun* (August 22, 1941)

6 "Content is a Glimpse . . . ," *Location* (New York, Spring, 1963)

7 "I Cannot Evolve Any Concrete Theory," *Possibilities, I.* (New York, 1947–48)

8 Letter to the *New York Times* (June 7, 1943)

9 *Existentialism and Humanism* (New York/London, 1948)

10 Will Grohmann, review of "The New American Painting," in *Der Tagesspiegel* (Berlin, September 7, 1958)

11 Andrew Forge, "On Painting," published by The Cooper Union, New York, in its "Critiques" series (1974)

12 Eric Goldman, *The Crucial Decade—and After* (New York, 1960)

13 Pells, *op. cit.*, p. 367

14 See Rose Lee Goldberg, *Performance* (New York/London, 1979)

15 Cited in Bruce Cook, *The Beat Generation* (New York, 1971)

16 John Clellan Holmes, *The Beat Boys* (London, 1959)

17 "Unscrewing the Locks: the Beat Poets," in *Poets of the Cities, New York and San Francisco 1950–1965* (New York, 1974)

18 Richard Howard, *Alone With America* (New York/London, 1969)

19 "On the Road: Notes on Artists and Poets," in *Poets of the Cities, op. cit.*

20 Quoted in Michael Crichton, *Jasper Johns* (New York, 1977)

21 Nicolas Calas, "Jasper Johns and the critique of painting," *Point of Contact* (September–October, 1976)

22 Lawrence Alloway, *American Pop Art* (New York, 1974)

23 "Gotham News, 1945–60,' in *Avant-Garde*, edited by John Ashbery and Thomas B. Hess (New York, 1967)

24 Nicolas Calas, *op. cit.*

25 John Ashbery, "The Invisible Avant Garde," in Ashbery and Hess, *op. cit.*

26 Jules Langsner, *Four Abstract Classicists*, Los Angeles County Museum (1959)

27 Catalogue foreword for "Barnett Newman: A selection 1946–1952" (French & Co., March 11–April 5, 1959)

28 Catalogue of Stedelijk Museum exhibition (Amsterdam, January, 1979)

29 Catalogue of Stedelijk Museum exhibition, *op. cit.*

30 Irving Sandler, *The New York School: The Painters and Sculptors of the Fifties* (New York, 1978)

31 Theodore Solotaroff, *The Red Hot Vacuum and Other Pieces on the Writing of the Sixties* (New York, 1970)

32 Reuven Frank, cited by Jeff Green-

field, in "Remembering the Sixties, as Seen on T.V.," in the *New York Times* (June 20, 1976)

33 Joan Didion, *Slouching Towards Bethlehem* (New York, 1968). (Yeats's poem ends: "And what rough beast, its hour come round at last,/Slouches towards Bethlehem to be born?")

34 Karl Ernest Meyer, *The Art Museum: Power, Money and Ethics*, a 20th-Century Fund Essay (New York, 1979)

35 Meyer, *op. cit.*

36 Carter Ratcliff, "Art Establishment: Rising Stars vs. the Machine," *New York Magazine* (November 27, 1978)

37 Sandler, *op. cit.*

38 Barbara Rose, "The Primacy of Color," *Art International*, VIII/4 (1964)

39 Lewis Mumford, *Interpretations and Forecasts, 1922-1972* (New York, 1972)

40 William Seitz, *The Art of Assemblage* (New York, 1976)

41 Basil Taylor, "Art–Anti-Art," *The Listener* (November 12, 1954)

42 Henry Martin, *An Introduction to George Brecht's Book of the Tumbler on Fire* (Milan, 1973)

43 Full title "The Machine as Seen at the End of the Mechanical Age" (1968)

44 Michael Fried, essay for catalogue "Three American Painters", Fogg Museum, Harvard University (April 21–May 30, 1965)

45 Bruce Glaser, "Questions to Stella and Judd," in Gregory Battcock, *Minimal Art, A Critical Anthology* (New York, 1968)

46 Lucy Lippard, *American Pop Art* (New York/London, 1966)

47 Quotation in "An Interview with Gene Swenson," in Ashbery and Hess, *op. cit.*

48 Lloyd Goodrich, "What is American in American Art?," *Arts in America* (August, 1963)

49 Lawrence Alloway, *op. cit.*

50 G. R. Swenson, "Interview with Andy Warhol," *Art News* (November, 1963)

51 L. M. Danoff, essay for catalogue *Emergence and Progression*, The New Milwaukee Art Center (1979)

52 Excerpt from interview with Michelangelo Antonioni by Jean-Luc Godard; appeared originally in *Cahier du Cinéma* and reprinted in *Environments: Notes and Selections on Objects, Spaces and Behaviors*, ed. Stephen Friedman and Joseph Juhasz (Belmont, CA, 1974)

53 D. W. Bongard, newsletter, *Art Aktuell* (October, 1973)

54 Alfred North Whitehead, *Modes of Thought* (New York/London, 1930)

55 Wallace Stevens, "The Relations Between Painting and Poetry," in *The Necessary Angel* (New York, 1951)

56 *Art and Literature*, No. 3 (1964)

57 "Primary Structures," in *Arts* (May, 1966)

58 Rosalind Krauss, *Passages in Modern Sculpture* (New York/London, 1977)

59 Harold Rosenberg, *The De-Definition of Art* (New York, 1972)

60 Robert Morris, in *Über Kunst, Artists' Writings on the Changed Notion of Art After 1965*, ed. Gerd de Vries (Cologne, 1974)

61 Sol LeWitt, in *Über Kunst, op. cit.*

62 David Cross, "Toward a Radical Theory of Culture," *Radical America* (November–December, 1968)

63 Jeremy J. Shapiro, in *Radical America, op. cit.*

64 Lucy Lippard, "This Is Art?" *Seven Days* (February 14, 1977)

65 Roger Shattuck, *New York Times Book Review* (January 6, 1974)

66 Robert Hughes, "Ten Years That Buried The Avant-Garde," *Sunday Times* (London) (January 11, 1980)

67 V. Shklovsky, "Art as Technique," in *Russian Formalist Criticism: Four Essays* (Univ. of Nebraska Press, 1965)

68 Richard Diebenkorn, *Modern Painting and Sculpture Collected by Louise and Joseph Pulitzer*, Fogg Museum (Cambridge, Mass., 1958)

69 Al Held, catalogue for Whitney Museum exhibition (1974)

70 Hilton Kramer, "Frank Stella's Brash and Lyric Flight," *Portfolio* (April–May, 1979)

71 Allan Frumkin Gallery Newsletter, No. 5 (Spring, 1978)

72 Allan Frumkin Gallery Newsletter, No. 7 (Winter, 1979)

73 Rafael Ferrer, in catalogue for the Institute of Contemporary Art, Boston, Mass. (September–October, 1978)

74 *The Will to Power*, ed. Walter Kaufmann (New York, 1967)

75 Statement in *Structure*, John Gibson Gallery (New York, 1972)

76 Jack Burnham, in Hans Haacke, *Framing and Being Framed* (Halifax, 1975)

77 Conversation with the author

78 Douglas Davis, *Artculture* (New York, 1977)

79 Bernard Tschumi, "Architecture and Limits," *Artforum* (December, 1980)

80 Sam Hunter, *Art in Business: The Philip Morris Story* (New York, 1979)

81 Interview by Jonathan Fineberg, *Portfolio* (April/May, 1979)

List of Illustrations

18 ADJA YUNKERS
Tarrassa XIII 1958
pastel on paper 70 × 48 (177·8 × 121·9)
Collection of The Whitney Museum of
American Art, New York. Photo courtesy
André Emmerich Gallery, New York

19 ARSHILE GORKY
The Betrothal II 1947
Oil on canvas $50\frac{3}{4}$ × 38 (128·9 × 96·5)
Collection of The Whitney Museum of
American Art, New York

20 CLYFFORD STILL
Untitled 1953
oil on canvas $92\frac{7}{8}$ × $68\frac{1}{2}$ (235·9 × 174)
The Tate Gallery, London

21 JACKSON POLLOCK
Easter and the Totem 1953
oil on canvas $82\frac{1}{8}$ × $57\frac{7}{8}$ (208·6 × 147)
Private Collection

22 MARK TOBEY
New York 1944
tempera on cardboard 33 × 21 (83·8 × 53·3)
National Gallery of Art, Washington. Avalon
Fund

23 SAM FRANCIS
The Whiteness of the Whale 1957
oil on canvas $104\frac{1}{2}$ × $85\frac{1}{2}$ (265·4 × 217·2)
Albright-Knox Art Gallery, Buffalo, New
York. Gift of Seymour H. Knox, 1959

24 MORRIS LOUIS
Gamma Iota 1960
acrylic on canvas 102 × $156\frac{1}{2}$ (259·1 × 397·5)
Courtesy Waddington Galleries Ltd., London

25 FRANZ KLINE
Figure 8 1952
oil on canvas $80\frac{1}{2}$ × $63\frac{1}{2}$ (204·5 × 161·3)
Collection Mr. and Mrs. Harry W. Anderson,
Atherton, California

26 PHILIP GUSTON
The Return 1956–58
oil on canvas $70\frac{1}{8}$ × $78\frac{3}{8}$ (178·1 × 199·1)
The Tate Gallery, London

27 HELEN FRANKENTHALER
Mountains and Sea 1952
oil on canvas $86\frac{7}{8}$ × $117\frac{1}{4}$ (210·7 × 297·8)
Collection the artist. On loan to The National
Gallery of Art, Washington

28 MORRIS LOUIS
Vav 1960
acrylic on canvas $102\frac{1}{2}$ × $141\frac{1}{2}$ (260·4 × 359·4)
The Tate Gallery, London

29 JOAN MITCHELL
Hemlock 1956
oil on canvas 91 × 80 (231·1 × 203·2)
Collection of The Whitney Museum of
American Art, New York

30 GRACE HARTIGAN
Grand Street Brides 1954
oil on canvas 72 × $102\frac{1}{2}$ (182·9 × 260·4)
Collection of The Whitney Museum of
American Art, New York. Anonymous gift

31 RICHARD DIEBENKORN
Berkeley No. 54 1955
oil on canvas 61 × 58 (154·9 × 147·3)
Albright-Knox Art Gallery, Buffalo, New
York. The Martha Jackson Collection

32 LESTER JOHNSON
Three Men, Green Writing 1962
oil on canvas $59\frac{1}{2}$ × $90\frac{1}{8}$ (151·1 × 228·9)
Alcoa Collection of Contemporary Art,
Pittsburgh. Courtesy Alcoa of Great Britain
Ltd.

33 LARRY RIVERS
Parts of the Body: Italian Vocabulary Lesson 1963
oil on canvas 69 × 52 (175·3 × 132·1)
Courtesy Marlborough Gallery, New York

34 LOUISE BOURGEOIS
Garden at Night 1953
wood 45 (114·3)
Private Collection. Photo courtesy Stable
Gallery, New York

35 LOUISE BOURGEOIS
The Blind Leading the Blind (second version)
1941–48
painted wood 67 × $64\frac{1}{2}$ × $16\frac{1}{4}$ (170·2 × 163·8
× 41·3)
Courtesy Xavier Fourcade, Inc., New York

36 LOUISE NEVELSON
Royal Tide V 1960
wood, painted gold (21 compartments)
102 × $80\frac{5}{8}$ (259 × 205)
Private Collection. Photo courtesy the artist

37 GEORGE SUGARMAN
Six Forms in Pine 1959
laminated carved wood 60 (with base) × 96
× 60 (152·4 × 243·8 × 152·4)
Courtesy Robert Miller Gallery, New York

38 JAMES ROSATI
Delphi IV 1961
bronze $27\frac{1}{2}$ (69·9)
Courtesy Marlborough Gallery, New York

39 RICHARD STANKIEWICZ
Untitled 1961
iron and steel 84 (213·5)
Stable Gallery, New York. Photo courtesy
the artist

40 MARK DI SUVERO
Hankchampion 1960
wood and chain $77\frac{1}{2} \times 149 \times 105$ $(196\cdot9 \times 378\cdot5 \times 266\cdot7)$
Collection of The Whitney Museum of American Art, New York. Gift of Mr. and Mrs. Robert C. Scull

41 LEE BONTECOU
Untitled 1966
mixed media $99\frac{1}{2} \times 90 \times 26$ $(252\cdot7 \times 228\cdot6 \times 66)$
Private Collection. Photo courtesy of Leo Castelli Gallery, New York

42 ROBERT RAUSCHENBERG
Bypass 1959
oil and mixed media on canvas 59×53 $(149\cdot9 \times 134\cdot6)$
Courtesy Leo Castelli Gallery, New York

43 JASPER JOHNS
Numbers in Color 1959
encaustic and collage on canvas $66\frac{1}{2} \times 49\frac{1}{2}$ $(168\cdot9 \times 125\cdot7)$
Albright-Knox Art Gallery, Buffalo, New York. Gift of Seymour H. Knox

44 ROBERT RAUSCHENBERG
Almanac 1962
oil and mixed media on canvas 96×60 $(243\cdot8 \times 152\cdot4)$
The Tate Gallery, London

45 ROBERT RAUSCHENBERG
Canto XX: Illustration for Dante's Inferno 1959–60
wash and pencil $14\frac{1}{2} \times 11\frac{1}{2}$ $(36\cdot7 \times 29\cdot1)$
Collection, The Museum of Modern Art, New York. Given anonymously

46 JASPER JOHNS
Target with Four Faces 1955
encaustic on newspaper over canvas surmounted by four tinted plaster faces in wooden box with hinged front $33\frac{1}{2} \times 26 \times 3$ $(85\cdot3 \times 66 \times 7\cdot6)$ with box open
Collection, The Museum of Modern Art, New York. Gift of Mr. and Mrs. Robert C. Scull

47 JASPER JOHNS
Tennyson 1958
encaustic and collage on canvas $73\frac{1}{2} \times 48\frac{1}{2}$ $(186\cdot7 \times 123\cdot2)$
Des Moines Art Center. Photo courtesy Leo Castelli Gallery, New York

48 EDWARD KIENHOLZ
The Beanery 1965 (detail)
mixed media environment (life-size)
Stedelijk Museum, Amsterdam

49 BRUCE CONNER
Couch 1963
mixed media assemblage $31\frac{1}{2} \times 72 \times 26$ $(80 \times 182\cdot9 \times 66)$
Pasadena Art Museum

50 AD REINHARDT
Brick Painting 1951–52
oil on canvas 80×42 $(203\cdot2 \times 106\cdot7)$
The Tate Gallery, London

51 FRITZ GLARNER
Relational Painting Tondo No. 20 1951–54
oil on fibreboard $47\frac{3}{8}$ $(120\cdot3)$ diameter
Hirshhorn Museum and Sculpture Garden, Smithsonian Institution, Washington, D.C.

52 BURGOYNE DILLER
First Theme: Number 10 1963
oil on canvas 72×72 $(182\cdot9 \times 182\cdot9)$
Collection of The Whitney Museum of American Art, New York

53 JOHN MCLAUGHLIN
No. 18 (diptych) 1974
acrylic on canvas each panel 60×48 $(152\cdot4 \times 122)$
Courtesy André Emmerich Gallery, New York

54 BARNETT NEWMAN
Who's Afraid of Red, Yellow and Blue II 1967
oil on canvas $120 \times 98\frac{1}{2}$ $(304\cdot8 \times 250\cdot2)$
M. Knoedler & Co., Inc., New York

55 ELLSWORTH KELLY
Yellow-Blue 1963
oil on canvas 90×65 $(228\cdot6 \times 165\cdot1)$
Des Moines Art Center. Coffin Fine Arts Trust Fund, 1971

56 WILLEM DE KOONING
Untitled 1963
oil on canvas 80×70 $(202\cdot9 \times 177\cdot5)$
Hirshhorn Museum and Sculpture Garden, Smithsonian Institution, Washington, D.C.

57 ELLSWORTH KELLY
White-Dark Blue 1962
oil on canvas $58\frac{1}{4} \times 33$ $(148 \times 83\cdot8)$
Courtesy Arthur Tooth & Sons Ltd., London

58 JACK YOUNGERMAN
Totem Black 1967
oil on canvas 123×81 $(312\cdot4 \times 205.7)$
Courtesy Betty Parsons Gallery, New York

59 AL HELD
Echo 1966
acrylic on canvas 84×72 $(213\cdot4 \times 182\cdot9)$
Courtesy André Emmerich Gallery, New York

60 RAY PARKER
Untitled 1959
oil on canvas 70 × 70⅞ (177·8 × 180)
The Tate Gallery, London

61 ALEX KATZ
The Red Smile 1963
oil on canvas 78¾ × 115 (200 × 292·1)
Courtesy Marlborough Gallery, New York

62 PHILIP PEARLSTEIN
Female Model on an African Stool 1976
oil on canvas 72 × 60 (182·9 × 152·4)
The Cleveland Museum of Art, Purchase Mr.
and Mrs. Marlatt Fund

63 MARK ROTHKO
Red on Maroon 1959 (one panel of the set
commissioned for the Four Seasons Restaur-
ant, Seagram Building, New York)
oil on canvas 105 × 94 (266·7 × 238·8)
The Tate Gallery, London

64 MARK ROTHKO
Murals in the interior of the Rothko Chapel,
Houston, Texas, 1965–67. Chapel dedicated
in 1971.
Courtesy Menil Foundation, Houston

65 PHILIP GUSTON
The Inhabitor 1965
oil on canvas 76 × 79 (193 × 200·7)
Private Collection. Photo courtesy David
McKee Gallery, New York

66 ROBERT MOTHERWELL
Africa 1965
acrylic on canvas 80 × 225 (203·2 × 571·5)
The Baltimore Museum of Art. Gift of
Robert Motherwell

67 DAVID SMITH (l – r)
Cubi XIX 1964
stainless steel 113⅛ (287·3)
Cubi XVII 1963
stainless steel 107¾ (273·7)
Cubi XVIII 1964
stainless steel 115¾ (294)
Courtesy Marlborough Gallery, New York

68 JOSEPH CORNELL
Hôtel du Nord c.1953
construction: glass, paper and wood
19 × 13¼ × 5½ (48·3 × 33·7 × 14)
Collection of The Whitney Museum of
American Art, New York

69 KENNETH NOLAND
Tropical Zone 1964
acrylic resin on canvas 83⅜ × 212½ (211·8 ×
539·8)
Courtesy André Emmerich Gallery, New
York

70 FRANK STELLA
Six Mile Bottom 1960
acrylic on canvas 118 × 71½ (299·7 × 181·6)
The Tate Gallery, London

71 RONALD BLADEN
3 Elements 1965
wood and aluminum 108 × 48 × 120 × 21
(274·3 × 121·9 × 304·8 × 53·3)
Courtesy Fischbach Gallery, New York

72 DONALD JUDD
Untitled 1965
galvanized iron and aluminum 33 × 141 × 30
(83·8 × 358·1 × 76·2)
Collection Philip Johnson. Photo courtesy
Leo Castelli Gallery, New York

73 TONY SMITH
Gracehoper 1972
sheet steel 276 × 552 × 396 (701 × 1402 ×
1005·8)
The Detroit Institute of Arts. F. S. Purchase,
W. Hawkins Ferry and Founders Society
Funds

74 ROY LICHTENSTEIN
Hopeless 1963
oil on canvas 44 × 44 111·8 × 111·8)
Collection Mr. and Mrs. Michael Sonnabend,
Paris-New York. Photo courtesy Leo Castelli
Gallery, New York

75 ANDY WARHOL
Saturday Disaster 1964
synthetic polymer paint and silkscreen enamel
on canvas 118⅞ × 81⅞ (302 × 207·5)
Brandeis University Art Collection, Rose
Art Museum. Gevirtz-Mnuchin Purchase
Fund, by exchange

76 ROY LICHTENSTEIN
Modern Painting with Arc 1966
oil and magna on canvas 48 × 48 (121·9 ×
121·9)
Private Collection

77 JAMES ROSENQUIST
F-111 (detail) 1965
oil on canvas with aluminum 120 × 1032
(304·8 × 2621·3)
Collection Mr. and Mrs. Robert Scull.
Courtesy Leo Castelli Gallery, New York

78 CLAES OLDENBURG
Giant Toothpaste Tube 1964
vinyl over canvas, filled with kapok; wood,
metal and cast plastic 25½ × 66 × 17 (64·77 ×
167·6 × 43·2)
Private Collection

79 RICHARD LINDNER
The Street 1963
oil on canvas 72 × 72 (182·9 × 182·9)
Courtesy Cordier and Ekstrom, Inc., New York

80 ALLAN D'ARCANGELO
US Highway I 1963
acrylic on canvas 70 × 80 (177·8 × 205·7)
Collection Mr. and Mrs. Sidney Lewis, Richmond, Virginia. Photo courtesy Fischbach Gallery

81 GEORGE SEGAL
Bus Riders 1964
plaster, metal and vinyl 69 × 40 × 76 (175·3 × 101·6 × 193)
Hirshhorn Museum and Sculpture Garden, Smithsonian Institution, Washington, D.C.

82 WILLIAM T. WILEY
The Balance is Not So Far Away from the Good Old Daze 1970
watercolor and ink on paper 22 × 30 (55·9 × 76·2)
Collection David Lawrence, Chicago. Photo courtesy Allan Frumkin Gallery, New York

83 OYVIND FAHLSTROM
Exercise (Nixon) 1971
ink and acrylic on paper 14 × 16 (35·6 × 40·6)
Courtesy Sidney Janis Gallery, New York

84 ROBERT GROSVENOR (l-r)
Wedge 1966
fibreglass, steel and plywood 156 × 96 × 24 (396·2 × 243·8 × 70)
Tenerife 1966
fibreglass, steel and plywood 72 × 252 × 36 (182·9 × 640·1 × 91·4)
Installation at The Dwan Gallery, Los Angeles. Photo courtesy Paula Cooper Gallery, New York

85 DAN FLAVIN
Greens Crossing Greens 1967
8 × 96 (20·3 × 243·8)
Installation at The Dwan Gallery, New York, October 1967. Photo courtesy Dwan Gallery, New York

86 EVA HESSE
Tomorrow's Apples (5 in White) 1965
enamel, gouache and mixed media on cardboard $25\frac{5}{8} × 21\frac{5}{8} × 3\frac{1}{2}$ (65·1 × 54·9 × 8·9)
The Tate Gallery, London

87 RICHARD TUTTLE
Installation, 2nd change, at The Whitney Museum of American Art, New York, October 8, 1975

88 ROBERT SMITHSON
Spiral Jetty 1970
Great Salt Lake, Utah
Photo by Gian Franco Gorgoni courtesy John Weber Gallery, New York

89 MICHAEL HEIZER
Double Negative 1969–71
Virgin River Mesa, Nevada
rhyolite and sandstone 18,000 × 600 × 360 (45,720 × 1524 × 914·4)
240,000 tons (243,840 tonnes) displaced
Collection Virginia Dwan, New York. Photo courtesy Xavier Fourcade, Inc., New York

90 BRICE MARDEN
Conturbatio 1978
oil paint and wax on canvas 84 × 96 (213·4 × 243·8)
Courtesy The Pace Gallery, New York

91 ROBERT MORRIS
Installation at Leo Castelli Gallery, New York, April 1968
felt
Courtesy Leo Castelli Gallery, New York

92 CARL ANDRE
Plain 1969
36 pieces of steel and zinc 36 × 36 × $\frac{3}{8}$ (91·4 × 91·4 × 1)
Courtesy John Weber Gallery, New York

93 SOL LEWITT
Cube 15·25 1967 (executed 1972)
painted wooden lattice work cube on painted board $45\frac{1}{4} × 45\frac{1}{4} × 15\frac{1}{4}$ (115·5 × 115·5 × 38·5) overall
Photo courtesy The Courtauld Institute of Art, London

94 ARAKAWA
Study for the I 1978–79
acrylic, colored pencil, graphite, watercolor, mat medium 41 × 59 (104·1 × 149·9)
Courtesy Robert Feldman Fine Arts, Inc., New York

95 MEL BOCHNER
The Theory of Sculpture Demonstration No. 6 (Commutativity) 1972
chalk and stones
Collection the artist. Photo courtesy Lisson Gallery, London

96 DOROTHEA ROCKBURNE
Drawing Which Makes Itself (part of the series) 1973
lines generated from folds in carbon paper 34 × 40 (86·4 × 101·6)
Private Collection. Photo courtesy The Museum of Modern Art, New York

97 AGNES MARTIN
Untitled No. 12 1977
india ink, graphite and gesso on canvas
72 × 72 (182·9 × 182·9)
Courtesy The Pace Gallery, New York

98 STEPHEN GREENE
Signature 1979
oil on canvas 60 × 60 (152·4 × 152·4)
Courtesy Marilyn Pearl Gallery, New York

99 JAKE BERTHOT
Walken's Ridge 1975–76
oil on canvas, two panels mounted on wood
60½ × 168 (152·5 × 427) overall
Collection, The Museum of Modern Art,
New York. Louis and Bessie Adler Foundation
Fund

100 DEBORAH REMINGTON
Tudor 1971
oil on canvas 73½ × 72 (186·7 × 182·9)
Courtesy Galerie Darthea Speyer, Paris

101 PAUL ROTTERDAM
Substance 323 1979
acrylic on canvas 79 × 76 (200·7 × 193)
Courtesy Susan Caldwell, Inc., New York

102 POWER BOOTHE
The Gift 1980
oil on canvas 72 × 72 (182·9 × 182·9)
Courtesy A. M. Sachs Gallery, New York

103 PHILIP GUSTON
Source 1976
oil on canvas 76 × 117 (193 × 297·9)
Courtesy David McKee Gallery, New York

104 MARK ROTHKO
Untitled 1960 Harvard Mural panel
oil on canvas 105 × 95½ (266·7 × 242·6)
© The Mark Rothko Foundation, Inc.,
1981. Photo Quesada/Burke

105 ROBERT MOTHERWELL
The Spanish House (Open No. 97) 1969
acrylic on canvas 92½ × 114 (235 × 289·6)
Collection the artist

106 RICHARD DIEBENKORN
Ocean Park No. 122 1980
oil on canvas 100 × 81 (254 × 205·7)
Courtesy M. Knoedler & Co., New York

107 PHILIP GUSTON
The Ladder 1978
oil on canvas 70 × 108 (177·8 × 274·3)
Private Collection. Photo courtesy David
McKee Gallery, New York

108 FRANK STELLA
Guadalupe Island, Caracara 1979
various media on honeycomb and sandwich
foam aluminum 93¾ × 121 (238 × 307·5)
The Tate Gallery, London

109 AL HELD
Solar Wind III 1974
acrylic on canvas 84 × 84 (213·4 × 213·4)
Courtesy André Emmerich Gallery, New
York

110 JIM DINE
Jerusalem Nights 1979
acrylic on canvas, two panels 96 × 95½
(243·8 × 242·6) overall
Courtesy The Pace Gallery, New York

111 JACK BEAL
The Harvest 1979–80
oil on canvas 96 × 96 (243·8 × 243·8)
Courtesy Allan Frumkin Gallery, New York

112 STEPHEN POSEN
Boundary 1977–78
oil on canvas 90 × 70 (228·6 × 177·8)
Courtesy Robert Miller Gallery, New York

113 DUANE HANSON
Race Riot 1969–71
fibreglass and polyester lifesize
Courtesy O.K. Harris Works of Art, New
York

114 WILLIAM TUCKER
Arc 1977–78
laminated mild steel 64 × 24 × 246 (162·6 ×
61 × 624·8)
Courtesy Robert Elkon Gallery, New York

115 HERBERT GEORGE
Visit and the Apparition 1980
steel, wood, paint and plaster 80 × 53 × 120
(203·2 × 134·6 × 304·8)
Courtesy the artist

116 RAFAEL FERRER
Mr. Equis 1978
mixed media 96 × 36 × 32 (243·8 × 91·4 ×
81·3)
Courtesy Nancy Hoffman Gallery, New
York

117 LUCAS SAMARAS
Mirror Room No. 2 1966
wood and mirrors 96 × 120 × 96 (243·8 ×
304·8 × 243·8)
Courtesy The Pace Gallery, New York

118 WILL INSLEY
*Passage Space Hill Slip, vanishing point perspective,
interior view* 1975–76
ink on ragboard 40 × 60 (101·6 × 152·4)
Courtesy Max Protetch Gallery, New York

119 JOEL SHAPIRO
Installation at Paula Cooper Gallery, New
York, November 1980. Courtesy Paula
Cooper Gallery, New York

120 TOM CLANCY
Memoriam Installation in the central mall of
the Pratt Institute, New York, April 1980
7 cubic yards (5·35 cubic meters) of gray
concrete with steel reinforcement bars sup-
ported on 40,000 pounds (18,237 kilograms)
of melting cake ice 36 × 144 × 432 (91·4 ×
351·4 × 1097·3)
Photo courtesy the artist

121 JACKIE FERRARA
A198 Tower: Bridge for Castle Clinton 1979
wood 150 × 282 × 168 (381 × 716·3 × 426·7)
Courtesy Max Protetch Gallery, New York

122 JAKE BERTHOT
Belfast 1981
oil on canvas 73¼ × 49 (186·1 × 124·5)
Courtesy David McKee Gallery, New York

123 ISAMU NOGUCHI
Hart Plaza, Detroit 1980
Photo Balthazar Korab

124 STEPHEN DE STAEBLER (l-r)
Standing Figure with Bow Leg 1979
fired clay 86½ × 11½ × 26 (219·7 × 29·2 × 66)
Collection the artist
Standing Figure with Yellow Breast 1979
fired clay 87½ × 14½ × 26½ (222·3 × 36·8 ×
67·3)
Collection Dr. Roger Stinard, Pleasanton,
CA. Courtesy the artist and Hansen Fuller
Goldeen Gallery, San Franciso.

125 CHRISTOPHER WILMARTH
Gnomon's Parade (Peace) 1980
glass and steel 96 × 40 × 35½ (243·8 × 101·6 ×
90·2)
Courtesy the artist

126 AGNES MARTIN
Untitled No. 9 1980
gesso, acrylic and graphite on linen 72 × 72
(182·9 × 182·9)
Courtesy The Pace Gallery, New York

127 ROBERT WILSON and PHILIP GLASS
Einstein on the Beach 'Opera',
premier performance at Avignon, 1976
Photo © Babette Mangolte

128 CHRISTO
Running Fence Sonoma and Marin Counties,
California 1972–76
216 × 24 miles (548·6 × 38·62 kilometers)
Photo Wolfgang Volz courtesy of the artist

129 ROBERT ISRAEL and PHILIP GLASS
Satyagraha 'Opera', Rotterdam, 1980 Act II:
Arjuna (r) and Krishna (l) with Mahatma
Gandhi in foreground. Photo courtesy Robert
Israel

130 VITO ACCONCI
The People Machine Installation at Sonnabend
Gallery, New York, April 1979
aluminum, fabric and sound
Courtesy Sonnabend Gallery, New York

131 LEANDRO KATZ
The Lunar Typewriter (from *The Lunar Alphabet
Series*, 1979
black and white photomontage 30 × 40 (76·2
× 101·6)
Courtesy of the artist

132 RUDOLF BARANIK
Napalm Elegy 5 1969
oil and collage on canvas 50 × 60 (127 ×
152·4)
Private Collection. Photo courtesy Lerner-
Heller Gallery, New York

133 MAY STEVENS
Rosa (from *The Rosa Luxemburg Series*) 1980
mixed media 52¾ × 41½ (136·5 × 105·4)
Courtesy Lerner-Heller Gallery, New York

134 HANS HAACKE
Thank You, Paine Webber 1979
2 panels, each 42¼ × 40¾ (107·3 × 103·5)
Courtesy John Weber Gallery, New York

135 MARGIA KRAMER
Secret I (detail from *The Freedom of Information
Act Work*) Installation at The Artists Space
Gallery, New York, January 1980
colored gravel and wood
Photo courtesy the artist

136 MIRIAM SCHAPIRO
Silver Theatre 1979
acrylic, fabric, found edging on paper 37 × 30
(94 × 76·2)
Courtesy Lerner-Heller Gallery, New York

137 ROMARE BEARDEN
Conjure Woman 1971
collage on board 22¾ × 16½ (57·8 × 41·9)
Courtesy Cordier and Ekstrom, Inc., New
York

138 WILLIAM T. WILLIAMS
Deli-Bud 1979
acrylic on canvas 84 × 60 (213·4 × 152·4)
Courtesy Touchstone Gallery, New York

139 SAM GILLIAM
Balloons, Shutes, Days 1980
acrylic on canvas 80 × 90 (203·2 × 228·6)
Courtesy Middendorf/Lane Gallery, New
York

140 BERNARD TSCHUMI
The Park Sequence No. 20 (from *The Manhattan
Transcripts*) 1978
photograph and ink
Photo courtesy the artist

Index